Cloning Terror

W. J. T. MITCHELL **Cloning Terror**

THE WAR OF IMAGES, 9/11 TO THE PRESENT

THE UNIVERSITY OF CHICAGO PRESS CHICAGO & LONDON

W. J. T. Mitchell is the Gaylord Donnelley Distinguished Service Professor in the Department of English Language and Literature, the Department of Art History, and the College at the University of Chicago. He is the author, editor, or coeditor of fourteen previous books, including *What Do Pictures Want?*, winner of the James Russell Lowell Prize of the Modern Language Association. He is also editor of the journal *Critical Inquiry.*

The University of Chicago Press, Chicago 60637
The University of Chicago Press, Ltd., London
© 2011 by The University of Chicago
All rights reserved. Published 2011
Printed in the United States of America

19 18 17 16 15 14 13 12 11 1 2 3 4 5

ISBN-13: 978-0-226-53259-2 (cloth)
ISBN-13: 978-0-226-53260-8 (paper)
ISBN-10: 0-226-53259-3 (cloth)
ISBN-10: 0-226-53260-7 (paper)

Library of Congress Cataloging-in-Publication Data

Mitchell, W. J. T. (William John Thomas), 1942–
 Cloning terror : the war of images, 9/11 to the present / W. J. T. Mitchell.
 p. cm.
 Includes bibliographical references and index.
 ISBN-13: 978-0-226-53259-2 (cloth: alk. paper)
 ISBN-13: 978-0-226-53260-8 (pbk.: alk. paper)
 ISBN-10: 0-226-53259-3 (cloth: alk. paper)
 ISBN-10: 0-226-53260-7 (pbk.: alk. paper)
 1. War on Terrorism, 2001–2009—Art and the war. 2. War on Terrorism, 2001–2009,
in mass media. 3. War on Terrorism, 2001–2009—Psychological aspects. 4. Visual
communication—Psychological aspects. 5. Visual communication—Political aspects. 6. Oral
communication—Psychological aspects. 7. Oral communication—Political aspects. I. Title.
HV6432.M58 2010
973.931—dc22

 2010015032

♾ The paper used in this publication meets the minimum requirements of the American National Standard for Information Sciences—Permanence of Paper for Printed Library Materials, ANSI Z39.48-1992.

To the memory of
JACQUES DERRIDA
& EDWARD SAID

Contents

Illustrations

For a War on Error

War is nothing but a continuation of political
intercourse, with a mixture of other means.
CARL VON CLAUSEWITZ, *On War*

Every history is really two histories. There is the history of what
actually happened, and there is the history of the perception of
what happened. The first kind of history focuses on the facts and
figures; the second concentrates on the images and words that
define the framework within which those facts and figures make
sense. Thucydides' history of the Peloponnesian War, for instance,
is rigorously divided into a history of "what happened" and "what
was said," the narrative and the speeches. The War on Terror, simi-
larly, can be broken down into two histories: what happened, and
what was said to justify, explain, and narrate it as it was happen-
ing. The difference is that, in our time, both the things done and
the things said are filtered through mass media, and the role of
images and imagination (which were already quite significant for
Thucydides) is much expanded. Contemporary war can be seen
and shown in multimedia presentations in real time—and not
just broadcast media such as television, but social media like You-
Tube and Twitter, on devices such as cell phones and digital cam-
eras. The shaping of perceptions of history does not have to wait
for historians or poets, but is immediately represented in audio-
visual-textual images transmitted globally.

The chapters in this book originated during or shortly after the
period of the Bush presidency, the epoch of the War on Terror.
They were initially an attempt to analyze the role of verbal and
visual images in the War on Terror, and to examine the peculiar

character of this war as itself an imaginary, metaphoric concep-
tion that had been made real. Early on in the process, however, a
second image began to impose itself on my reflections. This was
the figure of the clone and cloning, which seemed to weave its way
through the imagery of the War on Terror as a kind of undertone
and counterpoint. Cloning during this period emerged as an image
of imaging as such, a symbolic condensation of a whole range of
technical revolutions in media and technoscience—digital imag-
ing, the copying of gadgets and devices, questions of biological
identity, and of course the quite literal issue of cloning higher an-
imals, including human beings. There was also the scientific fact
that cloning is a natural process that takes place every time the
immune system fights off a cold, or when a virus begins to pro-
liferate, migrating from host to host across geographical borders.
Cloning, in other words, was becoming a central exemplar, not just
of biotechnology, but of a wide range of biopolitical phenomena.

It is hardly surprising, then, that the expression "cloning ter-
ror" came to be an inevitable and obvious metaphor for the em-
pirical, statistical effects of this war, reflecting the fact that the
war on terror was having the effect of recruiting more jihadists and
increasing the number of terrorist attacks.[1] The National Intelli-
gence Estimate released in July 2007 made this abundantly clear:

We assess that the spread of radical—especially Salafi—Internet sites,
increasingly aggressive anti-US rhetoric and actions, and the growing
number of radical, self-generating cells in Western countries indicate
that the radical and violent segment of the West's Muslim population is
expanding, including in the United States.[2]

New York Times reporter Scott Shane put the report in the stark-
est possible light: "Nearly six years after the Sept. 11 attacks, the
hundreds of billions of dollars and thousands of lives expended in
the name of the war on terror pose a single, insistent question: Are
we safer?"[3] The answer, in the view of all the combined U.S. intel-
ligence agencies, was emphatically negative.

This answer was not based solely on statistics about the increas-
ing numbers of people being killed by terrorist attacks around the

world.[4] More significant was the *qualitative* assessment of the spread of radical ideologies made possible by new media, and the concept of the "self-generating cell" that functions independently of any centralized command. A self-generating cell is, of course, engaged in the process of cloning itself. Like a cancer cell, it is difficult to distinguish from the body's own healthy cells, and difficult to confine to one region or organ of the body. Like terrorism, it has a tendency to metastasize, leaping over the boundaries between organs in a process that is accelerated by the very systems of communication (e.g., the lymphatic system) that are necessary for the healthy functioning of a bodily constitution.

War, especially a *global* war, in contrast to intelligence and counterterrorist police tactics, is too blunt an instrument to be very effective against an invisible and unlocatable enemy that wears no uniform and mingles with, or is simply part of, a population. War in the classic Clausewitzian sense is the conflict between two sovereign states, and is, as Clausewitz famously explains, "an extension of politics," not an end in itself. Wars of revolution and insurgency, conducted by terrorism and other guerilla tactics, notes Anatol Rapaport,

> are not "symmetrical." Strategies and tactics used by one side are not those used by the other. . . . The "military forces" of the revolutionary adversary are diffuse. One is never sure whether one has destroyed them unless one is ready to destroy a large portion of the population, and this usually conflicts with the political aim of the war and hence also violates a fundamental Clausewitzian principle.[5]

The classic Clausewitzean tactics of invasion, conquest, and occupation, when aimed at insurgents and terrorists, have the effect of multiplying collateral damage in the form of civilian casualties and refugees, thus proliferating new insurgencies and national resistance movements. Al Qaeda was not in Iraq before the U.S. invasion; the invasion transformed Iraq from an ordinary belligerent military dictatorship, easily conquered by classical military means, into a fertile breeding ground for nationalist insurgency and international terrorism.

At the same time, the whole question of "breeding"—reproduction, fertility, sexuality, genetics—has made itself felt in the recent national and global debate over cloning, stem cell research, and all the related issues in bioethics and biopolitics. What might be called the "Clone Wars" constituted a "second front" alongside the war on terror. As a literal fact, cloning became the iconic enemy in anxieties about human reproduction, abortion, homosexuality, and the whole realm of biotechnology. "Cloning terror," in this sense, means not just the process by which terrorism spreads like a cancer, virus, or plague, but the *terror of cloning itself,* a syndrome I call "clonophobia" that grows out of ancient anxieties about copying, imitation, artificial life, and image-making. Like terrorism, therefore, cloning shuttled back and forth between imaginary and real, metaphoric and literal manifestations. Cloning in this way became the master metaphor or "metapicture" of image-making itself, especially in the realm of new media and biomedia. Insofar as my subject was the role of images in the war on terror, the topic of cloning seemed to become more and more inevitable.

This book begins in the present, at the end of the period that it is attempting to picture, a moment when the war on terror and the clone wars seemed to be fading into the past with the election of Barack Obama. It then returns to the beginning, to the moment of 9/11 when cloning and terrorism converged in a striking historical coincidence, as the Bush administration shifted its attention from the clone wars to the war on terror. This is followed by a kind of iconological snapshot or "biopicture" of the entire period, examining the way that the nexus of cloning and terror runs like a bright thread through the iconic figures of facelessness, headlessness, and anonymity; through a procession of twins, doubles, multiples, and mirror images, mutating and spreading like viruses; and through moments of image-smashing and image-creation, traumatic images of iconoclasm characteristic of terrorism, especially in its literalist and religious tendencies.

I then turn to the master version of the biopicture as such in the figure of the clone. What exactly is cloning? What did it become, both literally and figuratively, in this period, an era of "clo-

nophobia" that scientists at the Max Planck Institute in Berlin
have called "the times of cloning"? This is followed by an analysis
of more systemic and sociopolitical biopictures, particularly the
models of terrorism based in biological invasions—plague, virus,
infectious disease, epidemic, cancer—the terms that have been
used to explain the effects of terror on a social body or population.
These reflections lead to an alternative model for picturing terror,
namely, the immune system and its disorders, an extrapolation of
Jacques Derrida's picture of terrorism as an autoimmune disorder.
The limits of depiction and language are then explored in relation
to the twin practices of terror and torture in "The Unimaginable
and Unspeakable."

The book concludes with an in-depth exploration of what has
to be seen as the heart of the matter in any discussion of images
in the War on Terror, and that is the archive of Abu Ghraib photo-
graphs. Why did these photographs, and one in particular (the
Hooded Man), emerge as the central image-event of the epoch?
Why did the scandal of their appearance fail to bring down the
government responsible for their production? What is it in these
pictures that causes them to keep returning into public view? Are
they more like ghosts that refuse to be laid to rest, or a lingering
infection, or both? What have artists in a variety of media done
with them to help them come to life, or to rest quietly, open to a
devotional and critical attention? What specific formal and icono-
graphic features of the Hooded Man worked to produce a synthetic
icon of the Clone and the Terrorist, reawakening in the process
a host of secular and religious images that link figures of sover-
eignty and abjection in Christian, Jewish, and Muslim traditions?

Clearly this is a fairly dark subject, one that involves remember-
ing a body of images that most people would like to forget. Why
bring them back or linger over their irrepressible tendency to re-
turn? I can answer this best with a metapicture of the Abu Ghraib
photographs invented by Lawrence Weschler. It adapts Norman
Rockwell's famous painting *The Discovery,* but shows a shocked
adolescent boy finding in his parents' chest of drawers, not the
expected Santa Claus suit, but a stack of the Abu Ghraib photos
spilling out on the floor.

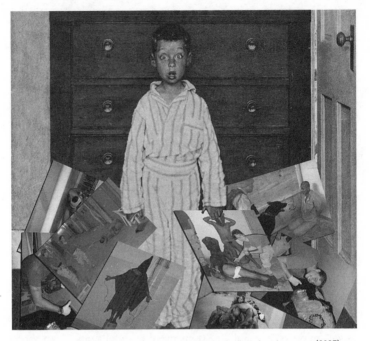

FIGURE 1. Lawrence Weschler and Naomi Herskovic, *American Innocence* (2007). Poster for a symposium convened in October 2007 by the New York Institute for the Humanities at New York University. Based on Norman Rockwell's *The Discovery* (1956).

This is a portrait of American innocence, and the seemingly infinite capacity of the American people to ignore or forget the inconvenient truths about the things that have been done in their name. So this book is at bottom a fairly simple exercise in memory and the prevention of historical amnesia. The systems of thought, both the "rationales" and the fantasies, that produced the Abu Ghraib images, and the War on Terror more generally, have not disappeared. They have simply lost political power for a time, and they could return at a moment's notice—by the election of 2010, for instance. If and when they do, I hope that this book will offer some useful resistance.

The book was written, then, partly as a war on *error*, an act of simple justice that is in solidarity with the legal and moral efforts to bring a conclusion to the War on Terror, its torture regime, and

the way a "faith-based" foreign policy made it into a holy war that threatened the American Constitution. It is also written to expose the mythologies of the Clone Wars, insofar as they were grounded in a "faith-based science policy" that allied itself with misogyny and homophobia. The tone of this book may seem cold and clinical in its treatment of terrorism and torture as affairs of images and imagination, and especially in its biopictures of cloning and infectious disease, but that is an essential part of their operational reality. While I write as part of the "reality-based community," I will be investigating the ways in which the imagination— including the religious imagination—is a constitutive core of that reality. The legal, ethical, and political understanding of both the Clone Wars and the War on Terror will not be complete without a grasp of the images that it spawned, and that spawned it.

A Note on Method

It might be useful at the outset to say a word about the methods of image analysis employed in this book. I call this method "iconology," the study of images across the media. Images, from an iconological standpoint, are both verbal and visual entities, both metaphors and graphic symbols. They are, at one and the same time, concepts, objects, pictures, and symbolic forms. Some of them become operative forces in sociopolitical reality, attaining what is commonly known as "iconic" status—widely recognizable, and provocative of powerful emotions. The figure of speech entailed in the phrase "War on Terror" was widely regarded as "the most potent weapon in the battle for public opinion"[6] waged by the Bush administration. The image of the Hooded Man of Abu Ghraib became a globally recognizable icon "more dangerous to American interests than any weapons of mass destruction."[7]

All metaphors and images are, in a fairly straightforward sense, "errors." A metaphor is, from the standpoint of logic, a category mistake, and an image is a simulation, an imitation, not the real thing. Thus a war on terror makes about as much sense as a "war on nervousness"; it is a literal impossibility. And yet it undeniably became a material, historical actuality in the first decade of the

twenty-first century, literalized and realized by the most powerful military machine on the planet. And this process of literalization was not done unconsciously, but was explicitly affirmed by key political advisers in this period. Journalist Ron Suskind reported on the following conversation with a key Bush aide just before the 2004 presidential election:

> The aide said that guys like me were "in what we call the reality-based community," which he defined as people who "believe that solutions emerge from your judicious study of discernible reality." . . . "That's not the way the world really works anymore," he continued. "We're an empire now, and when we act, we create our own reality. And while you're studying that reality—judiciously, as you will—we'll act again, creating other new realities, which you can study too, and that's how things will sort out. We're history's actors . . . and you, all of you, will be left to just study what we do."[8]

This statement is, of course, an expression of astonishing arrogance, but it also must be taken seriously as a guide to methodology in the treatment of images and metaphors. It is never enough to simply point out the error in a metaphor, or the lack of reality in an image. It is equally important to trace the process by which the metaphoric becomes literal, and the image becomes actual. This means a renunciation of the most facile and overused weapon in the iconologist's arsenal, the tactic of "critical iconoclasm," which wins easy victories by exposing the unreal and metaphoric character of an icon. Blunt, commonsense declarations about the illusory character of images will simply not do. We need instead a method that recognizes and embraces *both* the unreality of images *and* their operational reality.

I want to call this method a "sounding of the idols," following Nietzsche's wise advice in *Twilight of the Idols,* to abandon the notion of destructive, iconoclastic criticism in favor of a more delicate approach: the idols, says Nietzsche, "are here touched with a hammer as with a tuning fork."[9] The object, in other words, is not to smash but to sound, not to engage in destruction but (as Jacques Derrida would have put it) in *deconstruction.* This proce-

dure will, I hope, eschew the pleasures of a hollow victory over the hollow idols of terror and cloning that bedeviled the first decade of the twenty-first century, and transform those images into analytic and even therapeutic tools for resisting the cloning of terror in the foreseeable future.

A final point about method. Iconology, traditionally, has been an interpretive discipline that inquires into the meanings of images in their historical context. More recently there has been an emphasis on the *power* of images to influence human behavior. While these approaches are indispensable, we need to supplement them with an even older model of the image as a living thing. Images are, as Aristotle noted, and as every ancient culture has understood, imitations of life that constitute a "second nature." The foundational creation stories of the world religions almost invariably invoke a moment of image-creation and of the bringing of those images to life.

As sensible and skeptical modern people we of course have to insist that the model of a living image is "merely metaphoric." It is a figurative conception, and images are not literally or really alive. Their supposed life is precisely a product of human imagination, as when a child attributes life to a doll, or a so-called savage endows a material object with intentions, desires, and agency.

All these skeptical hesitations have been true—until now. In the last half century a technoscientific revolution has occurred that has brought new life forms into the world in the form of intelligent machines and engineered organisms. It is now possible to make an imitation of a life form that is itself alive, a living image of a living thing, and to do so *literally* and *actually*. That is what cloning epitomizes as a cultural icon, and as a paradigmatic object for iconology. The questions that need to be asked of images in our time, and especially during the epoch of the war on terror and the clone wars, are not just what they mean and what they do. We must also ask how they live and move, how they evolve and mutate, and what sorts of needs, desires, and demands they embody, generating a field of affect and emotion that animates the structures of feeling that characterize our age.

1 War Is Over (If You Want It)

Hence, in war prize the quick victory, not the protracted engagement.
SUN-TZU, *The Art of War*

The question of ontology—"What is the enemy?"—hardly surfaces,
and when it does . . . it is only too quickly rendered almost ephemeral
and a testimony to the vanishing, the drawing away of the enemy.
GIL ANIDJAR, *The Jew, the Arab: A History of the Enemy*

For quite a long time, I thought I would never finish this book.[1]
This is not just because it is a history of images of the present mo-
ment, and by definition, it will always be the present. The prob-
lem is more specific than that, and has to do with the very par-
ticular character of *this* present moment, and the peculiar icons
and metaphors that dominated the first decade of the twenty-
first century. My subject matter, the master image of a "Global
War on Terror," and all its attendant images and media, seemed
inherently endless. Like George Lucas's Clone Wars, the War on
Terror seemed to promise an endless supply of faceless warriors,
massed for interminable combat. The concept of a war on ter-
ror has brought something radically new into the world, perhaps
at last forcing a confrontation with the question of *what*—not
"who"—is the enemy. Traditional wars, the kinds that fill history
books, usually have fairly definite antagonists, and though they
may drag on for years, a concluding settlement is usually reached.
Even the Hundred Years' War, which lasted from 1336 to 1453, only
went seventeen years over its titular life span. But a war on ter-
ror is different.[2] Taken literally, it is something like a war on anxi-
ety. How could it ever end? How could it be won? Even the nomi-
nal author of the phrase, George W. Bush, admitted in a 2004 TV
interview with Matt Lauer that he didn't think the war on terror
could be "won" (although he continually conjured with images of
"victory" in Iraq, and in fact Iraq had the function of giving a local

habitation and name to a nebulous enemy, providing a "front" to a war that had no front).[3] How, then, could one write a history of a war that was by definition unwinnable, without that history going on forever?

Then history took a remarkable and improbable turn that drew a bright line marking the end of a period and the beginning of a new one. Within a month in the fall of 2008, the world economy began to collapse, and Barack Obama was elected president of the United States. Rarely has a historical epoch announced its beginnings, endings, and turning points with such iconic clarity as the first decade of the twenty-first century. Framed at each end by world-historic crises, and by the deeply antithetical images of Bush and Obama, the era of the War on Terror and the Bush presidency will also be remembered as a time when the accelerated production and circulation of images in a host of new media (Facebook, YouTube, Twitter) ushered a "pictorial turn" into public consciousness.

Images have always played a key role in politics, warfare, and collective perceptions about the shape of history, but there is something new in the emergence of public imagery in the period from 2001 to 2008. This is partly a matter of quantity. The development of new media, especially the combination of digital imaging and the spread of the Internet has meant that the number of images has increased exponentially along with the speed of their circulation. But it is also a matter of quality. Images have always possessed a certain infectious, viral character, a vitality that makes them difficult to contain or quarantine. If images are like viruses or bacteria, this has been a period of breakout, a global plague of images. And like any infectious disease, it has bred a host of antibodies in the form of counterimages. Our time has witnessed, not simply *more* images, but a *war* of images in which the real-world stakes could not be higher. This war has been fought on behalf of radically different images of possible futures; it has been waged against images (thus acts of iconoclasm or image destruction have been critical to it); and it has been fought by means of images deployed to shock and traumatize the enemy, images meant to ap-

pall and demoralize, images designed to replicate themselves end-
lessly and to infect the collective imaginary of global populations.

The onset of the war of images was the spectacular destruction
of the World Trade Center on September 11, 2001, and the launch-
ing of the iconic counterattack was the invasion of Iraq, complete
with the televised "shock and awe" bombing of Baghdad and the
destruction of Saddam Hussein's monuments, as well as untold
civilian casualties and the looting of Iraq's magnificent museums
as "collateral damage." The invasion of Afghanistan, by contrast,
was a relatively minor engagement in the war of images because,
as Defense Secretary Donald Rumsfeld noted at the time, it was
not a "target rich environment," either militarily or symbolically.
For a variety of reasons, Osama bin Laden seemed less than satis-
factory as an iconic figure of the enemy in the ill-advisedly named
"crusade" or holy war to stamp out radical evil. It proved easier to
focus attention on Saddam Hussein, a more visible and locatable
target. Hidden away in an ungovernable border region of Paki-
stan and Afghanistan, bin Laden's only presence as image was as a
soft-spoken cleric who occasionally appeared in videotapes of un-
certain origin. No statues, monuments, palaces, or regimes could
be leveled as ways of performing the destruction of bin Laden.
Hussein, by contrast, portrayed himself as a classic Arab warlord,
brandishing weapons in his photo ops and monuments, and he
had a long pedigree as the anointed villain of American fantasies
of its archenemy, a Middle Eastern successor to Hitler and to Cold
War adversaries like Stalin.[4] It is no wonder that a deliberate ef-
fort was made to attribute the spectacular wound of 9/11 to Sad-
dam Hussein, to declare Iraq as the "front" in the War on Terror,
and to produce a kind of composite image of the enemy as a fig-
ure of "Islamo-fascism" that could freely confuse Osama with Sad-
dam and vice versa.

If Iraq seemed to provide ample opportunities for icons of vic-
tory (the Mission Accomplished photo) and defeat of the enemy
(the capture of Saddam Hussein), at the level of reality things were
going quite differently. The combination of insurgency and civil
war defied all the attempts to produce imaginary victories, and the

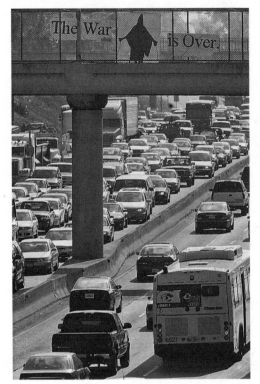

FIGURE 2.
FreewayBlogger,
The War Is Over
(installation, May 2004,
FreewayBlogger.com.)
Banner depicting the
abuse of a hooded Iraqi
prisoner as photo-
graphed on an over-
pass over the Interstate
10 West freeway, Los
Angeles. Photograph
by Damian Dovarganes.
Courtesy of AP/Wide
World Photos.

release of the Abu Ghraib photographs in the spring of 2004 sent a
deeply antithetical message of moral defeat for the United States.
Given the growing public awareness that Iraq had no weapons of
mass destruction, no connection to al Qaeda, and no role in 9/11,
the iconic photo of the Hooded Man on the Box drastically under-
mined the last remaining alibi for the war, namely, that it was a
moral crusade to liberate Iraq from tyranny. The image immedi-
ately became a recruiting poster for jihadists throughout the Arab
world, and the international antiwar movement seized upon it as
the emblem of the war's futility and illegitimacy. An artist's collec-
tive known as FreewayBlogger.com put the message of the image
in the most starkly emphatic terms: "The War Is Over" (fig. 2).

Of course the war was (and is still) not over. The image was
deployed to represent a wish, not a fact. Like John Lennon's fa-

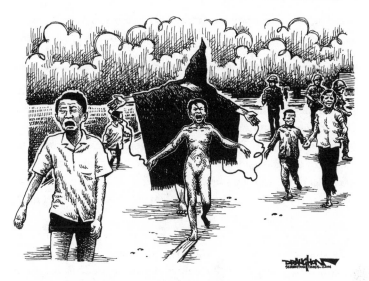

FIGURE 3. Dennis Draughon, *Abu Ghraib Nam* (2004). © 2004 Dennis Draughon. Courtesy of the artist and the *Scranton Times*.

mous song, "War Is Over (If You Want It)," it appeared in a conditional, not an indicative mood.[5] And like the iconic photo of moral defeat in Vietnam, the image of a naked Vietnamese girl fleeing her burning village, the photograph of the Hooded Man and the whole archive of torture and official criminality that it symbolized, took several years to have its effect, and its meaning has yet to be exhausted. The photo of Kim Phuc, we must recall, appeared almost three years before the end of the Vietnam War.[6] Tens of thousands of Americans and many more Vietnamese died after the appearance of this iconic signal of the end. A similar delayed reaction occurred with the Hooded Man, a parallel that was captured with stunning accuracy by the cartoonist Dennis Draughon in his composition, "Abu Ghraib Nam," depicting the Hooded Man as a kind of baleful shadow or afterimage of its Vietnamese counterpart (fig. 3).[7]

From Terror to Panic

A war, and a historical period that should have come to a conclusion in 2004 with the removal of the Bush administration, lin-

gered on for another four years, and the war is still not really over as of this writing. But the fall of 2008 will undoubtedly be remembered as the decisive moment in the war of images and the collective emotions associated with them.

Terror is a form of affect that tends to express itself as paralysis, the "deer in the headlights" syndrome. Since the terrorist enemy strikes without warning, and is invisible and unlocatable, it is not clear what action to take. And indeed, the main recommendation of the Bush administration to the American people after 9/11 was to do nothing—except to go shopping and enjoy its tax cuts—or simply to "be vigilant" and give the government unlimited powers to violate laws in the name of the war on terror. Someone else—an undermanned army and a very well paid cohort of independent contractors—was to handle the war on terror. Panic, by contrast, tends to produce immediate, badly focused actions that work at cross-purposes—runs on banks and poorly designed bailouts to the very institutions and individuals that produced the crisis in the first place. If panic is not arrested with timely, calm, and intelligent action, it can, of course, lead to depression, in both the emotional and financial senses of the word.

The iconic avatar of the historic period that began in terror and ended in panic was, of course, none other than George W. Bush. The image strategists of the Obama campaign understood this very clearly, and staged the war of images in the 2008 election as a contest, not with John McCain, but with Bush. They consistently portrayed McCain as "McBush," a clone of the deeply unpopular president, and by the end of the campaign, McCain himself was running against Bush.

It is worth pondering in more detail, then, the images of the two presidents that frame this era. The contrasts at the level of race and political positions were so blatantly obvious that they caused many to think that there was nothing further to say about the electoral war of images in 2008. But the actual image-contrast between the two men is not reducible to polarities such as black and white, liberal and conservative. A more accurate characterization would note that Bush's image was clearly defined from early

on, and changed very little, while Obama's is a paradigm of ambiguity and indeterminacy. Bush consistently portrayed himself as the cowboy president, the incarnation of white American Texas manhood, Christian faith, and a simple, unshakeable moral code that divided the world into good and evil. He was also depicted as "the CEO president," an image of businesslike delegation of responsibility and decisiveness, who would manage the nation like a well-run corporation.

Obama's image, by contrast, is much more difficult to specify. It comes in and out of focus. The Obama "icon" is an ambiguous and self-conscious image, a figure of multicultural and interracial hybridity that crossed the very boundaries that defined the black and white moral oppositions of the Bush era. Too black or not black enough, a Christian with a Muslim name, an American with an African father and an Indonesian stepfather, Obama scrambled all the codes that allow for easy labeling of an image. And of course the strategy of his opponents was precisely to stress this ambiguity, to raise questions about his real identity, his credentials, even his birth, and to use his celebrity against him by comparing him with superficial pop culture icons. Meanwhile Obama faced an opponent who was as sharply defined as Mount Rushmore, a visage of determination and decisiveness, a self-styled "maverick," and "man of principle" who would never compromise on anything, in contrast to Obama's conciliatory centrism. Given the further contrast between McCain's experience and Obama's almost complete lack of same, it was astonishing that Obama won the election. He had never been in an executive position, and had absolutely no credentials as a "decider." His formative political experience was as a community organizer, a branch of work that (so far as I know) has never produced a president before.[8]

Simply considered at the level of the image, then, it is something of a miracle that Obama won the election, and indeed, he often joked during the presidential campaign about the improbability of his candidacy and his image, including his big ears, skinny body, and funny name. The fact that he did win decisively is as much due to the fact that he came across as the non-Bush, the

anti-Bush, a distinctive antidote to the Bush image, as to any spe-
cifically positive features of his own image. As a blank slate, he
could attract both positive and negative projections, both the
hope for change, and the need for change driven by revulsion at
the whole sorry panorama of hypocrisy, incompetence, and crimi-
nality that characterized the Bush era.

But to gauge the real improbability of Obama's victory, we need
to look beyond the visual image of racial ambiguity to the sound
image of a name that should have been the kiss of death, politi-
cally. At the level of the poetic sound image his name was a virtual
composite of the two figures of the enemy in the war on terror—
"Hussein Obama." To those who "think with their ears," as The-
odor Adorno once put it, the election of Obama was nothing short
of revolutionary, in the most literal sense of the word. It was as if
the American people had decided to elect as their sovereign repre-
sentative the figure of the enemy they had been fighting through-
out the War on Terror. If this seems like a fanciful notion, it is;
but it was also the central operational fantasy in the political tac-
tics of the Republican Party during the 2008 election, in their tire-
less attempt to transform Obama into a Muslim, to emphasize his
middle name, and to portray him as "palling around with terror-
ists." Since the election the tactic has shifted to Cold War imagery,
and Obama is now routinely portrayed as a socialist or communist.

There were at least two other factors that made it possible to
overcome the long odds against Obama's election. First, his fas-
cinatingly complex and ambiguous visual image was accompa-
nied by the most masterful auditory style in modern politics, a
perfectly nuanced blend of soaring oratory trained in the black
church, on the one hand, and a quiet, professorial grasp of history
and policy, on the other, all leavened by a sense of calm, cool con-
fidence. At a rally in Milwaukee, he told a story about a Republi-
can voter, one of the new "Obamicans," who approached him to
confide, in a whispered aside, that she was crossing party lines
to vote for him. Obama thanked her for her vote, but then asked
her, "Why are we whispering?" This line, uttered in a stage whis-
per before an enormous crowd, captured perfectly the auditory

range that accompanied the optical spectrum comprehended by Obama's visual image. As a cultural icon, he managed to be simultaneously monumental and intimate, passionate and coolly rational, even ironic. He also enjoyed a streak of political luck throughout the election cycle that threatened to become a bit spooky when it appeared that he was arranging absolutely perfect weather for mass outdoor rallies at his nomination and election. God himself seemed to be on his side, and among the satiric caricatures of his image was, unsurprisingly, his portrayal as Jesus Christ walking on water. If the Hooded Man of Abu Ghraib was a reminder of the dark, violent side of Christian iconography (torture and mockery), Obama seemed endowed with the gift of tongues, reaching across classes, state boundaries, and beyond to preach peace and reconciliation to a global multitude that welcomed his coming.

The second factor was Obama's grasp of the new media that have established the battlefield on which contemporary political struggles must be waged. Obama is not just the first black president, but the first wired president. If Jack Kennedy was the first president to understand the power of television, Obama is the first to understand the new forms of social networking[9] made possible by the Internet, and to actually create a political campaign rooted organically in a cluster of social movements.[10] From Web fundraising to the organization of caucuses to the spontaneous emergence of media images produced by his supporters—even some, like "the Obama Girl," that were not especially welcome—Obama made e-mail and YouTube central arenas of political struggle. It is symptomatic of the shift that he pioneered in the location of democratic, grassroots politics, that the leading graphic icon of his campaign, the remarkable Shepard Fairey poster, was not produced by his campaign, but by an independent artist working on his own.

The historical period and the war of images that are the subject of this book may best be personified, then, by the Shepard Fairey poster as its termination and the caricature of George W. Bush that appeared on the cover of the *Nation* magazine as its beginning. (See figs. 4 and 5.)

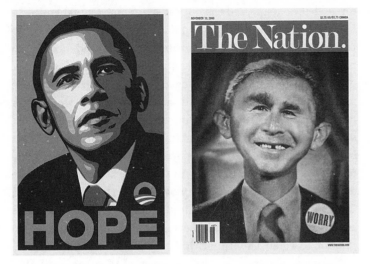

FIGURE 4. Shepard Fairey, *Hope* (2008). Silkscreen poster depicting Barack Obama.

FIGURE 5. Scott Stouffer, *Worry* (2000). George W. Bush depicted as *Mad* magazine's Alfred E. Newman on the cover of the *Nation* (November 13, 2000). Reprinted with permission of the *Nation* (www.thenation.com).

The *Nation*'s artist merged the features of Bush with the iconic figurehead of *Mad* magazine, Alfred E. Newman, the "What, Me Worry?" simpleton who has represented puerile American cluelessness for over a century, and added to it the simple but prophetic legend: "Worry." And worry, fear, anxiety, and (above all) terror followed by panic turned out to be the emotional watch words of the Bush era. If it seems a bit unfair to contrast the highly positive image of Obama with this negative caricature of Bush, one need only look to the right-wing blogs that immediately produced their own *detournement* of Fairey's image by associating it with images of Lenin that employ the same technique of a solarized palette coupled with a single word legend: "Hope" for Obama; "1917," year one of the Russian Revolution, for Lenin. The accusation that Obama is a socialist or perhaps even a communist could hardly be made more graphically explicit.

Let's consider the images of Bush and Obama as the outer frames and faces of the historical period under consideration

here, which is why I have named the terminal frame of this period as "the present." Obama's presidency opens onto a future, and he himself is iconic of a positive, hopeful vision of a future that exists, as of this writing, only as a present filled with potential and uncertainty. My subject, however, is the recent past and the period from 2001 to the present dominated by the imagery of the so-called War on Terror. We will see considerably more of Bush, particularly those moments when he tried to establish control over his preferred self-image as a "war president," protector of the American people, and tireless crusader in the war on terror that was the central conception of his presidency.[11] We will review the images that provoked and punctuated this war, from premonitory moments such as the destruction of the Bamiyan Buddhas by the Taliban, to the World Trade Center, to the destruction of Saddam Hussein's monuments in Iraq, to the Abu Ghraib photographs.

Obama has urged us to put all this behind us and look to the future. But there is a real question as to whether this epoch *is* behind us, whether the war on terror is really over, or has merely "gone quiet," waiting to be reawakened at any moment by a new attack on the United States that will, inevitably, be blamed on the Obama administration. That is why I treat the period described by this book as open-ended, as the story of an image-repertoire that seems to be fading, but is capable of returning with a vengeance. As with the Cold War that preceded the war on terror it is difficult to say when a period really ends, when its conflicts are safely confined to the past.[12] This uncertainty is what mandates that any historical study of the past, and especially of the immediate past, will of necessity engage with its own present. It may now be safe for a few bold American politicians to say the truth, that the Global War on Terror was a misbegotten fantasy from the first, a metaphor run amuck. Nevertheless, this phrase continues to be the default way of talking about global strategies for dealing with terrorism. And insofar as U.S. foreign policy continues to be centered around war and the occupation of foreign countries, this conception continues to frame all strategic thinking. Once a powerful metaphor has taken root in a nation's imagination, it is

not so easy to dislodge it with a bit of critical thinking or a change of phraseology.

A more emphatic way of putting this is to note that the era of the War on Terror was also a profoundly revolutionary moment in American history, marking a time when an American presidency arrogated absolute power under the cover of an indefinite state of emergency and rolled back many of the restraints on presidential authority that had been established in the post-Watergate era. It was a period of extreme danger, not only to the rule of international law, which was flagrantly and publicly defied, but to the American Constitution itself. If the election of Barack Obama was a revolution, then, it was a counterrevolution (perhaps an ephemeral one) in the name of the founding revolutionary ideals of that constitution, a counterrevolution that overturned a sovereign authority that had taken power in a judicial coup d'état in the presidential election of 2000, and maintained its power by terrorizing its own citizens.[13]

It has been objected that the whole concept of terrorism as a "war of images" and metaphors ignores the fact that "terrorist bombings are real violence."[14] Of course I know that these are real events that produce very real trauma and suffering. But that is no objection to recognizing the extent to which the terrorism involves spectacular symbolic acts, the creation of images that traumatize their beholders. Indeed, terrorism is, by definition, not a conventional military action of invasion, conquest, and occupation. It is the use of violence that, compared to open war, is relatively small and localized, usually targeted at noncombatants, in order to demoralize a society by sending a message that "no one is safe" and the ruthless enemy could be anywhere. It is, in other words, a form of psychological warfare designed to attack, not military opponents, but symbolic targets (preferably including "innocent victims"). It is an assault on the social imaginary designed to breed anxiety, suspicion, and (most important) self-destructive behavior.

The destruction of the World Trade Center was a symbolic event, the deliberate destruction of an iconic object designed as the production of a spectacular image calculated to traumatize a whole

society. This in no way denies the reality or the horror of what happened; on the contrary, it is a way of coming to a richer understanding of what happened, both what led up to it and what responses it produced. An iconological approach has to think the relation of the imaginary and real as a "both/and" as well as an "either/or," settling neither for a collapsing of the two categories nor a rigid segregation of them. We must attend to the ways in which the imagination surges ahead of the real, anticipating and predicting it, or those moments of lag when the trauma of the real produces a set of symbolic and imaginary symptoms, screen memories, repetitious behavior, and strange forms of acting out. Certainly the images of the terrorist menace and the War on Terror have produced some of the most self-destructive symptoms in the American public in many generations. It threatened, and perhaps still threatens, the basic principles of the American Constitution. The only good thing to be said for it, and for the Bush presidency, is that it may have brought a decisive end to the era of U.S. imperial adventurism. Between the probably avoidable catastrophe of 9/11 and the less easily avoidable calamity of the Great Recession of 2008, Bush administered decisive blows to the structure of the American political and economic system. In doing so, he provided the imaginative framework that made possible the revolutionary election of Barack Hussein Obama and the end of the War on Terror.

<div align="center">x x x x x</div>

The war on terror was, as I have suggested, not the only imaginary structure that governed the post–9/11 epoch. If one asks what Bush was thinking about on August 6, 2001, when he ignored the intelligence briefing with the title, "Bin Laden Determined to Strike in U.S.," the answer is not far to seek. As Frank Rich has noted,

he was readying his first prime-time address to the nation. The subject—which Bush hyped as "one of the most profound of our time"— was stem cells. For a presidency in thrall to a thriving religious right (and a presidency incapable of multitasking), nothing, not even terrorism, could be more urgent.[15]

Cloning was quickly erased from front-page news by the events of 9/11, but it remained as a kind of undertone throughout the next seven years, periodically exploited by the Bush administration as a wedge issue to mobilize the forces of right-wing reaction around questions of sexuality, reproduction, and hostility to science. Like terror, cloning became an iconic metaphor for the religious right, condensing fears of everything from homosexuality to abortion to biological science as such. The reversal of Bush's stem cell policies by the Obama administration came, as Rich goes on to note, with relatively little fanfare, aside from the usual hysterical claims that a microscopic cluster of cells enjoys all the status of an American citizen, and that the use of such clusters for therapeutic purposes is equivalent to abortion and Nazi eugenics.

Like terrorism, then, cloning is largely an affair of the imaginary, eliciting fantasies of industrialized organ farms and mindless, soulless "clone armies" that will serve as cannon fodder in wars of the future. There have been over a hundred films about cloning since the early 1990s, most of them belonging to the sci-fi horror genre. And the issues of terrorism and cloning have converged, as I will presently show, in everything from supermarket tabloids to the reports of the Presidential Commission on Bioethics.

But there is a larger aspect to the question of cloning that is crucial to the problem of the image and the iconological project. Cloning is not merely a specific biological process; it is a form of image-making in its own right, i.e., the production of living copies of living organisms. It is both a natural process and an artificial technology, both a literal, material event and a figurative notion, both a fact of science and a fictional construct. In the late twentieth century the metaphor of cloning, the idea of producing a living copy of a living thing, displaced the modernist notion of "mechanical reproduction." The old model of the assembly line and the mechanically copied image (paradigmatically the photograph) was superseded by a new era that I have called the age of "biocybernetic reproduction," a synthesis of biotechnology and information science.[16] The clone is the iconic symbol of biocybernet-

ics, just as the mechanical robot or automaton was the figurehead of modernity.

The clone wars and the war on terror have combined in our time to produce the composite master image of our time, the metapicture that framed the dominant imaginary of the Bush era. Both are metaphors that have become literalized, images that have become real. Biotechnology rendered the dream of making a living copy of a living thing into a scientific reality, and the war on terror was transformed from a "mere metaphor" into an all too potent and material actuality. Together they produced the syndrome I call "cloning terror," the process by which the war on terror has the effect of increasing the number of terrorists, and spreading terror as the image of an invisible and omnipresent threat. It will be the task of the following pages to expose the workings of this composite image, and to transform it from a pathological symptom into a diagnostic, analytic tool. Let's begin by going back to the moment of their convergence in 2001.

2 Cloning Terror

Cloning represents a turning point in human history—the crossing of an important line separating sexual from asexual reproduction and the first step toward genetic control over the next generation.

LEON KASS, chair of the President's Council on Bioethics, 2002

There is, therefore, only one principle in Islam, one principle that is not one, but double: "La religion et la terreur," says Hegel in French, religion and terror.

GIL ANIDJAR, *The Jew, the Arab: A History of the Enemy*

It is easy to forget that in the months before the terrorist attack of September 11, 2001, the dominant story in the American media was not terrorism but cloning.[1] The front-page story in the *New York Times* on September 11, 2001, was, in fact, a report from the National Academy of Sciences urging that cloning and human stem cell research be "publicly funded and conducted under established standards of open scientific exchange, peer review, and public oversight." This report supported a national policy quite different from the one that Bush had outlined in a major speech on August 9, 2001, which prohibited any new development of stem cell lines from human embryos and signaled a deep hostility to all forms of cloning, both reproductive and therapeutic. Bush ignored the numerous warnings throughout 2001 that terrorists were poised to attack the United States because he was concerned with the stem cell issue—"one of the most profound of our time."[2] The debate over human cloning was the top "continuing story" of the moment. Bush's ratings were below 50 percent as his handpicked Council on Bioethics recommended policies opposed by most of the scientific and medical community, and supported by Christian conservatives.

September 11 changed all that. The horror of cloning was replaced in public consciousness by the more immediate experience of terror. Or perhaps "replaced" is too strong a word. Cloning was driven off the front pages for a time by more urgent and seem-

ingly less speculative dangers, but it remained as a crucial wedge issue. It resurfaced, for instance, at the Democratic Convention in July of 2004. Ronald Reagan, Jr., the son of the former president, gave an eloquent speech in defense of therapeutic (not reproductive) cloning and stem cell research, and John Kerry's acceptance speech included a promise to be a president who "believes in science," an implicit contrast to George W. Bush's "faith-based" science policy, driven by Christian fundamentalist agendas.

Meanwhile the images of cloning and terrorism began to merge in popular fantasy. Osama bin Laden was rumored to be cloning Hitler to become an adviser to his inner circle. Five hundred elite Aryan SS storm troopers were reportedly being cloned in the mountains of Tora Bora, their blond hair and blue eyes coupled with perfect American accents making them ideal agents for al Qaeda. A much larger host of cloned storm troopers marched off to their destruction in the "clone wars" chapter of the *Star Wars* saga. And a Google search for images of "clones" and "terrorists" invariably dredged up an array of faceless, anonymous, homogeneous warriors. In advertisements, clones of the best-selling iPhone were depicted as shields carried by oncoming waves of masked storm troopers.

The most explicit convergence of cloning and terrorism in popular culture was Aaron McGruder's cartoon series on the Kerry campaign's support of stem cell research and therapeutic cloning. McGruder envisioned an "October surprise" just before the 2004 election in which Osama bin Laden appears on TV calling all jihadists to engage in stem cell research. Bin Laden's theory is that by encouraging Americans to clone themselves, they will age more quickly (a common fate with cloned organisms), leading the U.S. Army to be staffed by ailing senior citizens. The moral of the story is then drawn by a Fox News commentator: any scientist caught doing stem cell research should be regarded as an illegal enemy combatant, and John Kerry is clearly an unwitting tool of Osama bin Laden.

But similar (and more consequential) convergences of cloning and terrorism could be found in the philosophical deliberations of

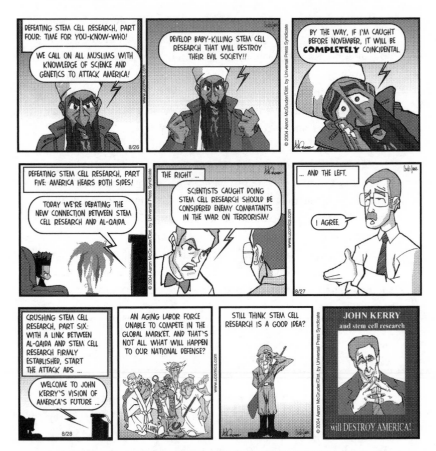

FIGURE 6. Aaron McGruder, *The Boondocks* (August 2004). © 2007 Aaron McGruder. Reprinted by permission of Universal Press Syndicate. All rights reserved.

the President's Council on Bioethics. Leon Kass, the chair of the commission, portrayed cloning as a process that provokes an "instinctive revulsion," leaving little room for ethical reasoning on a complex moral and scientific issue. Kass compared cloning to bestiality, cannibalism, incest, and rape, and concluded by urging us to steer a "middle course" between the Brave New Worlders (the cloners) and the Osama bin Ladens (the terrorists).[3] Cloning and terrorism converge as forms of extremism and are merged as forms of radical evil, the former loaded with sexual and reproductive taboos, the latter with demonic, even Satanic overtones.

Cloning, like terrorism, is an iconic concept, loaded with ideological and mythic connotations. It is not merely an abstract or technical idea, but conjures up associations with abortion, testtube babies, reproduction without sex or sexual difference, Nazi eugenics, and the commodification of organs and organ donors. It has the ability, then, to mobilize deep antipathy across the political spectrum, arousing both secular anxieties about "unnatural" processes and religious taboos on "playing god" with the creation and destruction of life. The figure of the clone has become synonymous with images of mutants, replicants, cyborgs, and mindless, soulless masses of identical warriors, ready to sacrifice themselves in suicide missions. What might be called "clonophobia" embraces a host of anxieties, from the specter of the uncanny double and the evil twin to the more generalized fear of the loss of individual identity.

If the so-called War on Terror was the dominant foreign policy melody of the Bush era, then, what could have been called the "Clone Wars" provided the baseline foundation for domestic policy. The war on terror united the faith-based community with a larger popular majority traumatized by the attacks of 9/11. Meanwhile, the stem cell issue fortified the faith-based community's hostility toward science, especially the sciences concerned with life and reproduction, and coupled it with suspicions on the left about the commodification of life forms by technology. Karl Rove, Bush's chief political advisor, made cloning the signature issue of the first year of Bush's presidency.[4] From a political standpoint, however, the shift from cloning to terror was the greatest good fortune the Bush administration could have wished for. Instead of fighting an indecisive battle over bioethics, it drew the winning hand in a holy war on terrorism. While cloning is debatable, a matter for serious ethical reflection, almost no one is willing to take the side of terrorism.[5]

The iconic ideas of cloning and terrorism are not merely linked, then, by historical coincidence, but are connected by a deep cultural logic that began to manifest itself visibly after 9/11. This logic has roots that go down deeper than the era of the Bush presidency. They are symptoms of a comprehensive cultural formation

summarized by Michel Foucault as "the birth of biopolitics," and of a period that extends back into the Cold War era that I have called "the age of biocybernetic reproduction." Biocybernetics is the historical successor to Walter Benjamin's characterization of the modern era (in the 1930s) as the "age of mechanical reproduction," a period defined by the twin inventions of assembly line industrial production, on the one hand, and the mechanical reproduction of images in the technologies of photography and cinema, on the other. In the age of biocybernetics, the assembly line begins to produce, not machines, but living organisms and biologically engineered materials; meanwhile, image production moves from the chemical-mechanical technology of traditional photography and cinema to the electronic images of video and the digital camera. The Turing machine and the double helix model of the DNA molecule might be taken as the emblems of the twin revolutions of biocybernetics—the decoding of the secret of life and the encoding of information, actions, and communication in the language of machines, i.e., the computer.

While it is relatively clear why the clone serves as a figurehead of biocybernetics, the twin revolutions of informational and biological science, the computer and the petri dish, it may not be evident how international terrorism fits the biocybernetic model. Terrorism has been a well-established tactic of warfare, insurgency, and the manipulation of mass emotions since at least the French Revolution, and probably before that. But contemporary terrorism has consistently been described in the framework of a bioinformatic model, as a social phenomenon that is comparable to an infectious disease. This is partly because the fact of new media and the Internet makes images of terrorist violence much more rapidly and broadly disseminated, as if a plague of images had been launched. Terrorism is so routinely analogized to things like sleeper cells, viruses, cancers, and autoimmune disorders that one is tempted to say that, at the level of imagery and imagination, all terrorism is bioterrorism, even when it uses traditional forms of violence such as explosives. (One should recall here that the anthrax attacks that followed soon after 9/11 were immedi-

ately assumed to be acts of Arab terrorism; it is more likely that they were homegrown.) The key thing about terrorism is not the weaponry employed (box cutters were the only thing the 9/11 hijackers required) but the psycho-biological assumptions that underlie it. Nonstate terrorism is a tactic of psychological warfare designed to breed anxiety and fear in a population; it is not a direct military engagement like invasion, siege, or occupation, but the staging of relatively limited acts of violence, usually against symbolic targets, designed to demoralize a population, and incite a reaction (generally an overreaction) by the police and military apparatus of a nation-state. Its aim, as Robert Pape has shown, is not conquest, but the influencing of political changes in established regimes—from the lifting of an occupation to the incitement of a civil war or revolution.[6] "Shock and awe" and the murder of innocent noncombatants are the crucial elements in a terror campaign, whether or not it is state sponsored, not direct military engagements. If all wars deploy images and the destruction of images as attacks on the collective imagination of a population, terrorism is a tactic that operates primarily at the level of the imaginary. The attacks on the World Trade Center had no military significance, but were the production of a spectacle designed to traumatize a nation.

The concept of a "war on terror," in this light, is revealed as a highly dubious fantasy, a form of asymmetrical warfare that treats the enemy as an emotion or a tactic (as if one could make a "war on flanking maneuvers"). And in fact the very idea of a war on terror is derived from earlier, explicitly figurative expressions that treat war as simply a metaphor for something like "maximum effort." The phrase was probably first used, as linguist Geoffrey Nunberg has pointed out, in the late nineteenth century's "war on tuberculosis," and it has been applied more generally as a "war on disease."[7] (The fact that terrorism is so frequently compared to a disease independently of the war metaphor should be noted here.) The metaphor was updated by Lyndon Johnson's "war on poverty" and Richard Nixon's "war on drugs" (another war, incidentally, that has proved to be endless and unwinnable). All these "wars"

were properly understood in quotation marks, as serious efforts to solve systemic problems in public health.[8] LBJ did not envision the bombing of poor neighborhoods as the way to conduct a war on poverty. (The drug war, on the other hand, is well on its way down the slippery slope toward literalization as military action.)

Of course innumerable commentators have insisted that the War on Terror is no metaphor, and in a sense they are right. It is a metaphor that has been made literal, an imaginary, fantastic conception that has been made all too real. And this is the key to the historic novelty of the post–9/11 era. It is not that terrorism was anything new; the radical innovation was the *war* on terror and terrorism. There is a striking parallel in this regard to the historic novelty of reproductive cloning in animals and humans. The idea of creating a living replica of an organism, an "imitation of life," has been a goal of art, aesthetics, and image technology at least since Aristotle. But the clone is a *literalization* of this goal, a realization of what was previously imaginary. Modern advances in biotechnology have made what was previously "only a metaphor" into a literal, technical possibility.

Once established as a technical and material actuality, however, cloning has been remetaphorized as a figure of speech for all kinds of processes of copying, imitation, and reproduction—as, in other words, an "image of image-making," or what I have elsewhere called a "metapicture."[9] The tool for copying parts of an image in Adobe Photoshop may be represented with the tiny icon of a rubber stamp, but it is named the "clone stamp" tool. The clone and cloning have become cultural icons that go far beyond their literal reference to biological processes. But it is the new reality and literalness of cloning technology that underwrites the proliferation of its metaphoric uses. Small wonder that the phrase "cloning terror" comes naturally to the lips as a way of describing the way that the war on terror has had the effect, not of defeating or reducing the threat of terrorism, but exactly the opposite. Of course, many terrorists have been killed. But why does it seem as if every time the killing of a terrorist is announced, it is quickly followed by an account of the more numerous innocent people who had to

be killed along with them? Why are there as many stories of "mistakes" with drone attacks as there are successful targeted assassinations? Is conventional war (bombing, invasion, occupation) the proper cure for the disease known as terrorism, or is it one of those cures that has the effect of making the disease worse? Why does it seem like every tactical victory in the war on terror (e.g., the destruction of the city of Fallujah in Iraq) seems to contribute to a strategic defeat for the overall goal of democratization and "winning hearts and minds"? The perverse logic of a war that seems to make the enemy stronger, more determined, and more numerous is reminiscent of the earlier perversity of an American war in which the U.S. military could talk about "destroying" villages in order to "save" them.[10]

If the Bush administration presided over an era of wars on cloning and terror, the arrival of the Obama administration has been punctuated by decisions that break more or less sharply with both of these "fronts." Obama has basically "undeclared" the wars on cloning and terrorism. He publicly announced on March 9, 2009, his decision to reverse his predecessor's ban on federal financing of stem cell research, much to the consternation of the antiabortion movement. By April 5, 2009, news organizations began to notice an unspoken parallel in the conspicuous silence surrounding the War on Terror. As Hillary Clinton noted when asked about this disappearance of the phrase: "I have not heard it used. I have not gotten any directive about using it or not using it. It is just not being used."[11] It is significant that no public announcement of the end of the war on terror was made by the president or any of his aides. The issue was finessed, no doubt to avoid the inevitable Republican accusation of being "soft of terrorism." Perhaps even more to the point: the War on Terror could not be declared over because it is not over, and never can be. The euphemism that has replaced it, "Overseas Contingency Operations" (OCO), is a bureaucratic obfuscation. We may find it necessary at some point in the future to bring the image of a War on Terror back in the interests of truth in packaging. The United States is likely to have troops in Iraq and Afghanistan for years to come, and there is always the

chance of a future attack on the United States that would com-
pletely reopen, and probably reliteralize and revitalize, the meta-
phor of a War on Terror. It is a dangerously stirring phrase, the
poetry of which has not been exhausted. Nor has the image of the
terrible, horrible clone, the "rough beast" that Yeats spied "slouch-
ing toward Bethlehem," been fully exorcised. The clone and the
terrorist are likely to be with us into the indefinite future, and that
is why insofar as this book is a history, it is one that extends into
the present. It is, in fact, an iconology of the present, an attempt
to sound the dominant verbal and visual images of the epoch that
opened on 9/11, and continues to unfold in our time.

3 Clonophobia

No passion so effectually robs the mind of all its powers of acting
and reasoning as fear. EDMUND BURKE

We have nothing to fear but fear itself. FRANKLIN ROOSEVELT

In the most general sense of progressive thought, the Enlighten-
ment has always aimed at liberating men from fear and establish-
ing their sovereignty.
THEODOR ADORNO, "The Concept of Enlightenment"

Be afraid. Be very afraid. DAVID CRONENBERG, *The Fly* (1986)

Before we address the fear of cloning, it may be useful to say a few
things about fear itself.[1] It is important at the outset to distin-
guish rational fears of actual threats from irrational anxieties and
neurotic phobias. Important, but also (we have to admit) very dif-
ficult, since the question of whether a fear is reasonable or not in-
variably depends upon a whole complex of background conditions
and hypothetical possibilities or probabilities, as well as a complex
set of normative frames, subjective, cultural, and perhaps even
physiological dispositions. A biological reductionist might argue
that there is a gene for fearfulness, and that the whole problem
of clonophobia will be overcome in the future by a simple medical
procedure. This seems highly doubtful. Despite FDR's comforting
words, there is something more to fear than fear itself, as FDR
well knew when he uttered them—though they did seem uncan-
nily relevant during a period (2001–8) when the cultivation of fear
was the fundamental strategy of the American presidency. Never-
theless, it is important to question the optimism about "educat-
ing the public" in the true, scientific "facts of life" as well as the
facts of technology. This is the view of (for instance) Richard Le-
wontin, who argues that the fear of cloning is really just a matter
of "error" and "confusion" to be corrected by straight-talking sci-
entists.[2] But the whole notion of the "facts of life," as Sarah Frank-
lin has shown, is really a "naturalized narrative that is troubled
by new technology."[3] Clonophobia is more than just a mistake or

cognitive error produced by ignorance or misinformation: it is a deeply rooted cluster of ideological anxieties and symptoms that continually shift ground, circulating around a historic crisis in the very structure of common understandings of the meaning of life itself. We find ourselves "in the times of cloning" without a clear moral or political compass to guide us. My own compass is fairly simple, and is based in the position of Dr. Mark Siegler, my colleague and director of the Center for Medical Ethics at the University of Chicago. Dr. Siegler invokes the widely accepted distinction between therapeutic and reproductive cloning, the former aimed at duplicating tissues and organs for the purpose of repairing bodies that have suffered (for instance) nerve damage or organ failure. The latter aims at the reproduction of entire organisms, not organs or tissues, and its practical aims are less clear. What is clear is that reproductive cloning is a highly problematic process, involving a very low percentage of "successful" (i.e., biologically viable) organisms, capable of living normal, healthy lives. Most clones are mercifully short-lived or stillborn, and many are born with deformities. It seems clear to most ethicists that reproductive cloning is questionable from an ethical standpoint. Therapeutic cloning, on the other hand, which is the primary objective of most stem cell research, promises to be of real benefit to humanity. Of course this fundamental distinction is blurred in a great deal of the polemicizing against cloning, as if there were no differences to be drawn between reproductive and therapeutic processes, much less between animal and human cloning.

I don't mean to suggest, however, that the irrational fear of cloning (clonophobia) may be straightforwardly cured simply by accepting this fundamental distinction. The case is more complicated than that. It may be useful, therefore, to lay out some of the basic facts about cloning before we plunge into the irrational attitudes that surround it.

X X X X X

"Clone" comes for the Greek word for a twig or "slip," and has its earliest applications in botany and the cultivation of plants,

where it refers to the practice of using grafts, cuttings, and bulbs to produce new individual plants out of one original stock. It has a wider biological use to refer to "any group of cells or organisms produced asexually from a single sexually produced ancestor" (*Oxford English Dictionary*).[4] There is just a hint, then, that cloning is an evolutionarily regressive process, involving a step backward from sexual procreation (in which offspring are genetically novel, randomized, and hybrid) to a simpler process of reproduction in which the offspring are twins or duplicates of the donor or parent organism. The original botanical, as distinct from zoological, application of the word suggest further a contrast between "vegetative" and "animal" reproduction as well. But of course cloning is a process that goes on naturally in all animals, and within the human body in the reproduction of asexual organisms like bacteria and antibodies. Many different kinds of cells (most notably cancer) clone themselves rapidly and with great success. It is also important to remind ourselves that "genetic engineering" in the sense of artificially manipulating reproductive strains in plants and animals is not a modern invention, but has been going on since human beings began to cultivate plants and raise domestic animals.

When the *Oxford English Dictionary* turns from these "literal" senses of cloning to "figurative" or metaphorical uses, the first thing we encounter is the following: "A person or animal that develops from one somatic cell of its parent and is genetically identical to that parent. Also (*colloq.*), a person who imitates another, esp. slavishly." These definitions involve two distinct stages of metaphorization of the literal meaning of cloning: 1) its application to a "person or animal," as a opposed, we must presume, to a plant, or (perhaps) a single-celled organism—something at the very simple end of the "animal" spectrum; and 2) its colloquial application as imitation or copying, especially the sort of copying that is not creative or innovative, but "slavish." The secondary figure is a personification that reinforces a deep-rooted tradition of anxiety about imitation as a form of slavery or servitude, a failure to achieve autonomy, independence, and individuality.

But the first metaphorical meaning is the one that is really strik-
ing, because it looks, at first glance, as if it is a meaning that has
become quite literal within the last twenty years, with the advent
of human and animal cloning along with a host of related biotech-
nologies. It now seems odd, in other words, to think of a cloned
animal or person as anything but a (literal) clone. It is as if what
was previously figurative, because it was only a hypothetical, spec-
ulative possibility, has now been overtaken by history and tech-
nology, and has now become a literal fact.

The difference between the literal and figurative meanings
of words is, of course, a central concern of iconology or image
science. The distinction is grounded (literally) in the contrast
between "letters" and "pictures," words and images, the arbitrary
signs of a writing system and the iconic signs of graphic repre-
sentation. The literal meaning is sometimes referred to as the
"proper" or straightforward meaning of an utterance, while its
figurative sense is "improper," or extended beyond some normal
meaning, and involves a "turn" or "trope," a "figure of speech or
thought" that transfers the literal meaning from its proper do-
main (biology, for instance) into the realm of culture and human
behavior. Hence, "slavish imitation" transfers the literal sense of
the clone as an exact, identical genetic copy to the social, human
world of copy machines and imitative behavior, and suddenly one
finds "clones" everywhere in ordinary language and everyday life.

The normal scientific approach to this sort of problem is to
bracket off the metaphoric uses of a term, and strictly limit the
investigation to its literal reference. Unfortunately, this option is
not open to image science, because one of its central concerns is
exactly this moment of transition between literal and figurative
meaning. The iconologist, unlike the biologist, cannot limit the
investigation to the literal meaning, but must examine the very
process by which the literal becomes figurative, and vice versa. The
latter process—the literalizing of the figurative—is what happens
in the phenomenon of the "dead metaphor" (the leg of a table, the
arm of a chair, the "body politic"). And it is an especially impor-
tant moment when this sort of transformation occurs as part of a

historical change in a language, as has obviously happened in our time with regard to the notion of cloning. This word, which used to "properly" designate a botanical and perhaps a very simple, elementary zoological process of reproduction, has now shifted its application, first figuratively, and then literally, to the world of the higher mammals and now even human beings. The "proper" use of the word has undergone a crisis, as is seen in the numerous debates about the ethics of human cloning, which did not even exist a few years ago (though, as we will see, there were anticipations of them already in the anxiety about "slavish copying" and image-making more generally).

In addition, cloning has now taken on a new range of metaphoric lives, well beyond its (new) literal meaning, and has been applied to machines, to buildings, to institutions, and even to images themselves. If an image is an icon, a sign that refers by likeness or similitude, a clone is a "superimage" that is a perfect duplicate, not only of the surface appearance of what it copies, but its deeper essence, the very code that gives it its singular, specific identity. Cloning might be called "deep copying," since it goes beneath the visual or phenomenal surface to copy the inner structure and workings of an entity, especially the mechanisms that control its own reproduction. Cloning has become an image of image-making itself, a metapicture of the most advanced form of image production technology in our time.[5]

x x x x x

I return, now, to the question of clonophobia, the irrational fear of cloning. Even in the bygone days when intellectuals had a deep confidence in the ability of "ideology critique" to expose and transform benighted attitudes, it was well known that it is devilishly difficult to educate people about their own self-interests, much less to talk them out of an ideology. Our situation now is, if anything, even more complex, since it is hard to specify what sort of epistemological high ground would be capable of providing a rational perspective on the techniques, ethics, and ideological presuppositions surrounding cloning. The ground is shifting under our

feet as we proceed with this scientific, historical, and philosophical endeavor. For that reason, I think we must take clonophobia quite seriously, and not dismiss it as a mere popular delusion, but analyze its workings in some detail. Like homophobia, misogyny, and racism, with which it has affinities, but from which it differs markedly (it's hard to say that human clones, for instance, are subject to something like racial or sexual prejudice when, at this moment at any rate, there are no existing specimens to despise), clonophobia is a deep-rooted syndrome, made even more complicated by the fact that there are no actual clones around to provide a determinate object of fear, only the shadowy, faceless potential of some "rough beast / slouching toward Bethlehem."

The surest sign that clonophobia is deeper than misinformation or misunderstanding is the fact that it spans left and right, secular and religious perspectives. It is not just the Jerry Falwells and Leon Kasses with their "instinctive revulsion" at the idea of human cloning, but an ultraleftist like Jean Baudrillard who regards the invention of cloning as a symptom of the denial of death and the embracing of a false immortality that will ultimately mean the end of the human species, a perverse fulfillment of the death drive. Baudrillard runs through the usual fantasies about soulless, acephalic organ donors on "clone farms" whose body parts will be harvested and commodified, but he reserves the real moment of horror for the long-term prospects of mass uniformity and evolutionary regression promised by cloning. The asexual character of cloning, Baudrillard predicts, will produce a kind of sameness that will "bring evolution to an end" and cause the "involution" and eventual disappearance of the human species.[6] The variations produced by environmental factors and culture will not be able to arrest this process. On the contrary, Baudrillard argues,

exactly the reverse is true. It is culture that clones us, and mental cloning anticipates any biological cloning. It is the matrix of acquired traits that, today, clones us culturally under the sign of monothought. . . . Through the school systems, media, culture, and mass information, singular beings become identical copies of one another. It is this kind

of cloning—social cloning, the industrial reproduction of things and people—that makes possible the biological conception of the genome and of genetic cloning, which only further sanctions the cloning of human conduct and human cognition. (25)

What is striking here is the way that Baudrillard reverses the causal, determinative chain so that metaphorical, figurative cloning precedes the invention of the real, literal thing. It seems clear that cloning is merely an extrapolation of Baudrillard's long-standing obsession with what he calls the "simulacrum," the "copy without an original" that multiplies itself endlessly in the contemporary regime of simulation and false appearance. The clone, in fact, is nothing more than the personification and corporealization of the simulacrum, or (as Baudrillard has expressed it elsewhere), the "evil demon of images."[7]

And this gesture points us, I think, in the right direction for getting at the taproot of clonophobia, the central issue from which its many branches emerge. It is not just the resemblance to fears of the "other," whether racial or sexual; not just the fear of violating natural or divine law, of transgressing the codes of evolution on the one side, or revelation on the other; it is not just the horror of desecrating the sacredness of life, or of erasing human individuality, or denying death for a static immortality, nor of turning human creatures into commodities. This last fear, as Lewontin points out, is nothing new: we have been commodifying people since time immemorial and have accepted this process as normal and natural, so why should it be an issue specific to cloning? No, the real problem with cloning is more fundamental and far-reaching. At bottom the fear of cloning is rooted in the fear of images and image-making, arguably one of the most durable phobias that human beings have ever developed for themselves. Cloning is a realization, a literalization of the most ancient fear—and (significantly) the most ancient hope—about images, and that is that we might bring them to life.

All the religious and secular forms of clonophobia I have just listed are, of course, recognizable variations on the anxieties char-

acteristic of the times of cloning. But we cannot grasp the complex taxonomy of clonophobic species without identifying its common ancestor in the phenomenon of the image. Clonophobia is, in short, the contemporary expression of a much more ancient syndrome known as *iconophobia,* the fear of the icon, the likeness, resemblance, and similitude, the copy or imitation.

Seeing clonophobia as a species of iconophobia does not have the effect of simplifying the matter. On the contrary, this shift of perspective puts the fear of cloning into a longer historical perspective, one that recognizes its novelty at the same time that it is prepared to trace its lineage in archaic anxieties about image-making. Certainly it must be obvious that the fear of cloning is rarely expressed in exclusively presentist terms, as if it were unprecedented. The routine invocation of the Frankenstein myth, the Pygmalion and Narcissus narratives, the legend of the Jewish golem, the artificial warrior animated from dead matter, all the way down to the modern robot and cyborg, testifies to the durability of human fascination with the prospect of creating an artificial human life form. (And of course it is *human* reproductive cloning that occupies center stage in the scenarios of clonophobia, though it has a tendency to radiate outward to animal cloning and even the most modest efforts in stem cell research and therapeutic cloning.) Indeed, one could add to the narratives of cloning the central creation myths of the Judeo-Christian tradition, from the making of Adam "in the image" of God, to the cloning of Eve from the rib of Adam, to the implantation of an embryonic life form in the womb of the Virgin Mary, leading to the human birth of a Son who (as Milton informs us) was "begotten not made" in asexual solitude by the Father long before his incarnation as a mortal man. If these divine creation stories are not so frequently associated with cloning, it is only because they are coded precisely as *divine* or supernatural, thus by definition exempt from the usual taboos and prohibitions on human creativity. God is permitted to clone himself and his creatures. For man to attempt the same kind of creative act is an impious transgression, and an appropriation of forbidden knowledge. Only God is allowed to create living

images, which is to say, only God is permitted to make images *tout court*. That is the undeniable message of the second command-ment, which forbids the making, not just of idols, but of *any* image of any living thing, whether found in the earth, sea, or sky. The theory here being that if any image-making is permitted, it will ineluctably lead toward an image with a life of its own, and all the related symptoms of animism, vitalism, superstition, magic, and idolatry.

So iconophobia in its most primitive, archaic manifestations al-ready contains premonitions of cloning. And this does not change when the images in question are the despised "idols of the mind" to be smashed by Enlightenment science and philosophy. Enlight-enment, as Theodor Adorno and Max Horkheimer argued, pro-duces its own dialectical return of the repressed myths, with all their accompanying idols, fetishes, and totems: "the disenchant-ment of the world is the extirpation of animism," with its "mul-titude of deities" who "are but replicas of the men who produced them." And science is not content with the extirpation of the primitive or spiritualist images alone, but sets its sights on the whole realm of theory and philosophical ideas: "there is said to be no difference between the totemic animal, the dreams of the ghost-seer, and the absolute Idea" of a Plato or Hegel. The Enlight-enment turns out to be "as destructive as its romantic enemies ac-cuse it of being": "the dark horizon of myth is illumined by the sun of calculating reason, beneath whose cold rays the seed of the new barbarism grows to fruition."[8] Totalitarianism (enlivened by the return of paganism in fascist politics) couples with bureaucratic efficiency and banal forms of instrumental rationality, whether driven by a Final Solution or a Bottom Line.

Adorno would have seen clonophobia, then, as a perfect exem-plar of the dialectic of Enlightenment, showing the ancient fears about the animated image reborn quite literally in the technosci-entific gadgets and commodities of late capitalism. In the clone, the "fetishism of DNA and the secret thereof"[9] merges with the hypericon of biocybernetic reproduction. For "the Clone" (to fi-nally give him/her a proper name) is not just an "icon" of late capi-

talism, postmodernity, or the age of biocybernetics, but a *hyperi-con:* that is, it is an image of image production, a figure for copying, duplicating, imitating, and all other forms of likeness production. It is the sign of sameness, which turns out to be even more terrify-ing than difference. It would be reassuring if Dolly the Sheep were a wolf in sheep's clothing. The idea of a sheep in sheep's clothing is more disturbing, but why? Is this the lamb of god? Or an impos-ter? Doesn't the Antichrist come as the double or clone of the true Christ? The fear of difference, of the stranger, the monster, the alien is what might be called a "rational" fear, or at the very least, a fear that has a determinate object or image. The racial or gendered other is (with the notable exception of homosexuality, to which we will return) visibly marked as different and distinguishable. But the true terror arises when the different arrives masquerading as the same, threatening all differentiation and identification. The logic of identity itself is put in question by the clone.

Clonophobia thus revives all the ancient taboos on twins, and the whole related clan of doubles, canny or uncanny, and doppel-gangers. Dead Ringers, locked in their Mirror Stages, stalk the halls of science fiction from replicants to mutants to cyborgs. The posthuman future is on the march, complete with cloned armies of storm troopers and terrorists, cloned Hitlers and Einsteins, Evil Twins and monstrous hybrids like the Ripley of the *Alien* trilogy. Similitude, artificiality, and uncanny lifelikeness, all the hallmarks of the image as such, are brought to life in these fantasies.

Even fictions based on relatively realistic assessments of the prospects of human cloning register the ineradicability of clono-phobia. Early novels like Pamela Sargent's *Cloned Lives* (1976),[10] in which a brilliant scientist produces five male and female offspring from his own DNA, portrays the plausible scenario of strong dif-ferentiation among the quintuplets in terms of personality and appearance. Yet the stigma of cloning hangs over the quints throughout their troubled lives, making them objects of curios-ity and disgust among the general population. More recent fic-tions such as Kazuo Ishiguro's *Never Let Me Go* shifts the clon-ing issue into the most familiar and even comforting of settings,

an English boarding school called "Hailsham" (the "healthy ham-let"?) where the cloned children receive a modest education from reform-minded educators who think (despite strong objections from conservative politicians) that clones might actually be educable, and even have creative souls. The *Jane Eyre*–ish tone of Ishiguro's novel, a feminized bildungsroman of a generation of clones whose destiny is to serve as organ donors, is hedged about, however, by a creeping sense of doom. The clones' highest personal ambition is to get a job as a driver or postman. They are convinced that they are "modeled from *trash*. Junkies, prostitutes, winos, tramps. . . . Look down the toilet, that's where you'll find where we all came from."[11] Their inevitable death from donating vital organs is described by the euphemism of "completion."

When the point of view of the human clone is represented in contemporary narratives, then, it tends to vacillate between innocent victims and merciless killers. In Arnold Schwarzenegger's *The Sixth Day* (dir. Roger Spottiswoode, 2000), for instance, the cloned Schwarzenegger gets to play both of these roles, first as victim, and then as avenger as he takes on the gang of murderous cloned security guards from the evil corporation that has been violating the "Sixth Day" prohibition on human cloning. The wonderful comic touch in this film comes when Schwarzenegger confronts his clone who is about to make love to his wife, and they engage in an inconclusive debate about which one is the model and which is the copy. In films like *The Island* (dir. Michael Bay, 2005) the clones are kept in an underground base in anxious ignorance of their real fate as organ donors by a comforting myth about repopulating the planet Earth after an ecological disaster has wiped out the human race. The clones are told that they are to be the new Adams and Eves, when in fact their (predictable) fate is to serve as organ donors for their wealthy and powerful "models."

As should be clear, these narratives have the effect of blurring the line between reproductive and therapeutic cloning. It is as if the "slippery slope" argument against the making of graven images were being transposed to the reproduction of living organisms. The critical linchpin in this logic is strikingly similar to, and builds

upon, the American "right to life" argument that the fertilized egg, the embryo, and indeed something as minimal as the blastocyst, is already a fully formed human being with all the rights and privileges of a U.S. citizen. Cloning is therefore straightforwardly equivalent to abortion.[12] Only God—or the randomness of evolutionary selection—is permitted to create an image of life. And anyone who violates this law against image-making—even if it has not been delivered to them—is to be punished by death.

As noted earlier, Hollywood has produced over a hundred films about cloning in the last fifteen years, and I have no idea how many more are on the way. Most of them are forgettable, because they recycle the familiar plots I have been summarizing. One could summarize them as expressions of clonophobia understood as a complex of fascination and horror—in short, a systematic ambivalence that resonates with numerous echoes of racial and sexual prejudice, yet is somehow different. What is this difference? Since clones (or all the members of a clone) look alike, they might seem like a racial subgroup that can be recognized on sight. But since the clones are copies of *us,* they cannot be recognized as such; they are like those who must "pass for white," even with just one drop of black blood in their veins. Since they are reproduced artificially, not "procreated" by a heterosexual union, there is a certain overtone of indifferentiation around the icon of the clone. The clone seems capable of both racial and sexual "passing," not to mention transvestism and transexuality. It is no accident that the pioneer model of macho homosexuality was called "the Clone."

During the 1970s, the weightlifter, leather boy, biker, cowboy— in short, the stereotype of the virile, masculine man—became the new prototype for gay males, replacing the dandy and the sissy. Al Parker, Gay Superstar, ruled the scene with his anonymous good looks and athletic sexual prowess. As a camp appropriation of masculinity, of course, the homosexual clone was a figure of considerable irony within the gay community, a queering of machismo. From the point of view of straight men, however, the clone was a figure of anxiety, a convergence of homophobia and clonophobia.

The problem with the clone, then, is not only that it is a liv-

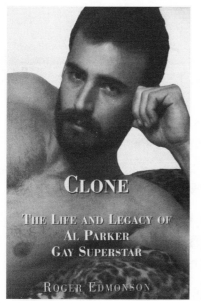

FIGURE 7.
Cover of Roger Edmonson's *Clone: The Life and Legacy of Al Parker, Gay Superstar* (New York and Los Angeles: Alyson Books, 2000).

ing image of a living thing, but that it is indistinguishable, anonymous, possessed by a kind of facelessness or impassivity that moves toward its most radical expression in the acephalic clone, the headless, mindless, soulless creature, the exemplification of the human organism reduced to "bare life." As a singular figure, the image of the clone is perhaps best captured by artist Paul McCarthy's disturbing sculpture, *The Clone*, a mannequin-like human body whose head and torso are hooded by a garbage bag, its detached arms lying on the ground at its feet.

McCarthy is referencing the standard narrative of the clone as organ donor, the reduction of the human organism to a purely instrumental and commodified condition—"modeled from *trash*," as Kazuo Ishiguro puts it.[13] But it is hard to miss the resemblance of this figure to the images of hooded Iraqi torture victims at Abu Ghraib prison, and difficult to forget the fateful memos of the White House lawyers who defined the permissible limits of torture as involving "organ failure or death."[14] The clone-as-organ-donor has the ultimate destiny of literalizing what philosopher

FIGURE 8. Paul McCarthy, *Clone* (2001/2004). Courtesy of the artist. Photograph courtesy of Friedrich Christian Flick Collection.

Gilles Deleuze called a "body without organs," the dismembered husk of a human body after all its organs are "harvested." The logical counterpart of this figure, then, are the organs without a body laying at the feet of McCarthy's clone. Arms, legs, kidneys, lungs, eyes, livers are all highly valuable commodities, especially if they can be implanted in the parent or "donor" organism of the clone, where the identical DNA signature will prevent the host body's immune system from rejecting the transplanted organs. The only disposable and valueless organ of the cloned body, as Baudrillard suggests, is the head and the brain. Eliminating this useless appendage (except for the automatic regulatory mechanisms to keep the rest of the body alive) has a doubly desirable effect of rendering the clone mindless, reducing it not just to an animal condition, but something more closely resembling a vegetative state, at the same time it eliminates the inconvenient feature of a human *face* that might arouse feelings of sympathy. The convergence of the hooded figure of the clone and the "suspected terrorist" is perhaps most vividly dramatized by the rumor in the Arab world that the detainees at Abu Ghraib were being used as organ donors by the U.S. The Turkish film *Valley of the Wolves* (Turkish title: *Kurtiar vadisi,* 2006, dir. Serda Akar and Mustafa Sevki Dogan) includes the scene of an operating room at Abu Ghraib where a hooded detainee is having a kidney removed. Presumably such an occurrence would have met the White House's "organ failure" criteria only if the transplant was unsuccessful.[15]

The concept of the clone, however, is not confined to the singular organism that has been replicated from a parent organism. The word also refers to the entire group or series. Like the word "flock" or "herd," "clone" designates a collective entity with an indefinite number of members. Thus when the *Star Wars* episode entitled *Attack of the Clones* shows the mobilized clone army marching in formation, we are not just seeing an assembly of individual clones, but a single, singular clone. All the members of this clone are identical twins of the parent organism, drawn from the template of the relentless bounty hunter Jango Fett, genetically engineered to make them more compliant with orders.[16] The image of the

FIGURE 9. Still from George Lucas's *Star Wars, Episode II: Attack of the Clones* (2002) depicting the clone army.

massed storm troopers evokes, of course, the images of massed fighters at the Nuremberg rallies, the most memorable incarnation of what Siegfried Kracauer called the "mass ornament," the assembly of the crowd into a single patterned formation. Busby Berkeley's massed geometric dance formations are perhaps the most thoroughly aestheticized versions of the mass ornament, along with the performance practices of "card sections" at sports events and political rallies, where individuals are reduced to ciphers or pixels in a digitized mass spectacle.

There is one important difference with the clone army, however. In classic theories of the crowd, it was thought that people lost their individuality when they entered into the mass, but that they could regain it by leaving the crowd, "going their own way," and returning to the private sphere.[17] But the cloned army permits no such return to individuality. The clones are not merely identical by virtue of their visibly uniform armor and helmets and their insertion into controlled mass formations. They are all *invisibly* the same deep down as well, with identical DNA. They are "deep copies" of their parent and of each other who maintain their group identity no matter how drastically they are separated from the mass. The old religious metaphor of the communal "body" of believers, which is still pervasive in the notion that one may be a

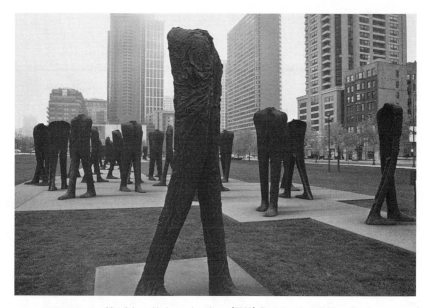

FIGURE 10. Magdalena Abakanowicz, *Agora* (2008). Sculpture installation, Grant Park, Chicago. Photograph by Alan Thomas.

"member" of an organization (i.e., organism) or corporation (i.e., a body) is rendered literal in this image. Their homogeneity is redoubled, moreover, by the fact that, unlike an organic or social body, there is no differentiation among the members or "organs" of the body—no "head" or "feet" or "hands." They are all *foot soldiers*, "boots on the ground" as the standard synecdoche for infantry puts it.

A recent work of art that condenses the whole image of what might be called "the new masses" into a single gestalt is a remarkable sculptural installation by the Polish sculptor Magdalena Abakanowicz. Installed in Chicago's Grant Park in 2007, *Agora*, as the name suggests, evokes the Greek concept of the public gathering place, either as a market or political space. But Abakanowicz modifies the classical figure of the crowd in several significant ways. First, and most obvious, all the figures (imposing in scale, at about nine feet tall) are *headless*. Second, and even more disturbing, they are all *hollow*, eviscerated, as if all their internal

organs have been harvested, leaving only half-bodies, open at the back, with frontal shells that consist of arms, legs, and torsos that are reduced to nothing but the clothing that would have covered their bodies, and the hands and feet that signal their motions, as if their skin and skeletons had been harvested as well. Finally, the grouping of the 110 figures seems conspicuously randomized. Although each figure seems to be striding purposefully in one direction or another, none of them walk together, or meet, or betray any of the bodily signals of merging into groups or even couples. In this sense, they are just the opposite of the images of the crowd as mass ornament, organized into tightly disciplined patterns. They strike the beholder as a crowd that may be in the process of gathering or dispersing, without any visible shape or coherence, except perhaps for one subtle indicator. They seem to be dividing into two clusters, one larger than the other, with a few figures strung out between them, as if playing the role of "go between" for two disorganized groupings. Perhaps this is a reflection of what is arguably the most primitive form of social organization, the division into friends and enemies, us and them. In any case, they cut a doubly headless figure, both at the level of the individual body and the collective assembly, which mills aimlessly about, as my mother used to put it, "like chickens with their heads cut off."

I don't think Abakanowicz intended this installation to remind us of clones and cloning. Her aim, as she has told me, was to reflect on the psychology of the masses more generally, particularly with reference to her own life experiences with communism and fascism. Certainly the motif of "hollow men" has a deep modernist pedigree, going back to T. S. Eliot. But the combination of hollowness, headlessness, and (at the social level) *heedlessness* and mutual obliviousness, strikes a resonant chord in the times of cloning.[18] These are bodies without organs as members of a body without organization.

The time of cloning, then, is now. We are experiencing something radically new in the history of the human species: the moment when our entire ecosystem, both internal and external, the organism and the environment, seems to be undergoing a major

transformation—what some have called "the age of the anthro-
pocene," when human agency becomes the biggest factor in the
natural environment, "more powerful than the rain."[19] The nov-
elty of this moment, however, has to be understood in relation to
its resurrections of the most archaic phobias—and hopes—of the
species. It is not a time for either nostalgia or presentism, but for
a massive rethinking of all our assumptions about the self-image
of the human animal, and its relations to all the life forms we live
among, and that live inside us.

4 **Autoimmunity** Picturing Terror

But whatever the appearances, American and Iraqi officials agree
on the essential structure of the Iraqi insurgency: it is horizontal
as opposed to hierarchical, and ad hoc as opposed to unified. They
say this central characteristic, similar to that of terrorist organi-
zations in Europe and Asia, is what is making the Iraqi insurgency
so difficult to destroy. Attack any single part of it, and the rest
carries on largely untouched. It cannot be decapitated, because
the insurgency, for the most part, has no head.

DEXTER FILKINS, "Profusion of Rebel Groups Helps Them
Survive in Iraq"

Cloning is the microcosmic face of biopolitics.[1] As a name for the
asexual reproduction of individual organisms, it designates "the"
clone as a particular thing, or a particular collection of things, all
deep copies of one another. But biopolitics also has a macrocos-
mic face that manifests itself in the metaphor of the "body politic"
or the "social body" in which individuals are members, often dif-
ferentiated in their status and roles, arrayed in a hierarchy that
ranges, for instance, from the "head" of state to the force of "arms"
to the "foot" soldier. The division of a tricameral government into
executive, judicial, and legislative branches mirrors a traditional
notion of the individual psyche as itself divided into "faculties"
such as deliberation, judgment, and action or will.

A traditional war, then, is waged between two distinct political
bodies, two sovereign nation-states with different cultures,
political systems, and histories. Civil wars occur when the body
politic splits in two, and ends either in a division into two distinct
polities or a resolution in favor of one side or another. Revolu-
tionary wars often merge with civil wars, pitting one segment of
the population (divided by class, religion, or political ideologies)
against another. None of these forms of war, needless to say, is
conducted in a pure form. Third parties, alien interests, and alli-
ances invariably come into play.

The question arises, then: what is the appropriate biopolitical
model for an international terrorist movement, and for its antith-

esis, the Global War on Terror? The usual answers are familiar to anyone who reads the newspapers. Terrorism is like a plague, virus, or cancer. It spreads invisibly and breaks out without warning in spectacular acts of sabotage and symbolic destruction. It does not come as an invading army marching across a border wielding modern weapons and conquering territory. It crosses borders with forged papers, dissimulating itself as a friendly guest, or lurks quietly in sleeper cells, awaiting its moment to break into the open. It does not necessarily have a foreign origin, but may be "native born," as the British have learned to their sorrow from the actions of terrorist agents who were doctors in the National Health Service. Most disturbing is the lateral, headless character of the terrorist organization, which, though it may have an ideological and iconic figurehead like Osama bin Laden, often functions with only the most minimal operational hierarchy. Like a cancer, therefore, terror can seem to metastasize, suddenly appearing in previously healthy regions of the body politic where it becomes very difficult to remove without damaging vital organs.

In the immediate aftermath of 9/11, and especially in the midst of the anthrax scare of fall 2001, the equation of terrorism with literal or metaphoric bioterrorism was unavoidable. But in that moment, an alternate biopolitical metaphor was offered by Jacques Derrida, arguably the most brilliant French philosopher of the last thirty years. Instead of the usual metaphors of infectious disease, Derrida proposed to picture terrorism as an "autoimmune disorder." Autoimmunity is, according to the MedLine Medical Encyclopedia, "a condition that occurs when the immune system mistakenly attacks and destroys healthy body tissue."[2] It includes many allergies, type 1 diabetes, rheumatoid arthritis, and Graves disease, among others. Like almost everyone who attempted to picture the dynamics of terrorism and its effect on the social body, Derrida turned to a biological metaphor, but one focused on the defense mechanisms of the organism itself, rather than on the usual picture of terrorism as a foreign invasion by alien microbes. The figure of the clone does not play any role in Derrida's analysis, but as we shall see, it has a crucial part in the microcosmic pic-

ture of *both* the infectious disease model and the image of auto-immunity. The clone in both models is the image of the individual "soldiers" or "cells"—the antibodies and antigens on the biopolitical battlefield. Derrida also anticipated the conclusions of historians who saw the attacks of 9/11 and the U.S. response as a residual symptom of an earlier political malady, namely, the Cold War.[3] He diagnosed the attacks of September 11 as "a distant effect of the Cold War"(92), more precisely, of "a Cold War in the head," a global "head cold" that had now mutated in an "*autoimmunitary process* . . . that strange behavior where a living being, in quasi-*suicidal* fashion, 'itself' works to destroy its own protection, to immunize itself *against* its 'own' immunity" (94).[4]

At first glance, this diagnosis of terrorism seems counterintuitive, perhaps even in bad taste. It seems to "blame the victim," the United States and the global system of which it is the "head," for bringing on the attacks, or even for being guilty of a "quasi-suicide." The image of autoimmunity would seem more strictly applicable to something like a military coup d'etat, in which the armed defenders of the external borders and the internal order, the army and the police, turn against the legitimately constituted government, attacking the legislature, the judiciary, and deposing the executive.[5] The terror attacks of September 11 came, we want to say, from *outside* the body politic, from faraway places like the Middle East; it was an attack by *aliens,* by "foreign bodies" that had taken advantage of American hospitality to infiltrate our borders.[6] Derrida's image of autoimmunity, and of the immune system more generally, seems to be "stretched" to the breaking point.

But on reflection, the stretching of the metaphor seems to be exactly the point. The limits, borders, boundaries of the body (politic), its relations of inside/outside, friend/enemy, native/alien, literal/figurative are exactly what is in question in the metaphor of the immune system, and in the new phenomenon of "international terrorism," which is quite distinct from the terrorism of local resistance movements (Ireland, Palestine, Spain) focused on a definite territory. The United States is, as Derrida points out, not just a distinct body politic with its own determinate borders

and identity; it is the "symbolic head of the prevailing world order," the chief organ of a much larger, global body, the contemporary world system. The attacks of September 11 were not merely on "U.S. territory," but on the "*World* Trade Center."[7] Like the boundaries of the world system, like globalization itself, the metaphor of the immune system stretches out to comprehend at least one dimension of the totality of the present historical reality.

In selecting the figure of autoimmunity as a tool for analyzing modern terrorism, Derrida chose an image with considerable surplus value, one whose immediate applicability is startling, and which continues to resonate well beyond the use he makes of it. As Donna Haraway points out, "the immune system is both an iconic mythic object in high-technology culture and a subject of research and clinical practice of the first importance."[8] It is important to stress Haraway's insistence on the doubleness of the concept, its status as "iconic" on the one hand, and as an indispensable research tool on the other. That is, we can try to resist the image as a "mere metaphor," a loose analogy, but it keeps coming back to haunt us in the biological figures that are part of the ordinary language for describing terrorism, and in the unavoidable language of biomedical research . Even more interesting is what I want to call the "bipolar" character of the entire foundational metaphor that Derrida's figure presumes, namely, the ancient figure of the "body politic."[9] This image, which invites us to see the collective, society, the nation, mankind, even all living things, as "one body" is *reversible*. That is, we find ourselves speaking, whether we want to or not, of the "political body" as well as the "body politic."[10] And it turns out that the very notion of "immunity" as such is originally based in a sociopolitical discourse, not a biological one: "The Latin words *immunitas* and *immunis* have their origin in the legal concept of an exemption," a sense that returns in the notion of "diplomatic immunity."[11] The whole theory of the immune system, and the discipline of immunology, is riddled with images drawn from the sociopolitical sphere—of invaders and defenders, hosts and parasites, natives and aliens, and of borders and identities that must be maintained. In asking us to see terror as autoimmunity,

then, Derrida is bringing the metaphor home at the same time he sends it abroad, "stretching" it to the limits of the world. The effect of the "bipolar image" is to produce a situation in which there is *no literal meaning*, nothing but the resonances between two images, one biomedical, the other political.

The impossibility of a literal meaning, of course, means that we literally "do not know what we are talking about" or what we are "literally" talking about.[12] We are caught in the circuit between two images, dancing in the alternating current between two realms of discourse. For Derrida, this admission of ignorance is crucial, because the real politics of the autoimmunity metaphor, beyond its power to deconstruct all the easy, Manichean binary oppositions that have structured the War on Terror, is the restaging of terrorism as a condition that needs to be thought through analytically, systemically, and without moral tub-thumping, exactly as we would approach the diagnosis of a medical condition.[13] Even more far-reaching is the implication that "a mutation will have to take place" (106) in our entire way of thinking about justice, democracy, sovereignty, globalization, military power, the relations of nation-states, the politics of "friendship" and enmity, in order to address terrorism with any hope of an effective cure. In other words, we have something to learn here. Preestablished certainties are exactly the wrong medicine.

But one clue is offered by the metaphor (and the literal operations) of the immune system itself. There are two systems in the human body that are capable of learning. One is the nervous system (to which we will return in a moment); the other is the immune system, which learns by "clonal selection," the production of antibodies that mirror the invading antigens and bond with them, killing them.[14] The implications of this image are quite clear. The appropriate strategy for international terrorism is not war, but the development of rational, open, public institutions of international justice. The "war on terror" is like pouring gasoline on a fire, or (to maintain the biopolitical analogy) like massive, unfocused doses of radiation or invasive surgical intervention, overreactive "treatments" that fail to discriminate the body from its attack-

ers or that even stimulate the proliferation of pathogens.[15] Even if one doubts that the "war on terror" has been accompanied by a measurable increase in the number of terrorist attacks (London, Madrid) and accelerated the recruitment of jihadists, the reframing of international terrorism within a public health perspective would surely give us pause.[16] The key issue is not "how many" terrorists are at large in the world much less how many can be killed in some statistical body count. The problem is really structural and qualitative. A cancer is not diagnosed solely in terms of numbers of deadly cells, but their quality (fast or slow-growing), shape, and location in the body. Overreactive tactics can actually breed new cancer cells that clone themselves more rapidly. (Cancer has an interesting relation to autoimmunity, since it is about the body's inability to recognize a destructive cell structure as alien; the cancer cells are the body's *own* cells—their DNA lineage is indistinguishable from the host body. So the immune system sleeps through the attack by the body's own cells.)

The best strategy is highly targeted and *intelligent* intelligence, coupled with judicious and judicial procedures—not pilotless drones wiping out tribal compounds, not high altitude bombing of "suspected concentrations of insurgents," not the "Black Ops" storm troopers, nor the private armies of "independent contractors," nor the hooded torturers that sprang from the Bush fantasyland of the War on Terror, but infiltrators who can simulate the enemy, who speak his language, understand, sympathize—who can present themselves as *friends* who can claim, with some credibility, to have their interests at heart. After all, terrorism is a fairly dead-end proposition for most people, rather like belonging to a criminal gang. It might be time, in fact, to begin exporting some of the most successful models for dealing with gang violence and drug dealing to terrorist organizations. David Kennedy, the director of the Center for Crime Prevention and Control and professor of anthropology at John Jay College of Criminal Justice in New York City, has pioneered new "smart" methods of dealing with criminal gangs by means of community involvement and targeted meetings that actually use moral persuasion to get criminals

to see the concrete results of their actions, and to open up alternatives. Aided by "social-network-analysis software to identify and target only key players in the gang" that can be "used to map interpersonal dynamics in anything from business organizations to infectious disease outbreaks and terrorist groups," the results of this approach have been dramatic in a number of American cities that defied all the tactics of forceful "crackdowns" on criminals.[17]

This sort of strategy would involve shifting much of the operational responsibility for dealing with international terrorism to the Islamic world, to its internal traditions of justice, its social and political networks, its established, legitimate police and military forces, its tendencies to modernization and secularization, as well as its deep religious commitment to peace and justice. The long history of European imperialism has, of course, deeply eroded these institutions in many Arab countries, leaving behind corrupt, authoritarian governments and shattered societies. The reparations for this damage, however, should *not* take the form of military intervention, but the building of clinics, schools, and infrastructures that actually bring something positive to ordinary people. As Nicholas Kristof points out, "for the cost of deploying one soldier [to Afghanistan] for one year, it is possible to build about 20 schools."[18] It is widely recognized, even by the most hawkish generals, that counterinsurgency is a matter of "hearts and minds," not "clear and hold" operations involving house to house fighting, much less pilotless drones, high altitude bombing, and misguided assassinations. Above all, it is essential that (in the case of a situation like Afghanistan) local, popular leadership such as councils of village elders be involved directly in the disbursement of resources and the exercise of "soft power." The Obama administration's decision in December 2009 to launch a military "surge" of thirty thousand additional troops to Afghanistan was arrived at after extensive consultations with everyone *except* the ordinary Afghans whose lives are directly affected.[19]

An enlightened use of U.S. military power would keep it in reserve for emergencies, humanitarian crises, and other limited-scale interventions. Outright preemptive war, invasion, and oc-

cupation of a foreign country that had not attacked us would be pretty much out of the question. Military adventures in "regime change" and democratization at gunpoint would be low on the agenda.

If we can listen to it, then, our immune system is whispering hints to us. That is, it is passing on a lesson to the nervous system, which is the other bodily system that can learn from experience. Not only that, the nervous system can accelerate its learning process with self-conscious reflection, critique, and the preservation of memory and history. Immunity is a form of cellular "memory"; the body learns by experience how to fight measles, and it doesn't forget. The most dangerous threat to the immune system, then, is amnesia, the forgetting of what it has learned: forgetting, for instance, that today's terrorists (al Qaeda, Osama bin Laden) were yesterday's allies, trained as antibodies against Soviet military power in Afghanistan; forgetting, even more dangerously, that yesterday's terrorists are often tomorrow's heroes of national liberation, and that moral absolutes are not just useless, but positively dangerous in any counterterrorist strategy.

Unfortunately, what Marshall McLuhan called "the central nervous system" of the social body, what Derrida calls the "technoeconomic power of the media," has been traumatized by an image—the spectacle, the word, above all the *number as enigmatic name:* 9/11. This image, the spectacle of destruction of the twin towers, has been cloned repeatedly in the collective global nervous system.[20] The mediatizing of the event was, in fact, its whole point, as Derrida points out:

What would "September 11" have been without television. . . . Maximum media coverage was in the *common* interest of the perpetrators of "September 11," the terrorists, and those who, in the name of the victims, wanted to declare "war on terrorism." . . . More than the destruction of the Twin Towers or the attack on the Pentagon, more than the killing of thousands of people, the real "terror" consisted of and, in fact, began by exposing and exploiting . . . the image of this terror by the target itself. (108)

In short, the attack was not immediately on the immune system, but on the nervous system. And it was carried out by a fabricated, produced image, an "impression" or "spectacle" staged for the world's cameras by the terrorists, exploited by a political faction to declare an indefinite state of emergency, of exemption—that is, immunity—from all the normal niceties of civil liberties and international law, not to mention, from all the legitimate, well-established institutions of its own immune and nervous systems, in the form of its own intelligence services, diplomatic and military experts, and the work of scholars who actually know something about the nature of the threat. What historian Rashid Khalidi calls a "faith-based foreign policy" was the perfect twin of the specter of a faith-based terror. One fanatic deserves, begets, another, and Uncle Sam is cloned as Uncle Osama.[21] Serious medical research into human cloning is banned by the same government that clones terror by declaring a war on it.

It is the "nervousness" of the nervous system, then, that is producing the "autoimmunity" of the immune system. This, of course, is standard medical wisdom about the relation between these two systems. When the nervous system is in a state of panic, anxiety, or depression, or even worse, in a psychotic state, generating hallucinations and paranoid fantasies, the immune system has a tendency to respond inappropriately as well. What is the cure? The first step is to change the images, to declare an end to the War on Terror. The Obama administration made a gesture in this direction by, as it were, "undeclaring" the war on terror by refusing to use the phrase and substituting the euphemism "Overseas Contingency Operations." A change of name is, as every literary scholar knows, a metaphor. "My love is a red, red rose." But it is also a *mere* metaphor. A rose by any other name would smell as sweet, and (as Gertrude Stein observed) "a rose is a rose is a rose." So a change of name is only a beginning, and could actually be nothing but a self-deception if the practices and policies dictated by the name are not also changed.

But both the biopolitical metaphors of the War on Terror, the model of infectious diseases and cancers, on the one hand, and the

autoimmune disorder, on the other, contain the alternate scenario for a strategy we are looking for, namely, a reframing of terrorism as a public health crisis rather than a war. In a rather precise sense this would mean a return to the *literal* basis of the historic origins of the inflationary use of the war metaphor to frame strategies for combating tuberculosis, poverty, and drugs. It would mean, not just a renunciation of the war metaphor, but an embracing of a positive alternative, a strengthening of the immune system, a refinement of tactics for determining the difference between friends and enemies, hosts and parasites, natives and immigrants, and a strengthening of that other central biopolitical component of the body politic, a "healthy constitution." It would mean strong doses of *preventive* medicine in the form of a world system that had strong institutions of international justice, both politically and economically. It would, above all, entail a *deflation* of the war model to its proper proportions, by treating terrorism realistically as a matter of political criminality for which the appropriate treatments are to be found in the body politic's own immune system, its police and intelligence systems, its judicial institutions, its ability to provide a decent standard of living for its own peoples. Military force would thus be a last resort, and primarily focused on peacekeeping and establishing security for endangered populations.

There are, of course, important limits to the application of biopolitical metaphors, and I do not offer them here as a universal panacea. Biopolitics tells us relatively little about the actual, complex motives of historical actors or the myriad issues that confront actual nation-states and political actors. They are, like all images, "good (or bad) to think with," depending on how they are used. They can become what Francis Bacon called "idols of the mind" that lead us astray and demand human sacrifice. But it is important to realize that they cannot be destroyed or purged from political discourse, and the attempt to destroy them simply makes them more powerful, as we have seen in the way that War on Terror has the perverse effect of cloning terror.

So the strategy I have adopted with these images is what Nietz-

sche described as "sounding the idols with a hammer as with a tuning fork." That is, striking them, not with the fantasy of smashing them, but with the goal of exposing their hollowness, and (more important) using them to play a new tune. Biopolitical icons and metaphors have two uses: first, to reframe strategies at the level of very general systems and structures, and second, to focus in on the microtactics appropriate to dealing with terrorism. So-called surgical strikes and high altitude bombing are exactly the wrong medicine, as are the even more intimate and medically charged tactics of torture, to which we turn now.

5 The Unspeakable and the Unimaginable

Whereof we cannot speak, thereof we must be silent.
LUDWIG WITTGENSTEIN

We have met the enemy and he is us. WALT KELLY

My teacher at Johns Hopkins, Ronald Paulson, exposed the depths of the so-called word and image problem, when he drew a fundamental distinction, located in eighteenth-century aesthetics and semiotics, between the "emblematic" image and the "expressive."[1] The emblematic was the image as word, as linked to, determined by, readable in words. The expressive was the obverse—the unreadable, the mute, the indexical—a "regression into primitivism prior to language, or a leap forward to the ineffable beyond language."[2] This distinction then was discovered to inform the spaces of the eighteenth-century English garden, in its development from "poetic" and allegorical garden spaces to the wilder, more open, and de-textualized spaces of the landscape garden and the picturesque.

Paulson's lesson still resonates with me, partly because it reminds us of the fundamentally dialectical character of the word/image problem, the way in which each term simultaneously contrasts itself with and incorporates its partner. The word/image problem is "inside" the problem of the image, and vice versa. I think Derrida would call this an "invagination" in discourse, one that is built into ordinary language.[3] The word as image, image as word; the word as a limit for the image, and vice versa. We see this limiting character most clearly when we note the way "words fail" to capture the density of signification in the image,[4] or conversely we find ourselves unable or forbidden to make an image of that

which we can nevertheless mention or name—God, the infinite, absolute chaos, or the void. We see the invagination of word and image when the allegorical or emblematic image dictates a determinate verbal signified, or (perhaps even more dramatically) when the verbal sign itself, as diagrammed by Saussure, reveals the auditory signifier as the bearer of its obverse, a pictorially rendered *signified* that is embedded within the structure of the verbal sign as a concept or mental image.[5]

The dialectical character of the word/image relation may be seen most clearly, however, when we note that this difference, or differánce/differend,[6] is actually a compound of at least two (perhaps more) differences, one articulated at the level of signs and symbols, the other at the level of sensory perception and production. That is, "word and image" is the name of two fields of relationship that intersect one another in logical space: 1) semiotic relations such as Peirce's symbol/icon (signs by convention and by resemblance, with the indexical sign by cause and effect forming a third space), and 2) sensory relations between the auditory and the visible. We see the interlacing of these two fields of difference in a common expression such as "verbal and visual media," in which the verbal denotes a certain kind of sign (the linguistic) and the visual indicates a kind of sensory channel. Signs and senses are interarticulated in the relation of words and images, and part of our work as analysts is to remain aware of these distinctions even as we observe the weaving of their distinct strands in the fabric of representation. We could go on, of course, to elaborate these distinctions in terms of other categories—Lessing's modalities of time and space, the structural and systemic distinctions Nelson Goodman drew between digital and analogical codes, the archaeological "strata" that Foucault called "the sayable and the seeable," or the Freudian drives that Lacan dubbed the "vocative" and "scopic"—the desire that animates the speaking/hearing circuit on the one hand and the optical/tactile construction of the visual field on the other.[7]

But in this chapter I want to explore a limit approached by both sides of the dialectic, namely, the frontiers of the unimaginable

and the unspeakable, the place where words and images fail, where they are refused, prohibited as obscenities that violate a law of silence and invisibility, muteness and blindness. And I want to take this up in order to bring the ancient topos of word and image to bear on the contemporary issue of terrorism, and the role of words and images in the War on Terror. My further aim is to link the phenomenon of terrorism to contemporary developments in the technology of image-making, developments that we have been summarizing under the rubric of *cloning*.

Just to restate the basic argument of this book: both image-making and war-making have undergone a radical transformation in our time, a transformation that can be summarized in the phrase, "cloning terror." By this I mean, on the one hand, the reproduction or proliferation of terror, often in the very act of trying to destroy it, and, on the other hand, the terror or horror of cloning itself, both as a biotechnology and as a figure for the indefinite duplication of life forms, especially those life forms (such as cancers and viruses) that are seen as bearers of death or threats to identity.

It is important to state at the outset that the categories of the unspeakable and unimaginable are anything but fixed and determinate limits on the domain of words and images, respectively. They are, rather, rhetorical tropes that simultaneously invoke and overcome the limitations of language and depiction, discourse and display. The invocation of the unspeakable is invariably expressed in and followed by an outpouring of words: it is a strategy, as Derrida put it in the title of a classic essay, of "How to Avoid Speaking," while of course *failing* to avoid speaking, and *succeeding* in saying a great deal.[8] The trope of the unspeakable has many names: a rhetorician might dub it a form of *occupatio*, the declaration that one "will not speak" of certain matters, because one lacks time, expertise, etc., a tactic that is usually accompanied by a rather comprehensive inventory of all the things one will not talk about. Or one may adopt the more sublime tones of negative theology and invoke a realm that one "cannot speak of" in a metaphysical and moral sense, because it surpasses human under-

standing. This version of the unspeakable is generally expressed by the moment of silence, the pregnant pause, followed by the rhetoric of apostrophe, of prayer and invocation, the address to that which remains silent, invisible, and beyond language or even imagining: "For never guiltless may I speak of Him, the Incomprehensible!" Coleridge remarks, confessing his guilt and adding to it in the same sentence. At the other end of the hierarchy of the unsayable is John Cage's opening to the *Lecture on Nothing:* "I have nothing to say, and I am saying it"—for forty-five minutes, to be exact.

These figures of the unspeakable or unsayable[9] are condensed into a single axiom in Wittgenstein's famous declaration in the *Tractatus:* "What we cannot speak about we must pass over in silence."[10] Although some commentators claim to know exactly what Wittgenstein meant by this statement, I have always found it to be radically ambiguous. Is the "cannot" based in what he elsewhere called a "metaphysical" can? Is the point that one literally is unable to speak about something because one knows nothing about it, has nothing to say? Is this, in short, something like a grammatical prohibition that says, in effect, "you can speak about this, but your speech will be meaningless, nonsensical, hollow. In that sense, it will not be speech, but merely a noisy form of silence." Or is it, on the other hand, a moral prohibition: I cannot speak of that which I am forbidden to mention; I cannot violate my inner sense of what I should and must say, or refrain from saying. In this latter case, the "cannot" of the introductory clause really becomes synonymous with and anticipates the "must [not]" of the main clause. We might invoke here the first law of Jewish ethics, as articulated by the late philosopher Sidney Morgenbesser: "Can implies don't."

The difference here is between the inability to speak and the refusal to speak, a distinction that might be illustrated by the famous torture scene in the film *Marathon Man* (dir. John Schlesinger, 1976). Laurence Olivier, the Nazi torturer, is interrogating Dustin Hoffman with the aid of a dentist's drill, and he persists in asking Hoffman, "is it safe?" (safe, that is, to retrieve his contraband dia-

monds from a Manhattan safe-deposit box). Hoffman has no idea
what the question even means, much less what the answer is, and
says so, but this does not satisfy his torturer, who interprets his
refusal to answer the question as a sign that Hoffman is conceal-
ing something. Soon Hoffman decides that he had better tell his
torturer what he wants to hear, and reassures him that yes, it is
safe—very, very safe. But of course Olivier is skeptical about this
and continues to torture him, whereupon Hoffman switches tac-
tics and tells him that in fact it is *not* safe, it is very, very danger-
ous. By this point Olivier doesn't know what to believe any more,
and so he carries on the torture (mercifully, for the viewer, in an
unseen—but not unheard—scene beyond the view of the camera)
until Hoffman's will is broken and he is reduced to howling animal
cries of pain, unable to say anything at all. At this point, Olivier is
satisfied that Hoffman "knew nothing—if he had, he would have
talked"—and orders his men to dispose of him.

The significance of this horrific scene is not just the unspeak-
ability of torture—what John Conroy has called "Unspeakable
Acts" in his book by that title.[11] The real horror, as Conroy shows,
is its staging of the unspeakable as conducted by "ordinary means"
(not to mention what Errol Morris calls "standard operating pro-
cedure") in order to force a subject to speak. Olivier plays Szell,
the "Weiss Engel," as a concerned, sympathetic dentist who makes
small talk with Hoffman about his interests as a graduate student
while preparing his instruments. He never raises his voice, but re-
mains cool and clinical throughout the process, as if he is probing
the inside of Hoffman's head to extract its contents, at the same
time that the cinematography is carrying the spectator vicariously
through Hoffman's experience of the unspeakable, and into the
unimaginable (conveyed by a dissolve into audiovisual oblivion at
the moment Olivier drives his drill into a nice fresh nerve). We
have been forcefully reminded by the events and images produced
at Abu Ghraib prison in Iraq that torture rarely produces any use-
ful information, that it has instead a kind of mirroring or doubling
effect in which the victim simply tells the torturer what he wants
to hear. "We have ways of making you talk" is the mantra of the

torturer, but those ways tend finally to producing nothing but an echo of the interrogator's question, and finally, the silence of the body reduced to inarticulate animal cries of pain.

Trauma, like God, is supposed to be the unrepresentable in word and image. But we incorrigibly insist on talking about it, depicting it, and trying to render it in increasingly vivid and literal ways.[12] Certain works of contemporary art are designed to transmit trauma as directly as possible, to rub the spectator's face in the unspeakable and unimaginable. The Holocaust industry now combines trauma theory's cult of the unrepresentable with a negative theology discourse to produce a virtual liturgy of the unspeakable and unimaginable, all rendered in an outpouring of words and images, objects, installations, architectural and monumental constructions.[13] The very term "Holocaust," as Giorgio Agamben has argued, signifies this elevation of the Final Solution from its grisly reality into a divine sacrifice, an apotheosis that produces very mixed results.[14]

So far I have been speaking mainly of the unspeakable and the unimaginable as if they were two sides of the same coin, and indeed, that may be the best metaphor available for modeling their relationship. Saussure talks of the relation between the signifier and signified as the two faces of a coin, and represents them as the two faces of the sign, separated by the coin itself, the bar (or what Peirce would call the index) that both separates and unites them.[15] But what is the relationship between the unimaginable and the unspeakable? How are they different, and how are they alike? Clearly both involve the double prohibition on representation, the "cannot" and "should not" of inability and refusal to speak or show something. But what is the difference between the domains of the unspeakable and the unimaginable? How can we contrast these anti-figural tropes? What are their distinct roles?

In one sense, they play exactly the roles of the signified and signifier, with the unimaginable standing in as the absent signified, the thing that cannot even be conjured up in fantasy as a mental image or concept, what cannot be remembered. The unimaginable is thus a trope for the unthinkable. The unspeakable signifier, on

the other hand, is the outward sign, the utterance or legible mark that must be silenced or erased. The partial erasure of the name of G-d is one symptom of this, as is the use of circumlocutions and periphrases to "talk around" the unutterable name of G-d with phrases such as "Lord of the Universe" or "the most Holy One" or (in the wonderful coinage of William Blake) "Nobodaddy." (The unspeakability of torture, similarly, is preserved by euphemisms such as "enhanced interrogation techniques.")

We might also ask ourselves: which is worse—that is, more awful and terrible and unrepresentable—the unspeakable or the unimaginable? Unspeakability is my candidate. It is the more emphatic, drastic interdiction, precisely because it has the most attenuated, indirect, and weak connection to the act to which it refers. Discussions of atrocity, genocide, torture, and terror are more likely to invoke the trope of "unspeakable acts" than "unimaginable" ones, though both are clearly involved. Is this because the signifier, the mere mention of an act, is further removed from the act than the signified, which is, in a sense the direct representation or image of the act? The signified is the ground of the sign. It is the imprint of the trauma itself, the graphic impression left by the injury, while the signifier is only an arbitrary, conventional sound that signifies an absent cause that left a mental trace behind in memory. Or it is the "transcendental signified," God himself, the ultimate object of negative theology. This God cannot be represented in images, of course, and in fact to do so would be immediately to violate the double prohibition of the second commandment: you cannot and must not make a graven image of God (or, truth be told, of anything else). But the continuation of the commandment to avoid the "vain use" of the name of God is seemingly qualified and softened by the possibility of *talking,* however cautiously and indirectly, about God. The speakable, then, is the weaker, more indirect, more removed form of representation.[16] So if even *it* is prohibited, if one cannot even mention the name of the signified, the danger seems proportionally higher.

But the real contrast between the unspeakable and the unimaginable can only be seen, I think, if we remove it from the outer/in-

ner, physical/mental dichotomy suggested by Saussure's picture of the signifier/signified relation, and put the two sides of the coin out in a public space at the same time. I would like to offer the following simple diagram as a quite literal rendering of the two "faces" of the coin of the unspeakable/unimaginable. I ask you to imagine one face of the coin with two eyes, and a gag drawn across the mouth, the other face showing a mouth, with a blind-fold drawn across the eyes. One face can see but not speak; the other can speak but not see. Muteness and blindness are the two faces of the unspeakable and unimaginable, understood, however, not as natural, physical conditions, but as imposed and artificial. (I set aside for the moment the associated senses of hearing and touch, which, in Lacan's model of the vocative and scopic drive, are required to complete the circuit of each drive, vision as a form of extended touch, and speaking as part of the "phonation circuit" that includes the ears.) I would ask you to keep in mind this double image of the gagged and blindfolded face as a schematic emblem of the torture victim rendered helpless and anonymous in the by now all too familiar images of suspected terrorists wearing hoods. The hood serves as both a gag and blindfold simultaneously, and mir-rors the hood-as-mask that is typically worn by torturers to con-ceal their identity from victims and the public. This blocking of the scopic and vocative drives receives its most literal rendering, of course, in the scenes of decapitation that circulated on television and the Internet at the nadir of the war on terror. These scenes are in themselves "unspeakable" and "unimaginable," even as they symbolize the ultimate interdiction of speech and vision, and are themselves subjected to censorship on American television, while widely circulated on the Internet.

One further thought on the unspeakable and unimaginable: as tropes, they are *turns* in the stream of discourse, swerves in the temporal unfolding of speech and spectacle.[17] The unspeakable and unimaginable are, to put it bluntly, always *temporary*. Which means they exist in historical time as well as the discursive time of the unfolding utterance, or the temporality of personal expe-rience. What was once unspeakable and unimaginable is always a matter of becoming, of a speech and an image to come—often

rather quickly. If I tell you not to think of the face or name of
your mother, you will not be able to prevent yourself from con-
juring up her image and name. Declare that God is unrepresent-
able, and you also declare yourself a representative of the truth
about him; you make a representation, an authoritative declara-
tion, of his unrepresentability. Declare that something is invis-
ible, inaccessible to visual imaging, and someone (usually an art-
ist or scientist) will find a way to depict it.[18] Prohibit something
from being shown, hide it away from view, and its power as a con-
cealed image outstrips anything it could have achieved by being
shown. We should always say, then, this is unspeakable or unimag-
inable—up till now. The law against the representation of some-
thing in words or images must, in effect, always break itself, be-
cause it must name, describe, define—that is, represent—the
very thing that it prohibits. That is why the law is so parsimonious
and discreet in representing that which it prohibits from repre-
sentation. Laws against pornography (unspeakable, unimaginable
acts of lust, sadism, and animality) thus fall back on the "I know
it when I see it" formula, to avoid specifying (and thus inspiring)
the prohibited acts.[19] Both the divine and the demonic, the ulti-
mate good and the ultimate evil, inhabit the extreme zones of the
human imagination of which we cannot or should not speak, and
which we certainly should not depict in visual images.

I hope it is becoming clear what all this has to do with terror,
which fuses the divine and the demonic in a single unspeakable
and unimaginable compound. The terrorist is a holy warrior or a
devil, depending upon your point of view, or your historical posi-
tioning (yesterday's terrorist is today's hero of the glorious revo-
lution). Terror is also the deliberate combining of the semiotics
and aesthetics of the unimaginable with those of the unspeakable.
You can't imagine anyone doing this, going this far? You think the
unnamable horror, the indescribable, unspeakable act cannot be
named, described, and reenacted? Terrorists speak the language of
the unspeakable. They perform and stage the unimaginable. Their
acts as producers of words and images, symbolic forms of violence,
are much more important than their acts of actual physical vio-
lence. Strategic forms of violence such as war or police action are

not essential to their repertoire. The main weapon of terror is the violent spectacle, the image of destruction, or the destruction of an image, or both, as in the mightiest spectacle of them all, the destruction of the World Trade Center, in which the destruction of a globally recognizable icon was staged, quite deliberately, as an icon in its own right. The people consumed with the image are collateral damage, "enemies of God" who are of no interest. Or they are holy sacrifices, whose innocence is precisely the point. From the standpoint of the terrorist, their innocence makes them appropriate sacrificial victims. From the standpoint of counterterror, their innocence confirms the absolute, unspeakable evil and injustice of the terrorist cause. (There is, of course, the intermediate, compromise position common in state terrorism known as "collateral damage," which expresses regret for the loss of innocent life, but claims nevertheless a statistical kind of justice in [often] unverifiable claims about the number of guilty terrorists killed; see the previous chapter on the very high percentage of innocent civilians killed by bombing and drones.) Either way, the point of terrorist violence is not the killing of the enemy as such, but the terrorizing of the enemy with a traumatizing spectacle. "Shock and awe" are the tactics that unite nonstate with state terrorism, and in both cases the traumatic spectacle can be rationalized as a humane act of restraint. Instead of killing large masses of people, it is sufficient to "send them a message" by subjecting them to shocking displays of destruction.[20]

Terrorism, then, is a war of words and images carried by the media, a form of psychological warfare whose aim is the demoralization of the enemy, and not the direct destruction of military personnel or equipment.[21] I don't mean by this that it is not a real war, but that it is an updated version of a very old kind of war, which is conducted mainly by symbolic gestures of violence, attempting to conquer the enemy through psychological intimidation rather than physical coercion. Terrorists do not occupy territory. They de-territorialize violence, making it possible for it to strike anywhere. The randomness and unpredictability of terror, coupled with its sense of overdetermined symbolic significance, produce a different kind of battlefield, one that has no front or

FIGURE 11.
"Uncle Osama." Anti-
war advertisement in
the *New York Times*,
(September 25, 2002).
Courtesy of TomPaine
.com.

back. Of course all this means that conventional military means, most especially prolonged conquest and occupation of territory are absolutely useless against terrorism (just as the talking cure of psychoanalysis is worse than useless against psychosis). The whole notion of a conventional, military "war on terror," in this light, is quite incoherent, confusing one kind of war with another. It is the sort of asymmetrical warfare that is doomed, not just to failure, but to actually strengthening the enemy against which it is waged.

The futility and incoherence of the war on terror became spectacularly evident in the unspeakable and unimaginable spectacles emerging from the U.S. invasion and occupation of Iraq. But it was already anticipated by an image that eloquently predicted the outcome of the invasion. This was a parody of the Uncle Sam poster circulated in American newspapers by Common Cause, showing the figure of "Uncle Osama" bin Laden, pointing his finger at potential recruits, and declaring "I want you—to invade Iraq." This image condensed in a single potent figure the intentions of

al Qaeda, explicitly articulated, as the U.S. counterterrorism czar Richard Clarke noted, in the writings of Osama bin Laden: "The ingredients al Qaeda dreamed of for propagating its movement were a Christian government attacking a weaker Muslim region, allowing the new terrorist group to rally jihadists from many countries to come to the aid of the religious brethren."²² This dream came true in Iraq. Uncle Osama propagated his movement by impersonating Uncle Sam calling American youth to a holy war for democracy and freedom, a crusade against Evil. The national icon of American military mobilization is mirrored by its uncanny double or Evil Twin, the arch demon of terror. One can hardly imagine a more perfect updating of Walt Kelly's famous line in the *Pogo* comic strip: "We have met the enemy and he is us"—which in this case, perhaps should be rewritten, "U.S."

But it is also a perfect emblem of the autoimmune character of the invasion of Iraq. The immune system, you will recall, works by trial and error, cloning new antibodies until it finds one that matches the invading antigen in the way a key matches a lock. This is the process that goes on when the body is searching for the right antibody to fight off a common cold. When the right fit is discovered, the immune system duplicates those antibodies by cloning them and remembering the shape of the "key"; this is in fact what immunization amounts to. The antibody is not identical to the antigen; it is its mirror opposite or negative double. In this case, Uncle Sam, the personification of the American immune system (its military) is transformed into Uncle Osama, the enemy of the body politic and its constitution. The Common Cause image not only brilliantly captures the perverse ignorance of the Bush administration in falling into the trap laid by al Qaeda, but it also exposes to view the systemic biopolitical logic that underlies the entire ruse.

This brings me back to the issue of cloning, which might at first glance seem to be quite remote from the problem of the unspeakable and the unimaginable, much less the question of terror. And yet the clone is, as we have seen, the key figure that circulates between words and images in *our* time of terror. Cloning

is, to repeat the testimony of Leon Kass, the former chair of the Presidential Commission on Bioethics, an object of "instinctive horror and revulsion"—a figure for the unspeakable and unimaginable.[23] As we have seen in the discussion of clonophobia, the clone updates of all the ancient phobias about image-making, mimesis, doubling, mirroring, and copying. The original prohibition on the making of "graven images," given to Moses on Mount Sinai, is really a law that aims at heading off the production of living images, artificial life forms, the most potent and virulent of which is the idol, the image that condenses the collective desire for a representation of the unrepresentable God.[24] The clone is, in short, the living image of the unimaginable in our time, and it is very difficult to speak of it without lapsing into the same tones of metaphysical and moral certainty that inform discussions of terrorism.[25] The uncanny mirroring of the figures of the clone and terrorist as hooded and masked, respectively, united in their faceless anonymity, unites them as twin icons of the unimaginable. Together they personify twin anxieties about the production and destruction of living images, respectively: The clone incarnates the horror of the biological simulacrum, the uncontrolled proliferation of organisms associated with cancers, viruses, plagues, and autoimmune disorders. The terrorist is the figure of iconoclasm and the destruction of living images, literally in the form of human bodies, metaphorically in the destruction of monuments. Clone and terrorist unite in the image of what Giorgio Agamben has called "*homo sacer*," the human being that may be dismembered for its spare parts, tortured for its hidden knowledge, and killed or sent on suicide missions.[26]

The images of the clone and terrorist exemplify the new symbolic complex that I call the "biopicture," a fusion of new technoscientific images and the literalization of image-fears (especially religious) that have emerged in the epoch of the war on terror and the clone wars. We have already been discussing this concept in relation to biopolitical models of the social grounded in figures of autoimmunity and infectious disease, the master metaphors that depict terrorism as an alien invasion, on the one hand, and

an internal threat, on the other, as well as the clone as an impious abomination, on the one hand, and as a violation of natural law, on the other. I want to turn now to what might be called the "musée imaginaire" of the War on Terror, a gallery of concrete, visible biopictures. These are the images that punctuate and constitute the memory archive of the war. Some of them, like the destruction of the twin towers, are unforgettable. Others (Colin Powell's phantom truck; Saddam Hussein's dental examination; Mission Accomplished action figures; Bionic Abu Ghraib Man; the iRaq/iPod) are probably forgotten by most people, but they survive in archives and sometimes in works of art. Still others, primarily the Abu Ghraib photographs, periodically sink out of sight and then return, almost seasonally, like the obscene Christmas presents that spill out of the parents' closet in Norman Rockwell's *The Discovery* (see fig. 1).

Many of these are images we would prefer to forget. They brought unspeakable and unimaginable things into view. They also disclosed the ordinary, the everyday, the normal—what turns out to have been "standard operating procedure" (to recall the title of Errol Morris's documentary on Abu Ghraib)—and the more documents that emerge to explain them, the clearer it becomes that these procedures came from the very top of the U.S. government. Why look at them now? Hasn't everything already been said about them? On the contrary: the Obama administration's understandable desire to look toward to the future has colluded with the amnesia of the mass media and the all-too-human tendency of a people to disavow responsibility for the terrible things that have been done in their name. That is one of the things we mean when we call something unspeakable and unimaginable. But American citizens have a moral obligation to face these images for whatever shocks of recognition they may provide. At the very least they may serve as diagnostic instruments to understand a historical nightmare from which the United States and the world is still trying to awaken. That which we could not have imagined has become all too imaginable, and the unspeakable has become that of which we are compelled to speak.

6 Biopictures

Pictures, like specimens, are the vehicles of images which, like
the species' gene pool, constitute the set of replicators that are
the species. Under this concept it is the images that are formally
alive, though for most practical, day-to-day purposes the image
replicator and its picture vehicle are inseparable.
NORMAN MACLEOD, "Images, Tokens, Types, and Memes:
Perspectives on an Iconological Mimetics"

Those images that fresh images beget. **W. B. YEATS**

In 1992, I coined a phrase, "the pictorial turn," that has been widely
adopted in the criticism of culture, society, and politics.[1] My idea
(hardly an original one) was that the image had become a conspicu-
ous problem, both in popular culture (where "image is everything"
was the mantra of the day) and in the study of the arts, the media,
cultural theory, and philosophy, where a turn from language to the
image seemed to be occurring. Richard Rorty's "linguistic turn,"
in other words, was being succeeded by another shift, this time to
pictures, images, and iconic signs across the media. The idea was
given other elaborations—the "iconic turn" of Gottfried Boehm,
and the "visual turn" of a newly invented proto-discipline called
"visual culture" or "visual studies."[2]

 The concept of a pictorial turn was thus a hybrid notion, com-
bining an idea of a specific historical event with that of a recurrent
phenomenon, one that may be a permanent feature of human so-
cieties. That is, the anxiety over images and pictures, the worry
that people are "turning" toward a false, seductive, and danger-
ous image, seems to be a perennial cultural phenomenon, one
that could be found throughout history, from the taboo on image-
making expressed in the second commandment, right down to the
contemporary debate about cloning. It's important, then, to un-
derstand the pictorial turn as *both* a synchronic and diachronic
notion, a recurring phenomenon, yet one that never takes exactly
the same form. The invention of artificial perspective in the Re-

naissance and the invention of photography in the nineteenth century are both versions of the pictorial turn, and yet they took place in substantially different ways.

A new version of the pictorial turn has taken place in the last twenty years or so. It is a turn toward the "biopicture," or (more precisely) the "biodigital picture," the icon "animated"—that is, given motion and the appearance of life by means of the techno-sciences of biology and information. The twin inventions of computers and genetic engineering have produced a new twist in the ancient trope of the pictorial turn, and especially in that aspect of images that has likened them to life forms—and vice versa. It is important to see that it is not just that images have always been compared to life forms, but that life forms have just as routinely been compared to—even constituted as—images, most notably in the concepts of "species" and "specimen," terms whose "specular" roots reveal the centrality of visual imaging to taxonomy.[3] The metaphoric relation of images and organisms is bidirectional, in a manner strikingly similar to the bidirectional metaphoricity of biological and social bodies. Images are imitations of life. And life forms are "specular" entities linked by visible homologies of form: we can *see* at a glance that one oak leaf is like another, one horse like another, and that they belong to the same general class despite the numerous individual differences among members of the class. Species, then, are like the generic images that pick out types and stereotypes that can be repeated in different individual specimens. Those specimens, in turn, are like *pictures,* that is, concrete, material instantiations of a species/image. When we say that a child is the image of its parent, we are invoking the same metaphor, this time in terms of what Wittgenstein called "family resemblance" rather than the more general similarity of members of a species.[4] Images are thus to pictures as species are to specimens, or as families are to members.

The foundational trope of the biopicture has obvious resonances with what Michel Foucault called "biopower" and "biopolitics," the transformation in politics that he associates with the governmental control of bodies and populations. When modern

nation-states move toward a concern with enhancing and controlling the "life" of their populations (as distinct from the traditional negative power of the sovereign over the instruments of death), we have entered, argues Foucault, into the age of biopolitics.[5] From the standpoint of the concept of the biopicture, this is an updating of a fundamental condition of the political, the production and exertion of power over living beings, one that is sensitive to the emergence of new political institutions such as representative democracy, neoliberal economics, and fascist totalitarianism with its emphasis on racial eugenics. But it is also sensitive to the rise of new technologies, and especially informational and biological technologies that provide opportunities for the engineering of both individual bodies (reproduction, sexuality, and genetic manipulation) and of populations through statistical tracking of diseases and genetic disorders. The body becomes the site of increasingly drastic intervention at the same time that populations are reduced to databases. But the most dramatic and symbolic innovation of this sort has been, as I have argued, the invention of cloning, which combines the revolution in information science with the one in biotechnology to inaugurate an age of "biocybernetic reproduction," one that promises to literalize and technologically realize many of the premonitional fantasies of biopower and biopolitics. At the level of image-making, this innovation is heralded by the arrival of digital imaging, which has a revolutionary effect on visual representation as profound as the invention of chemical-based photography had on manual image-making. In the space of less than two centuries, human beings have moved from handmade to mechanical to digital image production with fateful consequences for media and for everyday life, as well as for the very concept of the image as such. The principal symptom of this transformation is what I want to call the "biodigital picture."

The arrival of the biodigital picture was announced in the first blockbuster film of the 1990s in a science fiction fable about cloning. Stephen Spielberg's *Jurassic Park* condensed the whole conception into a memorable scene of biocybernetics run wild.[6] The moment is captured in a still image from a scene showing a veloci-

FIGURE 12. Still from Steven Spielberg's *Jurassic Park* (1993) depicting a "digital dinosaur," or a velociraptor with DNA coding projected onto its profile.

raptor with the letters of the DNA code projected on its skin. In the film narrative, the raptor has just broken into the computer control room of the dinosaur park, and has accidentally turned on the film projector loaded with the park's orientation film. The letters of the DNA code that governs the cloning of the park's dinosaurs are being projected onto its skin. The still thus captures in a single image the entire premise of this film: that dinosaurs have been cloned from extinct DNA, and creatures that previously existed only in pictorial or sculptural recreations have now been literally resurrected from, not just death, but species extinction. These are not merely "ghostly" or even material reanimations of the dinosaur as image, in other words, but all too real, embodied, and fleshly.

But of course we know at the same time that this "literal" and "real" reanimation is only a fiction, and these images are merely shadows on a screen. The images *fore*shadow a possible future[7] in which extinct animals could be brought back to life by cloning; it does not show a present actuality.[8] The present actuality that it does suggest implicitly is the very real technical breakthrough in

cinematic animation that occurred during the making of this film. *Jurassic Park* pioneered the transition from analog animation techniques based in robotics, animatronics, and Claymation to digital animation, the process that has made it possible to move seamlessly from "live action" to animation, and has brought a whole genre of feature-length animated films into existence. The revealing of the code of life on the dinosaur's surface suggests, by analogy, the revealing of the digital codes that make its cinematic animation possible. (We might recall here that dangerous key on early computers labeled "Reveal Codes," which dramatically revealed to the innocent user the labyrinth of ASCII codes that lay just beneath the surface of the verbal or visual signs she was manipulating.) So far as I know, this is the first explicit avatar of the biodigital picture, or simply the "biopicture," understanding that this refers to the new conditions of image-life in the age of biocybernetics,[9] the times of cloning and computing. The biopicture, then, is the fusion of the older "spectral" life of images (the uncanny, the ghostly) with a new form of technical life, epitomized by the contemporary phenomenon of cloning and the development of digital imaging and animation.

As it happens, this first instance of the biopicture is also an image of terror. The very name of the animal, "dinosaur," combines the Greek words for terror (*deinos*) and lizard (*sauros*) to form the name of the "terrible lizard." And the particular species we are observing in this scene is the velociraptor, a new model digital dinosaur that can manipulate door handles with its clever fingers, and is, in contrast to the older, more familiar species such as the *T. rex*, not a symbol of obsolescence, but of contemporary innovation and rapid adaptation. The raptors are the new, up-to-date forms of terror, appearing in a cinematic animal fable well in advance of their appearance as the enemy in the War on Terror.

What happens when the biopicture encounters the Global War on Terror? The most obvious result is that the role of images in war is multiplied exponentially. Images migrate around the planet at blinding speed; they become much more difficult to quarantine or censor; and they are subject to more rapid mutation than ever be-

fore. If human bodies carrying microbes circumnavigate the globe more rapidly than ever in the age of air travel, leading to periodic outbreaks such as SARS and swine flu, the global circulation of digital images on the Internet is even more virulent and rapid. It is no wonder that the circulation of images in the age of the bio-picture is often compared to an infectious disease in which the invasive life forms are growing and mutating more rapidly than our defenses can evolve to fight them off. Indeed, the paradox of the overuse of antibiotics is that they can accelerate the evolution of dangerous bacteria by weeding out weaker strains, leaving the resistant bacteria to reproduce more rapidly. Like the War on Terror, the war on disease can, if not conducted judiciously, actually have the effect of making the enemy stronger. But the most common metaphors for the spread of terrorism are, as we have seen, also based in disease such as viruses, cancers, sleeper cells, and autoimmune disorders. It is as if terrorism and cloning, like life forms and images, were locked in a relationship of mutual analogy.

The terrorist and the clone, then, are the mutually constitutive figures of the pictorial turn in our time. That is why, as we have noted in the preceding chapters, the terrorist is often portrayed *as* a clone, a faceless automaton, masked and anonymous, a mindless, pathological, and suicidal life form comparable to a virus, a cancer, or a sleeper cell that "incubates" inside the body of its host, turning the body's defenses against itself in what I have been describing as a sociopolitical form of autoimmune disorder.[10] The clone, in turn, embodies a host of ethical, religious, and aesthetic horrors: the reduction of human beings to mere instrumentalities or commodities (what Giorgio Agamben calls "bare life");[11] the impious effort to "play God" with technology; the specter of reproduction without sexual difference that leads quickly to fantasies of unleashed homosexual reproduction; the figure of the macho gay male (popularly known as a "clone") who subverts the reassuringly distinguishing stereotype of the dandy or sissy;[12] the specter of abortion raised by the technique of cloning, which involves the destruction of what some regard as an embryonic organism in order to create a new life form; the specter of the "monstrous double"

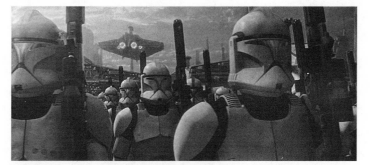

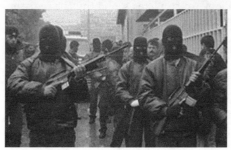

FIGURE 13.
Still from George Lucas's *Star Wars, Episode II: Attack of the Clones* (2002) depicting the advance of the cloned storm troopers.

FIGURE 14.
Masked Palestinian fighters (Google Image Search, June 2004).

or "evil twin" who perfectly simulates the "donor" or "parent" organism, and threatens to replace it with a new race of aliens, mutants, or replicants.[13]

The masses of anonymous storm troopers who march off to their deaths in George Lucas's *Attack of the Clones* are an updating of the old modernist fear of the crowd and the masses.[14] The modern idea was that individuals in a crowd would lose their individuality, but regain it when they left it. With the cloned masses, no such departure is possible; even singly, in private, all the members of the cloned army are identical twins. It is, moreover, not just that they *look* alike or are uniform in outer behavior and dress, but that they *are* alike, deep copies of one another at the level of the invisible genetic code that constitutes them. "They" are not clones (plural); "they" are "a" clone (collective singular).

The real horror of the masked storm troopers, then, is not that there is some monstrous face concealed under the mask, but that when the mask is taken off, the face might be that of a perfectly

ordinary person who could mingle among us, turning us against ourselves. As I noted in chapter three, "Clonophobia," the figure of Dolly the Cloned Sheep is not frightening because she is a wolf in sheep's clothing, but because she is a *sheep* in sheep's clothing, impossible to distinguish from the "real thing" by visual, or even genetic, examination. The clone represents an even deeper threat than easily profiled aliens or "racial others" who "all look alike," as the racist stereotype would have it. The clones do not necessarily look like each other (thus, no profiling stereotypes are available), but they may very well look exactly like *us,* and thus be indistinguishable and unclassifiable. Like terror, cloning takes the logic of the image as a figure of resemblance, similitude, and copying to the limit of virulence, toxicity, and insidious invisibility.

Perhaps the most vivid fantasy of the terrorist as clone (and vice versa) is a report in the online tabloid *Weekly World News* that the "mad mullahs of Iran and Syria" are cloning "toddler terrorists" from "the DNA of ruthless SS men who once formed Adolf Hitler's elite bodyguard."[15]

CIA "sources" (unidentified) are quoted to emphasize that "the most insidious part of the scheme is that these killers won't look like Arabs, and no traditional form of racial profiling will work to screen them." This "invincible army of 'superior' German warriors" will be trained to speak English with an American accent. A "respected Israeli historian and intelligence expert," Aviv Shimson, supplies the connections between Nazi Germany and Middle Eastern terrorists, reminding us that one of the most "notorious allies" of the Nazis was Haj Amin el-Husseini, the Grand Mufti of Jerusalem. Islamic fascism's anti-Semitic and anti-American alliance with Nazi Germany was only waiting for the technical breakthroughs of human cloning to produce its invisible Aryan army.

Bizarre as these associations of cloning and terrorism may seem, they would not have any efficacy if they did not engage some level of historical reality and collective fantasy in the American populace. As noted in chapter 2, the onset of the current epoch of terrorism in 2001 was launched in the context of a national debate in the United States about cloning and stem cell research. The

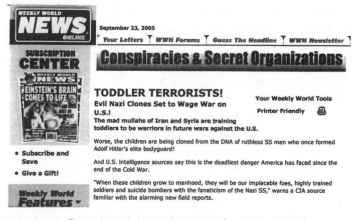

FIGURE 15. Excerpt from *Weekly World News Online* (September 23, 2005).

cloning issue was temporarily buried by the onset of the terrorist attacks, but it seemed to hover over the ruins of the World Trade Center, as if the gray dust that hung in the air for weeks after their destruction contained traces of the DNA of the victims. See the photographic collage by Kevin Clarke and Michael Collarone (fig. 18 below) for a graphic literalization of this image.

The War on Terror and the Clone Wars converge, then, at the level of image and metaphor, circulating between tabloid fantasies, on the one hand, and the sober deliberations of the Presidential Commission on Bioethics, on the other. To describe these as wars of or on images is in no way to deny their reality. It is, rather, to take a realistic view of terrorism as a form of psychological warfare, specifically a use of images, and especially images of destruction, to traumatize the collective nervous system via mass media and turn the imagination against itself. It is also to take a realistic view of cloning as, on the one hand, an actual biological process and as the object of fantasy, fiction, and metaphor—especially as a metaphor for image-making as such.

If the War on Terror was launched by the production of an image of destruction on 9/11, it was conducted by a whole series of iconic moments, from the conquest of Iraq to the images of torture taken in Abu Ghraib prison. I want to trace a pattern in these

images that expresses the logic of the biopicture. This is not just a matter of attending to their vitality as a function of Internet circulation. It also has to do with the form and content of the images, specifically, the figure of the terrorist as clone in the sense of an indefinitely multiplying organism, and (even more disturbing), as a "double," twin, or mirror image of the warrior against terror; the spectacle of terror as iconoclasm, the destruction and mutilation of images (architectural, sculptural, and bodily) as, paradoxically, the *production* of a new image in a staged spectacle or "photo op"; the recurrence of the headless, faceless, and hooded figure, or what Jean Baudrillard has called the "acephalic clone," a mindless repository of "spare parts" or an automaton without will or agency; the reduction of the human form to "bare life," and the (usually futile) attempt to censor, prohibit, and contain these reductive images. I will conclude, finally, with a meditation on the Abu Ghraib photographs, which I believe define a certain kind of end to this epoch, though its consequences are still unfolding for us as I write.

Twins

As though architecture . . . was now merely a product of cloning.
JEAN BAUDRILLARD

The destruction of the World Trade Center in New York has provided the most memorable image of the twenty-first century so far, destined to join the iconic mushroom cloud as the principal emblem of war and terror in our time, leaving behind it a space known as "Ground Zero," a label that links it (quite inaccurately) to a nuclear bomb. The "twin-ness" of the towers and their destruction has frequently been noted: the initial doubling of the image of destruction by the two moments of impact and the two moments of collapse, followed then by the indefinite doubling and redoubling of every detail, every conceivable angle of perspective on the disaster. The towers themselves were, of course, understood as iconic forms in their identical twin-ness and their mutual faceless- and headlessness. Jean Baudrillard compared them to bearers of

digital information, the "punch card and the statistical graph," "as though architecture, like the system, was now merely a product of cloning, and of a changeless genetic code."[16] The World Trade Center was already a global symbol, a "world picture" in its own right as well as an epitome of the "biodigital" moment of the pictorial turn.[17] Its destruction had been foretold since the moment of its building, staged repeatedly in disaster films, and even attempted in the early nineties.

The destruction of the twin towers was a classic act of iconoclasm (the destruction of the "idol of the other") as the creation of a countericon, one that has become, in its way, much more powerful as an idol than the secular icon it displaced. In this respect, the images of destruction followed precisely the pattern set a few years earlier by the Taliban in their destruction of the Bamiyan Buddhas. The Taliban regarded these quite innocent statues, which no longer have any religious cults associated with them in Afghanistan, as symbols whose idolatrous or fetishistic character was primarily a result of the Western interest in their preservation. A young Taliban intellectual toured the United States shortly before their destruction, patiently explaining that the reason for blowing them up was simply "because the West cares so much about them."[18] Their destruction was a poke in the eye of the West, and it became the subject of photographic reproduction by the Taliban themselves in proudly displayed calendar art.[19] Despite their fundamentalist prohibition on cameras, photographs, and graven images, the Taliban were happy to make an exception for images of destruction of the Buddhas, demonstrating one of the fundamental logics of the biopicture: the destruction of an image may also be the production of an image.

This logic was also at work in the American treatment of the destruction of the twin towers. The site was immediately declared "hallowed ground" and the victims apotheosized as heroes and martyrs. This is a process similar to the elevation of the Final Solution from a hideous extermination program into a "Holocaust," a sacred sacrifice, technically, a "burnt offering." The monumentalization of the holy place then proceeded with similar grandios-

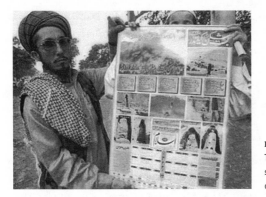

FIGURE 16.
Taliban calendar art
showing the destruction
of Bamiyan Buddhas.

ity, most notably in Daniel Liebeskind's proposed (and since abandoned) "Freedom Tower," which, exactly 1,776 feet high, and with features such as the "Park of Heroes," the "Garden of the World," and "Memory's Eternal Foundations," would have surpassed even his Jewish Museum in Berlin as a coercively allegorical contribution to the trauma industry.[20]

But it never will be built, and the adequate monument to 9/11 is still, eight years after the event, not in place. The incomplete memorialization of this event testifies to a failure to mourn, an inability to find a way to let go and remember at the same time. It is somehow appropriate that the site remain unfinished, that architecture fails to triumph, while in its place stands a perpetual work in progress—and occasional regress. Even when the inevitable structure rises on the site, it is likely to remain a wound, an unhealed and unresolved trauma waiting to be reawakened.

Perhaps this is why the principal mediation of the site is pictorial. Everyone carries with them some imprint of the images of destruction—the collapse of the towers, the image of the second plane, the falling bodies, the tangled ruins. Everyone recognized the ways in which these images reminded people of things they had already seen at the movies. When images fail like this we can call it the sublime from an aesthetic perspective, or melancholy from the standpoint of psychology. Perhaps they come to the same thing at some level. For Freud, it is the failure to mourn that leaves only melancholia, an inability to let go, to bury the dead, to re-

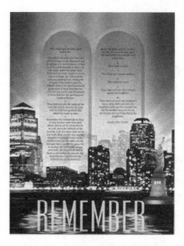

FIGURE 17.
Pastor Antony Mavrakos, "Remember"
(n.d.). Graphic of the twin tablets of the
Ten Commandments as a memorial
for the New York World Trade Center
twin towers. Courtesy of Pastor Antony
Mavrakos.

turn to the living. It is not that this trauma, any more than the Holocaust, is incapable of being represented. The problem is just the reverse: too many representations, too many images and bad dreams, and no way to arrive at a consensus, a communal acceptance.

The clearest symptom of this lack of resolution was the mobilizing of 9/11 as a divisive "wedge issue" in American politics. Consider, for instance, a proposed "virtual memorial" posted on the Internet by Pastor Tony Mavrakos. The proposed memorial replaces the twin *towers* with the twin *tablets* of the Ten Commandments, accompanied by the following commentary by Pastor Mavrakos:

We are providing this picture FREE so you can get it into people's hands, homes and hearts. This is the actual skyline of New York City where the Twin Towers once stood. They're gone but standing where they once stood are two other Twin Towers that no one can take down, including terrorists, the American judicial system, the ACLU or the American Atheists: the Ten Commandments.

Your brother in Christ, Pastor Tony Mavrakos[21]

Pastor Mavrakos nicely encapsulates the deeply religious and political rhetoric that launched the War on Terror as a holy war

whose daily intelligence briefings from the Department of Defense were prefaced by stirring biblical quotations.[22] It also makes clear that the War on Terror was not only directed at foreign enemies, but was a struggle against internal enemies, an autoimmune disorder that treated the American judicial system as somehow in league with the terrorists, a view that has been revived in the reaction to the Obama administration's decision to proceed with criminal trials for terrorists. Pastor Mavrakos's memorial illuminates vividly the fundamentalist paradox we have seen with the Taliban's images of the destroyed Buddhas. The second commandment forbids the making of graven images, especially those that become the object of worship. Mavrakos's virtual memorial has the effect of rendering the tablets containing the law that prohibits idolatry into an idol.

The image that best captures the melancholia around 9/11 and the twin towers is the photo collage by Kevin Clarke and Mikey Flowers of the ruins overlaid by the dust-filled scrim inscribed with the DNA code.[23] Flowers, an emergency medical technician, took the pictures of the smoldering ruins in the days immediately following September 11, and Clarke (an artist who also lives in lower Manhattan) overlaid the image with the letters of the DNA code (a practice he had been using for a number of years to create what I would call "deep portraits" or "biopictures" of human subjects).

This image evokes the longing for traces and relics of the victims that was so vividly evident in innumerable informal memorials that attached themselves to the site, and throughout lower Manhattan. But it recodes this longing as a desire for *literal* biological reanimation, just the reverse of the funerary liturgy, "ashes to ashes, dust to dust." The implicit logic of *From Dust to DNA*, by contrast, leads on to "from DNA to cloned resurrection." Or if not resurrection, at least identification of the particular victim whose dust has been reclaimed. More ominously, the DNA/dust equation suggests the toxic character of the lingering atmosphere that hovered for weeks above Ground Zero, damaging the lungs of the rescue workers who rushed to the site. If the inability to bury the dead properly leads to melancholy, it also had a physically patho-

FIGURE 18.
Dennis Grady, "Dust to
DNA," Photo montage,
2001. From *Mikey Flow-
ers 9/11 Ashes to Ashes,
Dust to DNA* by Kevin
Clarke and Michael
Collarone.

logical effect on those who found themselves literally breathing in
the remains of the dead. The Clarke/Flowers image is a reminder
of the biodigital picture that was already inscribed in the twin tow-
ers, their monumental flaunting of doubleness, twin-ness, and ar-
chitectural cloning, and hints at the ironic coincidence of clon-
ing and terror in the summer of 2001. While the men of al Qaeda
were making their final plans, while Richard A. Clarke, the head
of U.S. counterterrorism, was vainly trying to get the attention of
the White House to warn them of the impending threat, the Bush
administration was preoccupied with stopping the dangerous ac-
celeration of biomedical research in cloning.[24]

Bioterrorism and the Phantom Truck

All terrorism is bioterrorism in the sense that, although the *end*
may be a spectacle and an iconized event, the *means* are gener-

ally invisible. Literally, bioterrorism is the use of invisible chemical and biological weapons—anthrax comes to mind, but also archaic techniques like well poisoning, or biocybernetic crimes such as identity theft and the spreading of computer viruses. But the chief characteristic of terrorism *tout court* is the invisibility of its instruments and agents, whose aim is to pass through all systems of surveillance without detection. And it is not inconceivable that a future terrorist attack might completely forgo the element of spectacle in favor of an unseen disaster (e.g., the crippling of the nation's power grid) that would, quite literally, plunge the country into darkness and cut off all access to the media spectacle. Derrida (see the discussion of "Autoimmunity," chapter 4 above) predicted that the next attack after 9/11 would not be spectacular and graphic, but that it would come invisibly. And as we have seen in the discussion of the "unimaginable" (see chapter 5 above) the invisible and the unseen has, paradoxically, a greater power to activate the power of imagination than a visible image. This is a principle well established in horror films, where it is crucial to withhold visual access to the monster, to keep it hidden in darkness for as long as possible, delaying its visible appearance for the right moment of shock and recognition.

In a figurative sense terrorism is always an exercise of biopower in its reduction of its victims to forms of "bare life," valueless and expendable, signaled by its indifference to distinctions such as combatant and noncombatant. And it calculates on a poisoning, not necessarily of the physical body of particular individuals, but of the body politic and its collective imagination. It presumes the reduction of any group of individuals to be a mere population sample (cf. fruit flies) and aims at producing a shock to the collective nervous system of this body. Invisibility is thus, not just a feature of literal bioterrorism, but a crucial property of terrorism as such. The idea is to turn the imagination against itself by provoking a psychotic state, triggering the immune and nervous systems to overreact.

So how do we imagine the invisible? How do we fill in the blank space in consciousness where terror dwells? This was a problem that faced the Bush administration early in the launching of the

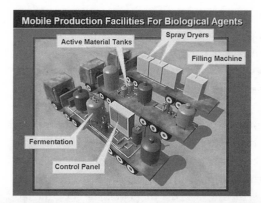

FIGURE 19.
"Mobile Production Facilities for Biological Agents." A PowerPoint slide depicting a mobile chemical weapons laboratory used by Colin Powell in his address to the United Nations (February 6, 2003).

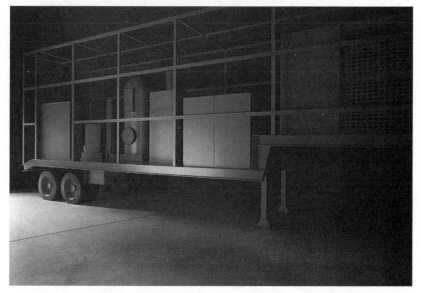

FIGURE 20. Inigo Manglano-Ovalle, *Phantom Truck*. Installation at Documenta 12, Kassel, Germany, 2007. Courtesy of the artist

War on Terror. Conjuring with the image of a "smoking gun" in the shape of a "mushroom cloud" was not enough.[25] One needed an image of a clear and *present* danger, something that would be by nature designed to elude detection, at the same time that it would provide an ominous sense of concrete materiality and documented authenticity. This image was provided by none other than Colin Powell, who tried to clinch the case for the invasion of Iraq

with a PowerPoint slide "reconstructing" the "Mobile Chemical and Biological Weapons Laboratories" of Saddam Hussein. This image had the advantage of creating a visible, iconic counterpart to the widely disseminated stories of Hussein's use (with tactical assistance by the United States) of poison gas against his own people back in the 1980s.

But I am less interested in the fraudulent character of this image (the actual truck turned out to be designed for launching weather balloons) than I am in the perfection of its design for this specific historical moment. It was the Platonic form of contemporary bioterrorism, as artist Inigo Manglano-Ovalle recognized when he reconstructed it as a work of installation art at Documenta 12. The truck was reconstructed at actual size, fabricated out of epoxy to make it resemble the schematic, constructed image in Powell's slide, which was clearly not a photograph of a real thing, and placed in a cavernous dark room. This room (which Manglano-Ovalle explicitly compared to a Platonic cave) could be entered by two routes: 1) a curved corridor that allowed one's eyes to gradually adjust as one approached the phantom truck, and 2) a dazzlingly bright room with a desertlike feel, on the floor a tiny radio emitting incoherent sounds. This latter passage made the subsequent encounter with the truck even more phantomlike, and suggested a stark contrast between the "Desert of the Real" and the shadowy world of imagination.

What is the point of Manglano-Ovalle's work? Is it just to make a three-dimensional political cartoon? (Not that there is anything negligible about brilliant political cartoons.) Or is it rather to monumentalize and memorialize the precise image that launched the war, the invisible counterpart to the visible spectacle of 9/11, the *casus belli* that provided the missing link between Iraq and al Qaeda, replacing Osama bin Laden with the visible enemy, Saddam Hussein? A monumental deception deserves an equally monumental commemoration, one that is designed not merely to remind, but to provide an analytic mechanism for diagnosing the operations of a toxic image, an entirely phantasmatic icon that was transformed into a material cause by subsequent historical events.

Saddam's Imaginary Army

Imaginary weapons require an imaginary army to wield them, and this was provided in abundance by Saddam Hussein. Commentators are divided over the question of why Hussein pretended to the last that he had a far more formidable military machine than he actually possessed. Realists were insistent that a decade of sanctions had weakened Iraq's forces considerably, and all the objective evidence suggested that he had no real capability of mounting a nuclear attack, or a long-range offensive of any sort. But Saddam and the American neoconservatives were united in their hostility to realism; the former lived in a fantasy world of omnipotence, and the latter shared that worldview insofar as they imagined American military power could be used to "create new realities" anywhere it chose.

A remarkable mural painted on an overpass on the road to Tikrit during the invasion of Iraq made this massive *folie aux deux* graphically evident. The painting (which was reproduced in a number of press photographs at the time) shows Saddam's army emerging as a stream of military might from the doors of a mosque or Mazar, rather like George Lucas's fantasy of the clone army emerging from the womb of the mother ship in *Attack of the Clones*. In the latter case it is biotechnology that breeds the massive army; in the former it is a religious crusade, or rather a countercrusade that combines images of massed Arab armies combined with the latest in high-tech weaponry.

The photograph vividly displays the fundamental contradictions of the whole invasion of Iraq understood as a war of images. First, there is the photograph's revelation of the fantasmatic character of Saddam's military machine, which is quite literally being penetrated and bypassed by a lone American Humvee speeding its way toward Tikrit. One could hardly ask for a more telling confirmation, both of Saddam's own delusions of grandeur and Donald Rumsfeld's equally delusional picture of easy conquest of Iraq made possible by light, rapid-strike forces, of which the thinly armored Humvee is the central icon. If the photograph seems to reframe the imaginary army inside the actual force of the real one, there is a detail in the mural painting that prophesies the

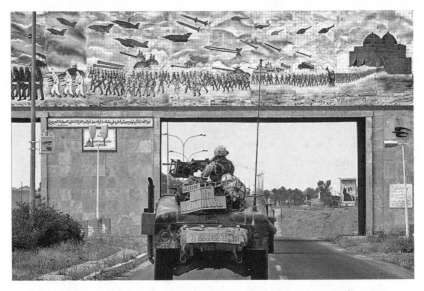

FIGURE 21. "U.S. Marines . . . roll toward Tikrit," from the *Chicago Tribune* (April 15, 2003). Stephanie Sinclair's photo depicts Saddam Hussein's "Phantom Army" in the mural overhead. Photograph courtesy of *Chicago Tribune*/PARS International Corp.

reality that was about to unfold before the U.S. invasion force. In the front ranks of Saddam's army are the ranks of hooded storm troopers in black and white uniforms. These figures foreshadow the real, as distinct from the imaginary, threat to the invaders, namely, the invisible, anonymous warriors and suicide bombers of the insurgency that will be largely manned by the dispersed host of Saddam's regular army. And this reading also undercuts the seeming invulnerability of the speeding Humvee, which will rapidly be transformed from an imaginary figure of American technical supremacy into a real death trap, a highly vulnerable target for IED (improvised explosive devices) and roadside bombs. If the Cold War was dominated by the acronym MAD (mutual assured destruction), one might characterize the first major military conflict of the twenty-first century as a scene of Mutually Assured Deception, with both sides creating double layers of fantasies about their respective enemies and about themselves.[26]

Osama, Saddam, and the Uncanny Double

Only when modeled, shaped, or even cloned from those interacting with them can terrorists become terrorists.

VINCENT RUGGIERO

We have already seen in the figure of "Uncle Osama" as the graphic twin or alter ego of Uncle Sam how the relation of the sovereign state ("Uncle Sam" means "U.S.") and its terrorist antagonist is one of mimetic symmetry, both similar and antithetical at the same time, as in the phenomenon of the "evil twin" or uncanny doppelganger (cf. Dr. Jekyll and Mr. Hyde).[27] But Uncle Osama, hidden in the mountains of Afghanistan, was not a convenient antagonist for the United States. He was merely the recruiter for the real war in Iraq, which had the conveniently demonized icon of Saddam Hussein as its sovereign. It was important to forget, of course, that Saddam Hussein's rise to power had been largely aided by the United States during the Reagan era and Iraq's catastrophic war with Iran. But the first Gulf War had firmly established Saddam's image as the Hitler of the Middle East,[28] and so it was no great feat to let him serve as a stand-in for Osama bin Laden, and to associate him (quite falsely) with al Qaeda and the attacks of 9/11.

As a symbolic substitute, Hussein had to be subjected to symbolic castration and humiliation. Fortunately he had provided ample imagery for staged photo opportunities of iconoclasm in the numerous statues portraying him as a figure of military prowess. The most famous of these photo opportunities was the scene staged in Firdos Square in Baghdad, where Saddam's statue was pulled down to the cheers of a small crowd that had been bussed in especially for the occasion.[29] Although hardly sufficient as an iconic answer to the laying low of the World Trade Center, this image possessed at least a minimal kind of symmetry with that awful day, countering the destruction of the headless twin icons of global capitalism with the bringing down of the dictatorial head of the Iraqi government.

Just before the photo op of the deposed sovereign, however, another photograph was taken of a kind of provisional and sym-

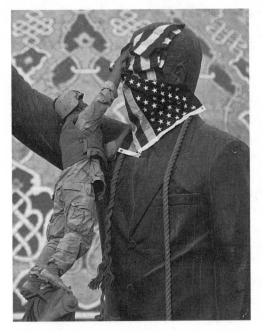

FIGURE 22.
"Hooding Saddam."
Corporal Edward Chin,
of New York (Third Bat-
talion, Fourth Marine
Regiment), places a
U.S. flag on the face of
Iraqi President Saddam
Hussein's statue be-
fore tearing it down in
downtown Baghdad
on April 9, 2003. Pho-
tograph by Laurent
Rebours. Courtesy of
AP/Wide World Photos.

bolic decapitation of the Iraqi head of state, and secured the sym-
bolic connection with 9/11. That was the famous photo of Cor-
poral Edward Chin hooding the head of Saddam's statue with an
American flag on April 10, 2003. This particular flag, which had
been flying over the Pentagon on September 11, was brought to
Iraq by Marine Lieutenant Tim McLaughlin, who had been on
duty in the Pentagon that day, and who ordered Corporal Chin to
shroud Saddam's statue with the flag.[30]

Apt as this symbolism might have seemed to some Americans
at the time, it was quickly understood to be sending an unwanted
message to the Iraqi people and to the rest of the world. Instead
of portraying the liberation of Iraq, it suggested the forceful im-
position of a new face of sovereign authority in Iraq, namely, an
American military occupation. A blank colorless hood of the sort
that the United States was already deploying when detaining sus-
pected Iraqi insurgents would have been considerably less pro-
vocative and would have conveyed the minimal message that the

tyrant had been deprived of his power. Instead, it overlaid that negative message with a positive assertion of triumphal colonial conquest. Small wonder that it drew immediate objections, and was immediately replaced by a photo op featuring the Iraqi flag/hood over Saddam's head.

In the age of digital media, however, withdrawing an image from circulation is easier said than done. The flag-hooded Saddam became, like the later images of his capture and execution, a symbol of outrage and shame to the Arab masses.[31] Like many other images of American triumphalism during the invasion of Iraq, it helped to mobilize Iraqi nationalism and to recruit jihadists from other Arab countries. Perhaps this is why a more positive photo opportunity was sought by the Bush administration, one that would rally public support behind an unpopular war of questionable legitimacy. The answer was found, not in images of Iraqi defeat, but of American victory in the form of Bush's famous "Mission Accomplished" photo op on May 2, 2003. Flying out to the American aircraft carrier USS Abraham Lincoln in the Pacific to declare a glorious victory and the end of "major combat operations," Bush seemed determined to project an icon of success.

In retrospect, of course, this photo op also turned out to be deeply embarrassing, not only for its premature declaration of victory in a war that has now lasted longer than World War II, but for its violation of one of the unspoken taboos of American presidential iconography. The president represents the *civilian* control of the military, and is therefore not supposed to appear in military drag, except perhaps for a discreet jacket or cap. Military garb is for dictators (like Saddam Hussein) who have assumed power illegitimately, by military force. Given the questionable legitimacy of Bush's election in the first place, the photograph would turn out to be as inconvenient as the flag-hooded Saddam, and the Bush administration did everything it could to disavow responsibility for it. But nothing could erase the responsibility for the image of Bush himself festooned in the flight gear of a carrier pilot, playacting a kind of *Top Gun* machismo, cutting a figure quite at odds with his dubious record as a malingerer and deserter in the Air

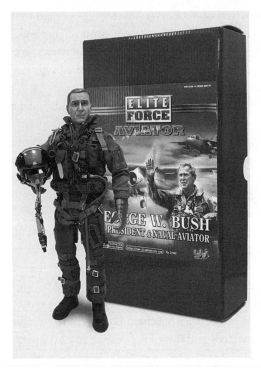

FIGURE 23.
George W. Bush as
"Elite Force Naval
Aviator." Action figure,
12 inches. Photograph
courtesy of Blue Box
International Ltd.

National Guard during the Vietnam War. This photo op could not be disavowed or withdrawn from circulation, and in fact it was cloned repeatedly in the form of an action figure, suitable for boyish fantasies.

Like the botched photo opportunities that showed Bush in military garb, scanning the "front" with binoculars whose lens caps are still in place, or reading *My Pet Goat* to an elementary school class on 9/11, Bush's propaganda machine, like the rest of his administration, seemed to vacillate between a fantasy of imagined omnipotence and a reality of actual incompetence.

Saddam's Dental Examination

The hooding of the head, and especially of the "head of state," is an ideal strategy for humiliating the enemy in a war of images. But an even more inventive treatment of the "head" was afforded by

FIGURE 24. Photograph of Saddam Hussein's dental examination, reproduced on a T-shirt. Photograph of T-shirt by Janice Misurell Mitchell.

the actual capture of Saddam Hussein on December 15, 2003. The once-powerful tyrant had to be paraded for the cameras in a scene of abjection and humiliation, but not one that would suggest cruelty or torture.

Some inspired genius in the Pentagon's media liaison team must have come up with the idea for what became the iconic photo op of Saddam's capture: his dental examination. This image is, in a very precise sense, an inversion of the hooding of the head in that it penetrates the head, goes inside it to illuminate its dark interiors. A video loop of the dental examination, with a tiny flashlight being inserted into Saddam's mouth, lighting up his cheeks from within, was run repeatedly in the hours and days after his capture. The sheer repetition of this image rivaled the repetition of the images of destruction of the twin towers, rendering it the single most memorable image of the whole capture episode. Other images, like the removal of lice from Saddam's hair, or shots of the dark interior of the "spider hole" where he had been hiding, were simply not formally compelling enough to sustain interest. But the dental examination had the virtue of adding several sym-

bolic components to the primary effect of humiliating the head of state in the most literal possible manner. First, it defused any hint of cruelty by staging Saddam's captors as looking after his health, perhaps determining whether he had developed any cavities or abscesses during his underground existence, or preventing him from committing suicide with a cyanide capsule embedded in one of his teeth. Second, it suggested that the U.S. military had finally achieved the elusive objective of total victory, since now it had penetrated "inside the head" of the head of state. Any remaining secrets would now come to light, and it did not take long, in fact, for the image to be reproduced with a new caption: "the search for weapons of mass destruction continues." Third, the real purpose of the dental examination may well have been to extract a DNA sample from Saddam's mouth, to determine with certainty that the man in U.S. custody was not one of Saddam's many notorious doubles. Of course, if the captured Saddam was a clone, then even a DNA test would not have been able to differentiate the original from a copy. And to this very day the blogosphere continues to insist that the Saddam Hussein who was captured in December 2003, and executed by hanging on December 30, 2006, was not the real Saddam, but merely one of his doubles. The evidence: the bad teeth of the captured Saddam do not match the perfectly uniform dental work of the man himself.[32]

Cloning Bodies

The human body is the best picture of the human soul.
LUDWIG WITTGENSTEIN, *Philosophical Investigations*

We don't do body counts.
GENERAL TOMMY FRANKS

Until the spring of 2004, the war of images was mainly running in favor of the United States.[33] Inconvenient images of Iraqi civilian casualties had been successfully censored. The American army had made it clear that the Powell doctrine of "no body counts" (either of "enemies" or "innocent bystanders") would be continued. The only bodies counted, the only bodies that *counted,* were

those of American troops.³⁴ Then, in May of 2004, images of bodies began to proliferate in the mass media, and a new kind of photo op emerges: atrocity photographs and videos of the beheading of American hostages; the dismemberment of American contractors and the display of their mutilated bodies on a bridge outside the city of Fallujah; the flag-draped coffins of American soldiers; and the scandalous torture photographs from Abu Ghraib prison. The first two groups of images were photo ops deliberately staged by the enemy, the Iraqi resistance. The second two were produced by Americans themselves.

The leaked photographs of coffins being unloaded from transport planes, published in the *Seattle Times* in the spring of 2004, were instantly reproduced in newspapers and on the Internet throughout the world. In August of 2004, during the Republican National Convention in New York City, they provided the inspiration for a parade of one thousand flag-draped coffins past Madison Square Garden on Sixth Avenue (plate 1).

The proliferation of the images of coffins produced the predictable reaction. The ban on photographing the caskets of American servicemen was elevated from its status as a military policy to a legislative resolution of the U.S. Congress.³⁵ The argument was that the sight of these coffins, aside from being deleterious to morale in the Global War on Terror, would "violate the privacy" of the dead servicemen and their families. It is, of course, difficult to see how the anonymity of a shrouded casket violates anyone's privacy. The real motive for the ban was transparent: to minimize the number of American casualties, and to prevent the real human cost of the war from becoming visible, even in the most indirect, veiled forms of imagery. Like most bans on or destructions of undesirable images, the prohibition had the effect of spawning more reproductions, inspiring other ways of commemorating dead U.S. soldiers and Iraqis with objects such as photographs, empty boots, and fields of white wooden crosses like the weekly antiwar installations at "Arlington Cemetery West," on Santa Monica beach.

If the reduction of the human body to bare life and brutal death is the essential content of the biopicture, the photo opportuni-

ties staged by the Iraqi insurgency showed an intuitive grasp of the logic of the image-war. Horrible as they are, the images of decapitation betray a kind of symmetry with the hooding of Saddam's statue and the dental examination. The justice of an eye for an eye and a tooth for a tooth escalates to a head for a head, and a symbolic decapitation is trumped by the staging of the real thing on international television. These images were immediately censored, and denounced as barbaric and savage spectacles, but we should remember that decapitation was the standard (and literal) form of "capital" punishment in European nations up to and including the French Revolution, which invented the guillotine as a humane form of quick and easy execution, and it is still the legal form of capital punishment in Saudi Arabia today. The mock-clinical treatment of Saddam's head was the counterpart to the mock-judicial treatment of American hostages, whose beheadings were accompanied by the trappings of a legal execution, complete with the reading aloud of the charges, and the circulation of the images on the Internet to the global media.

The Fallujah photographs carried the deliberate staging and iconizing of the abject human body to a new extreme. On March 31, 2004, the bodies of four American contractors ambushed and killed outside Fallujah were set on fire, and mutilated horribly in a kind of echo of the European practice of "drawing and quartering." The remains of two of the contractors were then strung up as trophies for display from a bridge over the Euphrates river. The behavior of the crowd of Iraqis before the camera made it clear that the photographs were not merely the spontaneous recordings of a passing journalist, but staged photo ops meant to outrage the eyes of the enemy.[36] Like the bystanders and participants in American lynching photographs from the early twentieth century, the assembled crowd expressed unabashed delight in the spectacle they were creating for the camera, and held up signs declaring Fallujah to be a graveyard for Americans. In contrast to the decapitations, there is no attempt to stage these photo ops as records of judicial proceedings. They portray the rough, anarchic "frontier" justice carried out by an angry (and exultant) mob, a spontaneous act of

violence meant to express the collective will of the city of Fallujah to be "the graveyard of the Americans." (It is difficult to forget the earlier invocation of Texas standards of justice by Bush in his threats to "smoke out" and "hunt down" the terrorists, and his urging of the Iraqi insurgency to "bring it on"; the criminal murders of noncombatants and the equally criminal policies of torture and murder of prisoners provided a dark undertone to all these pronouncements.) One sensed from the moment that these photographs appeared that this message would be taken literally by the Americans, that the city of Fallujah was doomed, and that collective punishment would be carried out sooner or later. The siege and destruction of Fallujah, a city of three hundred thousand people, was duly executed by American forces right after the American presidential election in the fall of 2004.

A corpse is the primeval form of what I have been calling a biopicture. It is "only an image"—a still, inanimate, motionless relic— of what was once a living form. And yet it is, in every culture I know of, regarded as at least partly alive, and therefore taboo, uncanny. The mutilation of a corpse is, from a rational perspective, a futile exercise. The person, the subjective consciousness, who once inhabited the corpse cannot feel the wounds. And in fact, the wounds are not meant to inflict pain on the actual victim. They are meant to be transmitted in visual or verbal images that will terrorize and traumatize the victim's kinfolk.[37] Achilles drags the body of Hector behind his chariot in the *Iliad,* not to inflict pain on Hector, but on the helpless Trojans who are forced to witness the degradation of their hero. The images of the mutilated contractors, then, were not images *of* trauma, but images designed to traumatize American viewers. When propagated by digital reproduction and global circulation they produce a kind of effect quite different from what modern artists called "shock," which had a therapeutic, defamiliarizing aspect. There is nothing like "shock therapy" in the realm of trauma.[38] These images are designed to overwhelm the viewer's defenses, and that is why many of the news services that carried them on April 1, 2004, elected to *blur* them, rendering their contents almost unreadable.[39]

The mutilation of a corpse is thus the mutilation of an image, an act of iconoclasm that is reproduced as an image in another medium—in verbal reports and rumors, in the memory of an impression, in photographs that can be propagated indefinitely. But this is a form of iconoclasm that goes well beyond the prohibition on images shared by Islamic, Jewish, and Christian versions of the second commandment. If the human body is created "in the image of God," and is the sacred handiwork of God, then its mutilation—even as a corpse—is an act of desecration. One of the leading clerics of Fallujah accordingly declared that the mutilation of the contractors' bodies was a "desecration," and a violation of Islamic law.[40] From a Christian point of view, the mutilations were a double outrage, triggering not only the tribalistic reaction to the treatment of a member of the social body, but also constituting a theological outrage, a crime against God—or the *imago dei*—himself ("desecration" in the fullest sense). The mutilations made sense, in other words, only in the context of a holy war, and in the widespread perception in the Islamic world that the United States was engaged in a Christian crusade in the Middle East, not just an effort to bring secular democracy to the region.

Modern warfare is often portrayed as a de-realized spectacle, a mere simulacrum on the order of a video game. And indeed, that is the way the American media and its corporate and political minders would like to portray it: a war of faceless enemies marching in anonymous ranks to be vaporized by superior weapons from a safe distance. But television also has the capacity, as Edward R. Murrow pointed out long ago, to present the "little picture," up close and personal. And it can reduce our distance from events, even as it seems to distance us. Marshall McLuhan's vision of a "global village" has come to pass, not as the idyllic utopia that is often (wrongly) attributed to him, but as the terrifying *immediacy* of viscerally intimate violence portrayed in real time. Archaic forms of tribal violence designed to elicit the tribalistic reactions of the American public can make the global village a very dangerous place, especially when the full force of American military power is mobilized in reaction to a local provocation. And thanks

to the invention of digital media, these spectacles, the violent dis-
memberments of the biopicture, can be cloned indefinitely and
circulated globally. They are the poisonous "gift that keeps on giv-
ing," taking on a perverse life of their own in the global nervous
system. As McLuhan predicted, the electronic age produces a dia-
lectical reversal at the level of social interaction, fusing archaic and
modern forms of human behavior, tribalism and alienation, vis-
ceral embodiment and digital virtuality.

Bionic Abu Ghraib Man

All the features of the biopicture—instantaneous reproduction
and viral circulation; the irruption of twins, doubles, and mul-
tiples in the sphere of public, mass consumed imagery; the reduc-
tion of the human form to bare life, or to a mere image such as a
corpse waiting to be mutilated, defaced, and destroyed; the corre-
sponding loss of identity, and the proliferation of images of face-
lessness and headlessness, the acephalic clone—converge in the
central icon of the Iraq war, and indeed, of the whole War on Ter-
ror. I'm thinking, of course, of the famous image known variously
as the Hooded Man, the Man on the Box, or (simply) Abu Ghraib
Man. I will have much to say about this figure in the coming pages.
For now I simply want to reflect on the way it condenses all the
features of the biopicture, both as a contemporary technical phe-
nomenon, and as the literalization and realization of archaic be-
liefs about the "lives" of images.

The self-conscious articulation of this uncanny double life of
images is provided vividly in David Rees's brilliant cartoon strip,
"Bionic Abu Ghraib Man." The scene is a conversation in the White
House about the rumor that Abu Ghraib Man is "on the loose."
Like any good cartoon image, not to mention any widely recogniz-
able cultural icon, it has, as we say, "a life of its own." And it is mov-
ing fast, suddenly appearing right in the midst of a White House
meeting. The startled staffers tell Abu Ghraib Man to stop moral-
izing about torture, and get down off his soap box. (Abu Ghraib
Man replies, of course, that getting down off his box will have the
effect of electrocuting his penis.) Bush and his attorney general

FIGURE 25. Abdel Karim Khalil, "We Are Living the American Democracy" (2008). Marble, 17¾ × 10 × 7 inches. Collection of Salam Al Rawi. Photograph by Michael Stravato. Courtesy of Station Museum of Contemporary Art, Houston, Texas.

then proceed to ruminate on Abu Ghraib Man's origin (spawned in a midnight legal laboratory by Alberto Gonzalez), and rumors of a possibly dangerous mutation into a figure known as Bionic Abu Ghraib Man, or Bagman, as we shall call him for short. It is a nice coincidence that Iraqi artist Abdul-Karim Khalil created a marble sculpture entitled "We Are Living in an American Democracy," based on the ubiquitous figure of the hooded man (fig. 25). It seems only appropriate that, although nowhere near the proportions of Mount Rushmore, this figure should be monumentalized in the medium that has persisted (and survived the ravages of time) since the Greeks. It is also worth noting that, although the head of the figure is hooded, a closer look at the facial area suggests just the faintest hints of a face beneath the surface, as if the hood were being transformed into a veil that would allow the man underneath to look back, and to assume the position of seeing without being seen—perhaps an allusion to the common practice of depicting Mohammad with a veil (see plate 8).

The Bagman in Rees's cartoon has evolved into a superhero who derives special powers from the wires attached to his body. He has converted torture into a power source, becoming a transformer who converts his body into the image of a stealth bomber carrying weapons of mass destruction, flying toward the faces of the Founding Fathers at Mount Rushmore. George Washington is crying out with alarm at the approaching threat of the oncoming airplane, while Jefferson can only ask whether the threat is real: "Literally or metaphorically? I can't turn my head."

Rees brilliantly condenses all the dimensions of the biopicture in his treatment of the Abu Ghraib Man:

1. The viral, indestructible character of an image that is "on the loose," refusing to go away, and its ability to show up anywhere, anytime, and to keep returning despite all efforts at censorship (it is notable that, at this writing in the spring of 2010, Barack Obama is still keeping the full photographic repertoire of the torture archives secret).

2. The uncanny doubling of the image, and its splitting into symmetrically similar and antithetical poles (cf. Uncle Sam and

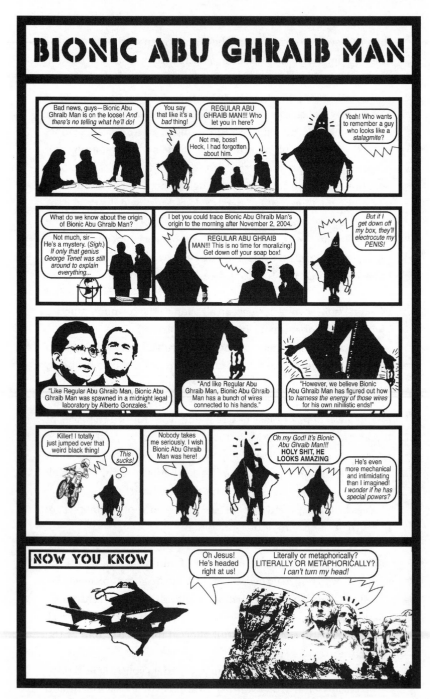

FIGURE 26. David Rees, "Bionic Abu Ghraib Man" (2004). Courtesy of the artist.

Uncle Osama). The polarities Rees stresses are those of the victim's weakness and abjection, on the one hand, and the irresistible power of a weapon of mass destruction, on the other.

3. The reversibility of defense and attack characteristic of the autoimmune disorder. The torture program that produced the Abu Ghraib icon was ostensibly intended to protect the United States from sneak attacks;[41] Rees's narrative shows exactly the opposite potential, that the predictable consequence of torture is the increasing probability of terrorist attacks on American monuments, the kind of "blowback" that brought down the World Trade Center—staged in the same way as an act of iconoclasm.

4. And the final twist to the biopicture, its alternation between literal and metaphoric vitality, real and imaginary effects. Is the attack on the heads at Mount Rushmore to be understood literally, as the prediction of an actual terrorist attack on the material monument? Or is it (even more dangerously) an attack on the symbolic meaning of that monument, its representation of the Founding Fathers, and the American Constitution itself?

If Bionic Abu Ghraib Man played the role of the powerful twin to the abject torture victim in American mythology, it found another twin or uncanny double inside Iraq, in a mural that appeared in Baghdad shortly after the release of the Abu Ghraib photographs. The mural, by Sallah Edine Sallat, portrays the Hooded Man on his box paralleled by a hooded Statue of Liberty on her pedestal.

Again, the "double" is both similar and opposite: the Statue of Liberty is clothed in the white robes and hood of the Ku Klux Klan, her hood perforated by eyeholes that reveal her as the torturer counterpart to the torture victim in his eyeless hood and black robe. Lady Liberty's arm is raised, moreover, not to elevate the torch of liberty, but to reach for the switch that will send electrical current flowing through the torture victim's body. The inscription on the mural, "That Freedom for Bush," is perhaps redundant, insofar as the metonymic juxtaposition of the Hooded Man and the Statue of Liberty became a kind of slang condensation for Iraqis, so that they reportedly began to refer to the Bagman himself as

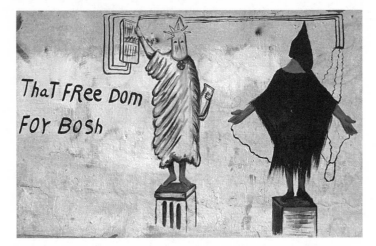

FIGURE 27. A mural by Iraqi artist Sallah Edine Sallat in Sadr City, Iraq, Baghdad's largest Shiite neighborhood, depicting America's Statue of Liberty in Ku Klux Klan costume at left, flipping the electrical switch on wires attached to a detainee of Iraq's notorious Abu Ghraib prison (May 23, 2004). Photograph by Karim Kadim. Courtesy of AP/Wide World Photos.

the Statue of Liberty, a powerful occasion for jokes about the American promise to bring electricity to Iraq along with freedom.

The Bagman Cloned

If ever an image has been cloned in the circuits of the mass media, this one was, both in the sense of indefinite duplication and in the further sense of taking on "a life of its own" that eludes and even reverses the intentions of its producers. The image of the Bagman moves beyond the binary, dialectical realm of the double or twin into the domain of repetition and multiplication. As famous as advertizing logos and brand icons like the Nike Swoosh or the Golden Arches, the image rapidly mutated into a global icon, that "had legs," to use the Madison Avenue expression. The Man with the Hood appeared throughout the world, on television, over the Internet, in protest posters, and in murals, graffiti, and works of art from Baghdad to Berkeley. Guerilla artists around the world found ways to reframe, mutate, and multiply the figure in an astonishing variety of ways. FreewayBlogger.com morphed the figure into a

FIGURE 28. FreewayBlogger, "Bagman Chorus Line" (n.d., FreewayBlogger.com).
Internet image capture.

chorus line that threatened to replicate itself indefinitely, snaking
across the computer screen while dancing to a parody of a Beach
Boys' tune calling American students to come to a beach party in
Iraq (minus, it should be said, the "chicks and booze").

The Bagman became so ubiquitous and recognizable that it
could insinuate itself subtly into commercial advertisements for
the iPod in New York subways, where it merged almost sublimi-
nally the figures of "wired" dancers wearing iPod headphones and
the "iRaqi" with his wired genitals. This bit of culture jamming,
the work of a group called Forkscrew Graphics, was especially ef-
fective, not only in calling attention to the ubiquity of the image
in parallel with the endless flood of advertizing logos, but in rais-
ing an interesting set of questions about the quotient of weak-
ness and power in the image that was explored by cartoonist David
Rees. Does the appearance of the "iRaq" Bagman constitute a sub-
versive intervention in the flow of media images? Or is it a symp-
tom of the absorption and disappearance of that image into the
media flow?

One could clearly make compelling arguments on both sides

FIGURE 29. "iRaq/iPod." Silkscreen poster by Forkscrew Graphics, inserted into iPod billboard near Bleecker Street subway station, New York (2004). Photograph by the author.

of this question. The image of the Abu Ghraib Man was expected by many antiwar activists to provide the powerful "smoking gun" that was to bring down the Bush administration in the elections of 2004, but it did nothing of the kind, and the scandal of the Abu Ghraib images, and the torture regime they revealed, completely disappeared from the presidential campaign that year. On the other hand, the image has never gone away, and it keeps returning with an almost cyclical predictability, requiring ever more futile efforts at censorship and forced amnesia. The most compelling reading of the iPod/iRaq juxtaposition, in my view, is one that, like David Rees, refuses any simple-minded reduction of the question of the "power of images" to an either/or resolution. As Rees shows, the image plays both roles, the abject helpless entrapment of the "Regular Abu Ghraib Man" and the powerfully destructive force of Bionic Abu Ghraib Man "on the loose." Perhaps the best way to understand the iPod/iRaq culture jamming is to analyze the relation between the self-pleasuring dancers, narcissistically

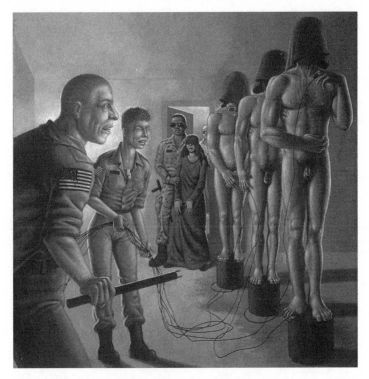

FIGURE 30. Guy Colwell, *The Abuse* (2004). Courtesy of the artist.

absorbed in a music only they can hear, and the self-torturing sta-sis of the Hooded Man, absorbed in a pain and terror only he can feel, accompanied by the menacing anticipation of electrocution to come if he steps off his box. The intervention of the Bagman icon into the iPod iconography is nothing more (or less) than a provocative to thought on a host of issues—the relation of art and politics, of pleasure and pain, motion and stasis, wired bodies, technologies of the sensorium, torture and sexuality.

These sadomasochistic overtones become a chorus in a com-position by San Francisco artist Guy Colwell, who emphasizes the cloning of the figure by portraying it as *triplets* in a tableau rem-iniscent of the surrealist artist Paul Delvaux. Three hooded men with wires on their hands and genitals stand on pedestals, stripped

naked from the neck down (perhaps to emphasize their connect-
edness to the pornographic scenes of nakedness from Abu Ghraib)
while American MPs brandish nightsticks and chemical lights, the
now-familiar instruments of rape and sodomy, and a blindfolded
Iraqi woman (or could it be Blind Justice or the Statue of Liberty?)
is led into the room to "witness punishment." The San Francisco
gallery that dared to show this image was attacked by vandals and
had to shut down, perhaps a forecasting of the American reception
of these images.[42] Although images, especially photographs of this
sort, are extremely powerful in exposing people to the truth, they
are not all-powerful, and they can be neutralized by clever strate-
gies of containment, censorship, and outright denial. Even the
straightforward realism of the video of Rodney King's beating by
Los Angeles police, for instance, was finally overcome by a defense
team that cleverly treated the video to a slow-motion, frame by
frame analysis that deconstructed its plain evidentiary character.
It's as if the longer and more intensely one contemplates these
kinds of images, the more opaque they become. As Mark Danner
put in the period shortly after their first appearance and subse-
quent suppression:

The images themselves . . . having helped open the door to broader
questions of how the Bush administration has treated prisoners in
the War on Terror, are now helping as well to block that door; for the
images, by virtue of their inherent grotesque power, strongly encour-
age the view that "acts of brutality and purposeless sadism," which
clearly did occur, lay at the heart of Abu Ghraib.[43]

Danner's own investigation into the "hidden story" behind the
images (which most of the official investigations did their best to
keep hidden)[44] tried to keep the door open. And the work of Sey-
mour Hersh and the initial interpretations of the images by Susan
Sontag and others have made it clear that a great deal more lies
behind the door. Certainly, in a world where the notion of human
rights and international justice had any force of law, the United
States' actions in Iraq would be condemned as those of a rogue
state placing itself above the law. The flagrant disregard for inter-

national law that was expressed by the highest officials of the Bush administration (including the president) would, in a just world, be grounds for criminal proceedings. But we do not live in a just world, and international law has no way of enforcing itself. So the question remains: what is to be done with and about these images once their "hidden story" has been revealed, and their political efficacy has (at least for the moment) been exhausted?

The answer, I think, lies in that "inherent grotesque power" that Danner observes in the images. Although this power can have the effect of blocking a concentration on the narrative and documentary meaning of the photographs, it can at the same time open up new dimensions of meaning in them—what I have called the "system behind the system" that made them possible—and that made something very like these images inevitable. What I am suggesting, in other words, is that there is something more to be learned from these pictures than the story of what happened at Abu Ghraib, and who is to blame for it. These images were, after all, paid for with the tax dollars of American citizens. We own them, and must own up to what they tell us about who we are, and what we are becoming in the age of the biodigital picture.

The beginning of an answer to this question is offered by Hans Haacke in his stunning image, *Star Gazing,* which shows a man in an orange jumpsuit with a star-spangled blue hood over his head (plate 2).

This image condenses the whole complex of biopictures we have been exploring, from the "acephalic clone" to the hooded terrorist or torturer to the hooded terror suspect transformed into a torture victim. The hood as an instrument to produce the faceless anonymity and blindness of the torture victim has been synthesized with the emblem of American sovereignty, summarizing the American "war on terror" as the self-destructive process it has been.[45] The curious mirroring of the torturer and the victim is eloquently expressed by a subtle ambiguity about the location of agency in the figure. On the one hand, the star-spangled hood stages this figure (like the hooded Man on the Box, or the statue of Saddam Hussein) as the passive, suffering trophy of American

power. On the other hand, the man's white skin and relaxed arms (no "stress positions" here) and the title of *Star Gazing* hint that this man has pulled the hood over his head all by himself. Stargazing Americans have indeed hoodwinked themselves with a peculiar combination of ignorance and idealism, blindness and innocence, a refusal to understand the consequences of their invasion and occupation of Iraq, coupled with the utopian rhetoric of freedom and democratization that has been employed throughout this war. And the war in question is not just in Iraq, but the whole planetary delusion of a Global War on Terror. Is Haacke's image suggesting that the wearer of this hood is capable of removing it and seeing things as they are? Or is the hood more like one of those disguises that American sports fans put on to cover up their shame at a disgracefully bad performance by their team? Is this version of the Bagman tormented by his blindness and muteness, or by his shame and loss of face? Whether the American people are ready to look without blinking at this and the other images of the War on Terror, to face what they have done to Iraq, to themselves, and to the world order, is still an unresolved question.

One image that will have to be confronted is among the heretofore unpublished photographs from Abu Ghraib, a photograph obtained with the help of Mark Benjamin, a reporter from *Salon* magazine. It is a portrait of an unidentified U.S. soldier with a swastika drawn on his forehead standing in front of a large American flag (plate 3). The scandalous images of torture from Abu Ghraib were generally labeled as "abuse" photographs. This one, reportedly taken at the Halloween party at Abu Ghraib on October 31, 2003, might be labeled "self-abuse." It is a portrait of one sort of face that might come to light were the hood removed from the head of Haacke's star gazer. I show it here, not to characterize this anonymous soldier as a fascist, but to suggest the way in which the stigma and stigmata of fascism were imprinted on the bodies of U.S. soldiers by a systematic policy of abuse approved at the highest levels of the Bush administration. The full extent of this policy, and the photographs that documented it, have yet to be made public. One can understand and perhaps even forgive

the Obama administration's reluctance to release the full archive of photographs that document the Bush torture regime, on the grounds that it will further inflame the Arab world, and add little to our understanding. What is neither understandable nor forgivable is Obama's repetition of the Bush alibi that the images of torture portray the acts of a "few bad apples" who have already been brought to justice. Like the soldier with the swastika on his forehead, the bad apples belong among the victims of Abu Ghraib. The real perpetrators, the architects of the torture policy, have yet to be brought to justice.

Meanwhile, there are the images, which unlike the bad apples, cannot be locked away. A great deal has been written about these images, and there is certainly more to come as the full archive of images from Guantanamo and Bagram prison in Afghanistan come to light. What is the meaning of this archive? How and why did the figure of the Bagman come to be the icon of the entire scandal? We have seen that this partly as a technical matter, the ability of new media to give images a viral, metastasizing life, "on the loose," as it were. But this is only a partial answer, and it does not tell us why one particular image, among all those taken at Abu Ghraib prison, achieved the status of a global icon. The contemporaneity of this image and its circulation in new media as a digital file is combined with something deeply archaic and uncannily familiar, something that resonates well beyond the effect of instant recognizability that goes with an advertizing logo or corporate brand. What is the basis for the uncanny vitality of this image, its tendency to go beyond any merely factual account of its production and circulation, its referentiality to a particular individual at a specific moment, and to become the historical monument, the living image or biopicture of an entire epoch, the times of terror and cloning? My final chapters will address these questions.

7 The Abu Ghraib Archive

The question of the archive is not . . . a question of the past. . . .
It is a question of the future, the question of the future itself, the
question of a response, of a promise and of a responsibility for
tomorrow. The archive: if we want to know what that will have
meant, we will only know in times to come.

JACQUES DERRIDA, *Archive Fever*

Criminal identification photographs are . . . designed quite literally
to facilitate the *arrest* of their referent.

ALLAN SEKULA, "The Body and the Archive"

For about three months in the fall of 2003, Abu Ghraib prison in
Iraq became the site of production of some of the most striking
and disturbing images in the entire war on terror. Images of naked,
hooded men being beaten, sexually humiliated, and subjected to
"stress positions" were captured by digital cameras, stored on hard
drives and compact discs, and disseminated over the Internet. In
the winter of 2004, the U.S. military began a series of internal in-
vestigations into the incidents of torture and abuse, with special
emphasis on the photographic record. An attempt was made to
recover and suppress the photographs, offering amnesty to any-
one who turned them in. But the containment effort failed, and by
April of 2004, the photographs had been revealed to the public by
CBS News' *Sixty Minutes* and Seymour Hersh's *New Yorker* articles.

Thus was created what I shall call the "Abu Ghraib archive," a
body of texts and images, recordings and remembrances that is
centrally constituted by, but not limited to, the 279 photographs
and nineteen video clips gathered by the Army's Criminal Inves-
tigation Command (CID). These images, first brought to CID on
January 13, 2004, by Specialist Joseph Darby, are only a small por-
tion of the total information in the CID archives (over one thou-
sand photographs remain classified), and it took two years for this
partial record to be released to the public. They were leaked by "a
military source who spent time at Abu Ghraib," and published by
Salon magazine in February of 2006, at which time investigative

reporters Mark Benjamin and Michael Scherer produced "The Abu Ghraib Files," an annotated, chronological archive that follows the CID timelines, supplemented by material from the numerous investigations, including classified material.[1] The Abu Ghraib archive now includes the numerous investigative reports by military and nonmilitary agencies, journalists, and scholars, and "secondary elaborations" by various interpreters, from the first analyses of the meaning of the images by Susan Sontag and Mark Danner, to more recent book-length studies such as Stephen Eisenman's *The Abu Ghraib Effect* and collections such as *Abu Ghraib: The Politics of Torture,* with articles by Barbara Ehrenreich and David Levi Strauss, among others. In addition, a large body of graphic secondary elaborations has gathered, from early protest posters, videos, and works of art, to fraudulent images of staged (usually pornographic) Abu Ghraib "fakes." In 2007 and 2008, a third wave of interpretations gathered in the form of documentary films on the scandal, beginning with Rory Kennedy's *The Ghosts of Abu Ghraib,* first screened at the Sundance Festival in February of 2007, and a year later *Standard Operating Procedure* directed by Errol Morris.

No matter how extensive this archive becomes, however, it was and is centrally constituted by the still photographs. Two images in particular have established themselves as the "icons" of Abu Ghraib: the pyramid of seven naked Iraqi men and the Hooded Man on the Box. It hardly seems necessary to reproduce or to look at these images anymore. They have been shown so many times that they are imprinted on collective memory, and need only a verbal mention to bring them to mind. These two images define, illuminate, and exemplify the imaginary and spectacular character of the entire archive of Abu Ghraib, both its images and the discourses that whisper around them. They are contrasting icons of what might be called "sex" and "stress" (assuming, of course, that these two concepts can be rigorously separated!). From a formal standpoint, at any rate, the contrast is clear: the one is a chaotic pornographic tableau, a pile of hooded, naked male bodies while the grinning faces of Charley Graner and Lynndie England greet us over the human pyramid. Photographed from a variety of

angles, this scene exemplifies that large proportion of the archive that represents simulated sex acts and other forms of sexual humiliation. The other, by sharp contrast, is a formally simple image, still, statuesque, and symmetrical. It exemplifies the "stress position" techniques employed by CIA interrogators, the shackling of inmates in uncomfortable positions that make any movement painful. In this case, the stress is also psychological: the Hooded Man has been told that if he steps off the box, he will ground the electric wires attached to his hands and genitals, and suffer electrocution. The whole strategy of the stress position is to put the human body in a position of self-torture, any movement to ease the stress causing an increase in pain.

The archive of stress position photographs is, perhaps inevitably, resonant of Christian iconography, with the crucifixion as its iconic tableau. Specialist Sabrina Harmon, who took a substantial number of the photographs in the Abu Ghraib archive, was first prompted to begin taking pictures when she noticed that an inmate with his arms shackled to his bunk "looked like Jesus Christ."

I cant get it out of my head. I walk down stairs after blowing the whistle and beating on the cells with an asp to find "The taxicab driver" hand-cuffed backwards to his window naked with his underwear over his head and face. He looked like Jesus Christ. At first I had to laugh so I went and grabbed the camera and took a picture.[2]

Once this association is triggered, a great many of the Abu Ghraib photographs begin to remind us of the crucifixion. Perhaps this is because torture, like pornography, admits of a relatively limited repertoire of bodily contortions, with a determinate range of positions between two extremes: the human frame forced into cramped or compressed positions, or splayed outward in a spread-eagled posture of maximum vulnerability. In any event, the shackling of prisoners to their bunks or cell doors with their arms behind them produced a number of images that inevitably evoke the crucifixion. And there was at least one tableau, the so-called Shit Boy photograph (fig. 36) that seems to be a "freestanding" version of the Christ figure. Here, an excrement-smeared Iraqi prisoner

(probably mentally ill) has been photographed in what looks like a choreographed Jesus position.

But it is the Hooded Man on the Box that evokes the iconography of Jesus across the entire image repertoire of the Passion of Christ: the hood recalls the mocked, blindfolded Christ; the pedestal recalls the Ecce Homo and the mock coronation of the King of the Jews; and the arm position recalls the Lamentation or "Man of Sorrows," as well as images of the risen Christ engaged in gestures of welcoming and rescue.

Understandably, the idea that this image has something to do with Christian iconography has produced considerable resistance. On the one hand, it seems to dignify the victim too much, turning him into a jihadist martyr whose appearance may be echoing the forced conversion of Muslims to Christianity during the Crusades. On the other hand, it has seemed to some commentators that it replaces potential sympathy for a real human being into a merely symbolic attitude. Sarah Sentilles goes so far as to argue that "applying the crucifixion narrative secures empire rather than disrupts it."[3] It is not clear to me what effect this reading has on empire. It may not "disrupt" empire, but it surely reminds us in graphic terms that the invasion of Iraq was seen by many in the Arab world as a continuation of the Christian Crusades, and a thoroughly imperialistic act. My own view is that the Christological association is not something that is "applied" willfully or arbitrarily, but that it is something more like an automatic response, conditioned by the uncanny resemblance to one of the most famous image-repertoires in the world. It is not as if Sabrina Harman, or thousands of other viewers, *chose* to see the Christological overtones in these images of torture. The fact is that these associations are inevitable, and the question is how to make sense of them.

The iconographic associations, in any event, are not limited to echoes of Christian iconography. The black hood and cloak also resonate with images from the Inquisition, the Ku Klux Klan, and other cults and secret societies, religious and secular. It captures the uncanny similarity between figures of the torturer or execu-

tioner, on the one hand, and the victim, on the other—the only difference being the presence or absence of eye holes in the hood.[4] This iconographic "rhyme" was exploited by a famous Iraqi wall mural pairing the black Hooded Man with a white hooded Statue of Liberty, portrayed as a Klansman/torturer reaching up to pull the electrical switch. (See the discussion of this image in chapter six, fig. 28.)

Behind the archive of Abu Ghraib, then, is a double archive of pornographic and religious images—a mixture of obscenity and uncanny holiness that (as Stephen Eisenman has shown) evokes the central *pathosformulae* of Western painting in which "victims are shown taking pleasure in their own chastisement and pain."[5] Eisenman argues that this familiar tradition is indissolubly linked with the glorification of imperial power, and the aesthetic justification of domination and torture, producing the "Abu Ghraib Effect," which inures spectators to the moral horror of what they are seeing. This explains, in Eisenman's view, why the images were so easily contained politically and psychologically, why they failed to stir the proper public outrage.

One could argue, conversely, that the pathos formula is exactly what makes the images memorable and powerful. (I lay aside for the moment the fact that there are few signs that the abused bodies at Abu Ghraib are portrayed as beautiful sufferers.) But whatever side one takes in this debate, the fact is the images seem to keep coming back to haunt the nation in whose name they were produced, while eliciting screen memories of lynching photographs, martyrdoms, and scenes of torture. We seem to have already seen them when they first appeared, as if we were recognizing the return of a whole set of familiar images, but in a new context, and carried by a new technology.

The filmmaker Errol Morris has predicted that a hundred years from now the American memory of the Iraq war, and perhaps the entire episode known as the "war on terror" will be centered on the photographs made at Abu Ghraib prison. Mark Danner may be right that there is an overemphasis on the images, a kind of voyeuristic fetishism that tends to distract attention from the system

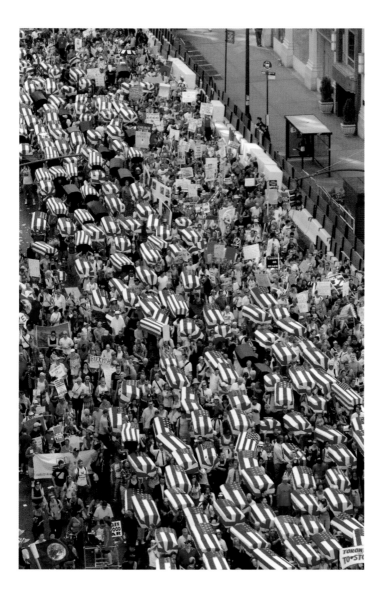

PLATE 1. Demonstrators carrying mock coffins draped with American flags symbolic of the soldiers who died in Iraq. Photograph by Bryan Smith, from the *New York Daily News* (August 30, 2004).

PLATE 4 *(facing page)*. Hildegard von Bingen, *Imago Mundi*.
From an eleventh- to twelfth-century Latin codex, "Visions
of Saint Hildegard of Bingen, Book of the Works of God," de-
picting Adam subject to universal forces (air, water, and fire).
Photograph courtesy of The Art Archive/Biblioteca Civica
Lucca/Gianni Dagli Orti.

PLATE 5. Anon., *Moses Praying on the Mountain* (fifth-century
mosaic, detail of ceiling). S. Maria Maggiore, Rome, Italy.
Photograph courtesy of Nimatallah/Art Resource, New York.

PLATE 6. Fra Angelico, *Entombment of Christ* (1438–40, detail from the predella of the main altar). S. Marco, Florence, Italy. Alte Pinakothek, Bayerische Staatsgemaeldesammlungen, Munich, Germany. Photograph courtesy of Bildarchiv Preussischer Kulturbesitz/Art Resource, New York.

PLATE 7 (*facing page*). Fra Angelico, *The Mocking and Flagellation of Christ* . . . (1437–45, detail of dormitory fresco). Convent of S. Marco, Florence, Italy. Photograph courtesy of The Art Archive/Gianni Dagli Orti.

PLATE 8. Anon., *The Prophet and a King Converse* (Persian, Safavid, ca. 1550, from a Mosque in present-day Turkey). Opaque watercolor, ink, and gold on paper, 21.3 × 30.0 cm. Photograph © 2010 Museum of Fine Arts, Boston. Francis Bartlett Donation of 1912 and Picture Fund (14.690).

and the stories behind them, but Danner's own resistance is testimony to the way this collection of images dominates the scandal of detention and torture in the war on terror. In fact, if there were no pictures, there would be no scandal. Verbal reports, no matter how detailed or credible, would never have had the impact of these photographs. Abu Ghraib has many lessons to teach us about the nature of the war in Iraq and the larger framework of the war on terror. It reveals essential things about the ideological motivations of the war, and the fantasies that accompanied its execution. In particular, it illustrates vividly the fantasies about the "Arab Mind" and its susceptibility to certain taboos that tell us as much about the American torture regime as they do about the realities of Arab culture.[6] But it also provides an important case for analyzing the role of digital images, digital archives, and their role in contemporary political culture. To utter the name "Abu Ghraib" is to name a place, an institution, and an event; but it is also to name a photographic archive and its widespread circulation in contemporary visual culture, a circulation that seems unlikely to abate any time soon.

What is the meaning of the Abu Ghraib archive? What are its boundaries? Is it complete or finished? What does it leave out, and what remains to be filled in? I ask these questions, not with any illusions that I can offer a final assessment of the event, and its trail of monuments and documents, the detritus of collective memory and nascent history. It is still too early to say what Abu Ghraib is going to have meant, whether it will be a symbol of national shame, a revelation of its political and religious unconscious welling up in obscene, pornographic—which is to say, sacred—images, or whether they will be safely quarantined as an exception, an anomaly, a peculiar episode of no special interest, quickly absorbed into the flow of mass-mediated images. One thing seems certain. These images will continue to be at the center of debates about the meaning of the War on Terror for the foreseeable future. Insofar as this war produced a new iconography of the archenemy in a global holy war against an ultimate evil, an Islamic fascism that threatens Western civilization itself, the image of a faceless,

hooded duplicate, the clone or "uncanny double," of the central icon of Christianity will continue to haunt all attempts to understand this period.

And this haunting, it must be said, will probably be most evident in the continued effort to disavow, quarantine, and "disappear" the images. The U.S. government has done everything in its power to contain, control, and close the case, with the result that the *suppression* of the images becomes the issue in itself (what do they have to hide?) and unleashes speculation about what they might contain. This is a classic instance of a case that has been repeatedly declared "closed," including the decision by the Obama administration to continue suppressing the remainder of the Abu Ghraib archive, along with photographic evidence of torture at Guantanomo, Bagram prison in Afghanistan, and the unnamed invisible "black sites" run by the CIA. But every effort to make the image of the enemy vanish, or (more precisely) of what has been done to the enemy in our name, has sparked a new revival of its circulation. Like the figure of the cloned terrorists, proliferating in sleeper cells in every corner of the globe, the suppression of the images has the paradoxical effect of cloning them and increasing their viral circulation.

I of course recognize that many people will try to forget about the images, or want to forget about them, or dismiss them as embarrassing reminders of something that (like Vietnam and its indelible images) needs to be "put behind us." Their relative unimportance compared with the images of My Lai or the Holocaust will be adduced to minimize their significance. Rush Limbaugh's notorious comparison of them to harmless fraternity initiation rituals will aid in this process, and the "already known" character of the images as originary repetitions (the *pathosformulae*, the comparison to lynching photos) will sustain the rhetoric of dismissal: move along, nothing to see here. Or if there is something to see, it is "already known," fully understood and accounted for by judicial processes.

The fragility of these disavowals may be seen in the self-contradictory character of the fundamental judgments that accompany them: these are bad images, but not *that* bad (and ter-

rorism requires stern measures); or, these images (with a few exceptions) are not exceptional, but represent "standard operating procedure." Or (conversely) these images *are* exceptional, not representative of what goes on systematically in the secret prisons of the "war on terror," and what happened at Abu Ghraib was the responsibility of "nine bad apples" (the original title of Errol Morris's film) who should not be allowed to spoil the whole barrel, much less indict the whole system that made them inevitable.

Perhaps the most insidious and tempting form of disavowal takes the form of a "more is less" judgment. The very circulation of the images, especially the central icon of the so-called Hooded Man or Abu Ghraib Man, is regarded as reducing the image to an empty signifier or "brand," like a corporate logo. The fact that the Hooded Man is now nearly as familiar as the Nike Swoosh or the iPod advertisements has the effect, it is argued, of neutralizing and co-opting its political impact. Even a clever bit of "culture jamming" like Forkscrew Graphics "iRaq/iPod" (fig. 29) is regarded as evidence for the weakness of the image. As Jacques Rancière puts the question in his general reflections on "the future of the image":

> Have not all the forms of critique, play, and irony that claim to disrupt the ordinary circulation of images been annexed by that circulation? Modern cinema and criticism claimed to interrupt the flow of media and advertising images by suspending the connections between narration and meaning. . . . But the brand thus stamped on the image ultimately serves the cause of the brand image. The procedures of cutting and humour have themselves become the stock-in-trade of advertising, the means by which it generates both adoration of its icons and the positive attitude towards them created by the very possibility of ironizing it.[7]

But Rancière hesitates over the adequacy of this conclusion: "no doubt the argument is not decisive," and it is possible to imagine circumstances in which the criticality of this montage is made evident, when it is relocated, for instance, "in the space of the museum" where they will acquire "the aura of the work damming the flood of communication" (28).

It seems clear, however (and Rancière notes this as well), that

such a critical relocation need not occur in the museum, but can transpire in the seminar or lecture room, in everyday conversation, or in the momentary double take that first notices the tactics of relocation embedded in the montage itself in situ—on a subway platform or billboard. The iPod/iRaq silkscreen, discussed in chapter 6 above, is itself a reflection on the reabsorption of images in the media flood. It explicitly juxtaposes two forms of contemporary self-absorption, the narcissistic self-pleasuring of the wired dancers with their iPods, and the obverse image of a very different kind of self-absorption experienced by the wired torture victim. Both images are reduced to anonymous silhouettes, both displayed as objects of indefinite serial repetition—what we have been calling "cloning." Together they produce a metonymic linkage of two images that may or may not be noticed, much less interpreted. As Rancière notes, "the effect is never guaranteed" (28). But this raises the further question: what would it mean to have an image with a *guaranteed* effect? Is this not precisely Clement Greenberg's definition of kitsch, which prescribes and attempts to program the predictable, guaranteed response?[8] More fundamentally, is the power of an image *ever* something that can be guaranteed by its autonomous, self-validating presence? Or do we need to ask some further questions: Power of what sort? Over whom? In what situations?

Like the indelible images of the destruction of the World Trade Center that launched this war, they will be forever associated with this epoch, and will mark a kind of termination point for both these wars. One sentence that inevitably accompanies the icon of the Abu Ghraib man is "The War Is Over," a sentiment rendered graphically in an installation over a crowded Los Angeles expressway by FreewayBlogger.com (see discussion in chapter 1). This is a statement that also reflects the common military wisdom that recognized the appearance of the Abu Ghraib archive as a decisive defeat for the American military adventure in Iraq. Captain Dan Moore, the commander of Naval ROTC, Northwestern University, a military theorist and historian, recognized the "terminal" character of the images on their first appearance. As he put it at one

of the first teach-ins on the photographs at Northwestern in June of 2004, "these images are more damaging to the American war effort in Iraq than any weapons of mass destruction." Given the previous discrediting of the claims that Iraq had weapons of mass destructions, that it was behind 9/11, or was supportive of al Qaeda, the images spelled the end of the last remaining alibi for the war, namely, that it represented a moral, even religious, crusade of liberation.[9] Of course FreewayBlogger's claim that "The War Is Over" is, within the composition of this photograph, immediately ironized by the oncoming stream of cars filled with oblivious motorists who will drive by without ever noticing the image. These are what Rancière calls "the poor morons of the society of the spectacle, bathing contentedly in the flood of images" (28) and driving on their freeways in vehicles fueled by cheap oil from the Middle East. In situ, the photograph reframes the Abu Ghraib Man in a tableau that says *both* that the war is over (morally) and the war goes on (physically, materially). Any claim for what Rancière calls an "exorbitant power" in the image to overcome the indifference of the spectacle is (as he insists) as simplistic as the overestimation of the spectacle itself and the underestimation of the morons under its influence.

Perhaps it is the language of the power (or weakness) of images, and the attendant longing for "guarantees" of political or aesthetic efficacy, that needs to be questioned. Stephen Daniels notes that the FreewayBlogger image echoes the famous John Lennon poster, "War Is Over (If You Want It)," an association that provides a better clue to the efficacy of this image.[10] What I have been proposing in place of the language of power is a language of affect and desire, what we want from images, and what they want from us, with "want" implying "lack" as well as positive demand or need.[11] Certainly there has been a longing for the Abu Ghraib images to have a decisive power and effect that has so far eluded them. This desire was especially acute in the immediate aftermath of their unveiling, when it was hoped that the images were the "smoking gun" that would bring down the government that had produced them. But this longing contains an implicit acknowledgment that

images (like "smoking guns") do not carry around with them a reservoir of power like storage batteries that can be tapped at will. Or rather, any power they do have is like that of dreams, a crystallization of desire that awaits interpretation and action, or like smoking guns, a constellation of evidence that awaits a proper judgment day.

Jacques Rancière's classifications of the three major categories of contemporary art may provide us with a way of precisely characterizing the central icon of the Abu Ghraib archive. Rancière differentiates what he calls "naked," "ostensive," and "metaphorical" images, the first corresponding to documentary and forensic images, the second, the iconic image with its instant recognizability, and the third the image in its mobility and mutability across different media environments (22–24). The Hooded Man (and many of the pornographic images) clearly fits Rancière's "naked" category of "nonartistic" images, exemplified by photographs from the concentration camps. Its formal simplicity and frontality links it to the ostensive images' "obtuse presence that interrupts histories and discourses" with "the luminous power of the face-to-face," the characteristic power of the cultural icon or idol, an effect that Meyer Schapiro long ago called the "theme of state," a format especially suitable for portrayals of the sovereign.[12] And in its viral circulation across different media environments it typifies the operations of the metaphorical image, as in its insertion into the iPod advertisements. Seen this way, it is difficult to think of another image in the contemporary mediasphere that does so many things while seeming to accomplish so little. This is why its only guarantee is memorability, and its only power is to awaken the desire for a justice to come.

But this raises the related question of the material and technical foundations of cultural memory as such. The other meaning of the Abu Ghraib archive is its importance in redefining the very concept of the archive. It may be the case that Abu Ghraib represents a radically new moment in the history of archives—and therefore the history of history—as such. An archive, as traditionally understood, is a collection of documents, objects, and records

that preserve some aspect of the past—an event (the Civil War) or a period (a presidency, a literary or artistic career). It is instituted by some authority, and is based on an authoritative decision to preserve, remember, collect, and make available the traces of a history that is open to a future. While the objects in the archive are relics of the past, aids to memory, the archive as an institution always points toward a future. As Allan Sekula notes, early photographic archives had a double mission in another sense: to extend the dignity of portraiture to middle-class consumers and to serve the policing of society by archiving the deviants, the poor, and the criminal classes. Politeness and policing produced what Sekula calls a "shadow archive" that "encompasses an entire social terrain."[13] In this sense, the content of the Abu Ghraib archive is utterly traditional. On the side of "politeness" is the ordinariness of the photographs, the sense that they were taken as souvenirs to be shared with friends back home. Sabrina Harman's explained her habit of smiling and giving a thumb's up sign for the camera, even in scenes of horror, as merely a polite reflex. On the side of the police is the fact that these were photographs of a crime scene, and became central exhibits in subsequent judicial procedures. Sabrina Harman even claimed that she took the photographs precisely for the purpose of documenting what she knew to be criminal activity.[14]

What is it that makes the Abu Ghraib archive new and different? Certainly it must be in part the fact that the central collection of documents is virtual (a body of digital images accompanied by metadata automatically encoded in their files), and that the archive itself—its location, structure, and retrieval system—is also virtual. The digital character of the images has had momentous consequences for their circulation, of course, giving them their notoriously viral character, resisting all attempts at quarantine and containment. The digital camera is a radically different technical apparatus from the analog camera: it is not just lightweight and easily concealed, but linked in unprecedented ways to a vast infrastructure of reproduction and circulation. Sabrina Harman's Sony Cybershot—I own one myself—can be slipped into a pocket,

and linked up to a computer to offload its images in mere seconds. We have to think of the digital camera, not only as an extension of the eyes and memory of an individual, but as linked very intimately to a global network of collective perception, memory, and imagining via e-mail and postings on the Internet. Some of the Abu Ghraib images were already serving as screen savers on laptops at the prison, and the effort of the military to declare an (appropriately named) "amnesty" was utterly futile.

It is important to recognize as well that the digital photograph produces a new dimension of legitimation and credibility, a new claim on the real.[15] Like the biocybernetic process of cloning, digital images constitute a "double-entry bookkeeping" technology that simultaneously copies the analog appearance (as with traditional photographs) along with the invisible digital codes for generating that appearance. We might think of this as the "DNA of the image," and it is what allows the indefinite cloning of exact copies, and the traces of their process of production. If the Abu Ghraib photos had been taken with traditional analog cameras, it would be much more difficult to establish their provenance, and to establish the date and time they were taken. But digital photographs unobtrusively and (usually) invisibly carry metadata with them. What Sekula calls the "truth apparatus" of the photographic document is no longer divided between its optical authority and the "bureaucratic-clerical-statistical system of 'intelligence' that archives the document."[16] It is as if digital images are directly connected to the filing cabinets where they are stored and the retrieval system that makes their circulation possible, carrying their own archiving system with them as part of their automatism.[17] Brent Pack, an investigator for the CID (military intelligence command), was able to specify the exact date, time, and camera of every photograph by examining the headers of the files. Much like a forensic analyst investigating the visible evidence of a crime scene, Pack was able to go well beyond the visible traces to the genetic code underlying the images. Pack won the Timothy Fidel Memorial Award in computer forensics for his masterful work of organizing the photographic archive of Abu Ghraib. An experi-

enced detective, Pack remarked in his interview with Errol Morris
that "more than half of crimes are solved because the criminal did
something stupid. Taking these pictures was incredibly stupid."[18]

But it was not *merely* stupid, and in the open past and future of
this archive, it becomes more and more evident that there was kind
of "cunning of history" at work in their production. The dominant
interpretation of the photographs has been that they were taken
as "trophies" to be shown off, a common practice of soldiers since
time immemorial. But that was not the only motive (it probably
explains only Charlie Graner, the leading sadist of the "Nine Bad
Apples"). Seymour Hersh has speculated that some of the photo-
graphs were encouraged by the CIA and OGA interrogators as part
of the "softening up" of prisoners, letting them know that their
humiliating nakedness was being witnessed and recorded (often
by women), and possibly using the images as blackmail to help
extort information about the insurgency.[19] (The insurgency was,
of course, the principal motivation for "Gitmoizing" Abu Ghraib
in the first place. Who knows when we will see the photo archive
from Guantanamo or Bagram?)

And then there is Sabrina Harman, who wrote letters to her
girlfriend back home at the time that described her own motives
as *forensic*.[20] "I took more pictures now to record what's going on.
Not many people know this shit goes on. The only reason I want to
be here now is to get the pictures to prove the U.S is not what they
think."[21] The first "detective" at Abu Ghraib, then, its first forensic
archivist, may have been Sabrina Harman, the pretty, smiling les-
bian who appears as the "thumbs up" girl in a number of photos.
Harman's conduct has been roundly condemned, and is often as-
sociated with the cheerful expressions on the faces of white folks
in lynching photographs. But her verbal testimony, both what was
written at the time, and what she has said subsequently, makes
the images come alive in a different way. We will return to this
"second" or perhaps "third" life of the images in the next chapter.

So everything about the Abu Ghraib archive and its central col-
lection of photographs seems to have a double, ambiguous char-
acter. Were they produced with official sanction for the purposes

of intelligence gathering? Or were they produced in violation of relevant rules and regulations? Certainly they constituted a violation of the Geneva Convention and the Uniform Code of Military Justice, but as we know the Geneva Convention had, by this time, been declared "quaint" and obsolete by the president of the United States and his lawyers. And Major General Geoffrey Miller, the commander of the Guantanamo Bay detention facility, had been sent to Abu Ghraib with the authority of the secretary of defense behind him to "get tough" on the prisoners being dragged in by the hundreds during nightly raids.

It is not just that the photographs are evidence of a crime, a kind of forensic body of clues that can be studied like the evidence (mug shots, crime scene photos) in any case file, but that the making of the photographs was *in itself* the crime. The strangest anomaly about Abu Ghraib is that the actual perpetrators of torture, the persons who were physically beating and killing Iraqi prisoners, are still largely unknown. They are the "shadow archive" of intelligence operatives, independent contractors, and "OGAs" ("other government agencies") who are outside the frame—and the frame-up—constructed around these images to contain their criminality. The only persons convicted of crimes are those who witnessed the crimes and took photographs of them, and especially those who allowed themselves to be photographed at the scene of the crime. Specialist Sabrina Harmon, for instance, did not physically abuse any prisoners. The only crime she was convicted of was *taking the photographs,* for which she received a sentence of six months.[22] Megan Ambuhl contends that the entire scandal would never have been revealed if the "image amnesty" had been effective, and all the photographs had been returned.[23] Charlie Graner, who took the majority of the pictures, surely did physically abuse some prisoners. But he seems to have been doing this with the full encouragement and guidance of the "ghosts" beyond the frame. In the midst of the abuses, Graner received an official letter of commendation for his good work.[24]

There is, as Derrida notes, a fundamental tension in the notion of an archive as, on the one hand, architectural—a place, an

institution, a building, even an *ark* where the documents are pre-served—and, on the other hand, a law, judgment, the decree of the father, the *archon*, the voice of tradition, memory, admoni-tion that is oriented toward a present and future time "to come." A prison is the perfect instantiation of this double principle. It is a place, a concrete architectural structure, that is instituted to en-force the law. Its inmates and the documents that classify their crimes and determine the length of their sentences go to make up the archive of a penal system. Abu Ghraib exemplifies the trans-formation of this image of the archive into its obverse as the first legal institution to *visibly* enforce the exceptional legal regime of the War on Terror. A place of lawlessness verging on total anarchy in the darkest days of October 2003, it was riddled with undocu-mented prisoners and gaolers, "ghost detainees" and equally spec-tral interrogators. Out of the dark labyrinth of this archive the photographs emerged as shafts of light that threaten to open up all the dark passages. So it is hardly surprising that the official containment operation took the form of condemning the images themselves as the crime, while the unofficial strategy is one of ex-aggerating their power, and then condemning them for their im-potence in bringing the war to an end. But the Abu Ghraib archive is far from exhausted. The containment operations have failed. And the real perpetrators, those who created the system of law-less law that it exemplifies, await the judgment that it demands and the lessons that it still contains.

8 Documentary Knowledge and Image Life

It is the pictures that will end the war. BRIAN DE PALMA, 2007

Every photo is a bullet for our enemy. SENATOR LINDSAY GRAHAM

If images have a tendency to come alive, they do not always do so in the same way.[1] Some take on a life when they seem to look back at us (certain Hindu goddesses are thought to come alive only when the eyes have been painted); others when they start to move (hence the whole medium known as "animation"); still others when they speak (either as a result of ventriloquism or the addition of a recorded soundtrack), or when they become "readable" (by virtue of the addition of a text, caption, or decoding). And then there is that most vivacious of images, the kind that merely needs to be seen by a human being to come alive—to take root in memory and imagination, "fresh images to beget," as Yeats put it. An archive of images is, in this perspective, something like a seedbed in which images, like seeds, are planted, waiting for the spring to bring them back to life and into the light. Or, conversely, the archive may be like a crypt in which the images have been laid to rest, sealed away from the light. To open the ark would be to unleash a plague of images.

Both these ways of thinking about the Abu Ghraib archive have been at work throughout its brief history, which is a classic instance of the dialectics of scandal, a struggle between forces of publicity and secrecy, disclosure and censorship. From the very first effort to destroy the images at their origin, with the declaration of an "image amnesty"—literally, a call to forget—to the most recent decision of the Obama administration to keep the nu-

merous unreleased images classified (along with their uncounted brethren from Bagram and Guantanamo and other "black sites"), the forces of state power have been on the side of darkness, secrecy, and encryption.[2]

Perhaps the most powerful weapon on the side of secrecy has been, paradoxically, a fetishizing of the already publicized images themselves, and those who appear in them, as radically exceptional cases. Once the cat was out of the bag, in other words, and the image amnesty failed, it was important to declare this cat to be a monster, a completely unusual, unprecedented creature—the "bad apples" tactic. The release of the Bush administration's previously classified torture memos in April of 2009 made it abundantly clear that the criminal responsibility for Abu Ghraib resided in the White House.

But a lie of the "bad apples" variety is what anthropologist Michael Taussig has called a "public secret." That is, an official public declaration (e.g., "The United States does not torture") is widely known to be sprinkled with silent, invisible asterisks such as "according to our definition of torture" or "as a matter of policy."[3] The asterisks make it possible for the lie to be true "in a sense" that has been carefully articulated in secret qualifying statements that cannot be disclosed for reasons of national security. It is the nation state's equivalent of the children's game of telling a lie with one's fingers crossed behind one's back.

But the crossed fingers are now exposed, at least partially. The secret torture memos are public. What is not public, however, is the visible evidence that would show what the consequences of these memos were for actual human bodies. It is a testimony to the widespread conviction that images are more powerful than words, that the Obama administration was willing to release the verbal memos, but not the visible manifestation of their effects. Relatively few people will read the memos for themselves, whereas the pictures, as Abu Ghraib dramatically demonstrated, would have been worth a thousand words. And it is not just the quantity of words that they have the potential to unleash: it is their uncontrollable and unpredictable quality, their ability to spread

virally across linguistic and territorial borders, and to provoke instantaneous mass emotions. Suppose, for instance, that there is another iconic image lurking in the dark recesses of the still encrypted archive, another image as powerful as the Hooded Man, or the homophobic pyramid of naked bodies. Suppose there are (as is widely rumored) images of rape, sodomy, child abuse, or desecration of sacred objects? We have already seen an image of self-abuse that has escaped from the crypt (see "Swastika Patriot," plate 3, discussed in chapter 6 above). The continued censorship, while aimed at preventing the spread of yet another plague of images, may actually have just the reverse effect, since it leaves (as every horror film director knows) the monster hidden away in darkness, free to grow ever more fearsome in an imagination fed by rumors and the collective paranoia generated by the public secret.

Fortunately there is cinema. The age of cloning terror has also been a great time for filmic realism, ranging from straight documentary to historical fictions to reenactments of actual events. Led by the example of Michael Moore, the whole tradition of polemical, engaged documentary has flourished in this period with unprecedented mass appeal. The emergence of social media such as YouTube and Twitter has turned every citizen into a potential journalist, every innocent bystander into a potential witness whose testimony can be uploaded to the global nervous system. The period of the Clone Wars and the War on Terror has been, in other words, the period that realized the predictions of Marshall McLuhan's wired, global village—not as the peaceful utopia many mistook him for anticipating, but as the violent and dangerous place he predicted it would be.[4]

In the midst of all this media realism are the Abu Ghraib photographs, themselves among the first products of the media revolution, doubly coded with analog and digital information about an indexical, *indicated* reality in time and space. It was inevitable that these images would become the object of cinematic documentation. For one thing, it turned out that there were at least nineteen video clips of abuse taking place, a reservoir of cinematic raw material. For another thing, the immediate political stakes com-

bined with their ready-made documentary status made them ideally suited to one of cinema's founding vocations: making photographs come alive.

Before Rory Kennedy's *The Ghosts of Abu Ghraib* (HBO 2007) and Errol Morris's *Standard Operating Procedure* (Sony Pictures 2008) appeared, most of the language around the images had been descriptive and interpretive. The persons portrayed in the photos were trapped in the images, like the famous Barbara Kruger photograph inscribed with the legend, "Help, I'm being held prisoner inside this picture." The American soldiers had been talked *about* in great detail, but their own voices had not been heard. (The Iraqi detainees, we should note, have still not been adequately heard.) Kennedy's and Morris's films had the electrifying effect of breaking the soldiers out of their silent, voiceless pictorial prisons with the most straightforward device available to documentary film, namely, the interview.

Aside from that, they are quite different in approach. Kennedy's film is journalistic in structure, constructing an overall narrative with multiple kinds of evidence: interviews with participants, and with "talking heads," experts on politics, the law, and the psychology of torture. The "ghosts" of Abu Ghraib on the other hand, remain silent and invisible. The ghost detainees who were murdered and disappeared from the records, and the ghost operatives of Other Government Agencies (OGAs) are mentioned in the film, but no effort is made to conjure them up cinematically. Kennedy's film provides an "objective" introduction to the whole Abu Ghraib scandal, one that made the entire chain of criminal responsibility clear as early as 2007.

By contrast, Morris's film is deliberately myopic, a magnifying glass relentlessly focused on the pictures themselves, on the exact events and conditions that surrounded their production, and on the American soldiers who appeared in them and whose lives were damaged by them. Morris's emphasis on reenactment generates the eerie spectral aura that film can produce in an empty space, and in fact he literalizes this conceit with special effects that bring the phantasmatic figures of ghost detainees and inter-

rogators into the scenes. Morris's interviews with the "bad apples" employ his usual "frontal" approach. He places the subject against a blank, cell-like background, and uses his patented "Interrotron" (based on the teleprompter) to eliminate all visual signs of the interviewer. This frontal approach is in contrast to Kennedy's emphasis on lateral views of her interviews, sometimes with the subject's home environment in the background.

It would make sense, then, to exchange the titles of these films. Kennedy is the one who really documents the chain of command that made Abu Ghraib a symptom of "standard operating procedure." Morris is much less interested in these external factors. His aim is to immerse the viewer in what one of his interviewees, the private contractor Tim Dugan, describes as the "surreal" atmosphere of Abu Ghraib, a place where "you have to consider yourself already dead." If Kennedy mentions the ghosts of Abu Ghraib, Morris tries to take us into the haunted house of Cell Block 1A, the "hard site" where the abuses took place. He even went to the very considerable expense of reconstructing an exact model of the cell block on a sound stage in Hollywood, reenacting many of the scenes while the testimony of the American soldiers is backgrounded to the status of a voice-over accompaniment to the visuals. Morris alludes to the command structure only through interviews with General Janis Karpinski, who was singled out by the military to be the scapegoat of the officer class, and has an understandably partisan view of the scandal.[5] And the only "objective" witness he brings to the film is Brent Pack, the CID investigator who conducted the forensic analysis of the photographs, establishing their timelines and the identity of the particular cameras that took each photo. Even this dry and technical testimony is enlivened by a dazzling graphic rendering (inspired perhaps by *Star Wars*) of the "gathering" of the Abu Ghraib photographs in cyberspace, as if they were random points of light floating in outer space, slowly gathering into patterns of temporal and spatial order. The music of Danny Elfman (a movie composer whose credits include *Batman*, *Spider-Man*, and *Terminator Salvation*) provides an ominous, melodramatic background to the visuals, and the cinematography of Robert Richardson (who has

done extensive work with Oliver Stone) supplies the dazzling special effects—hyper slow-motion renderings of Saddam Hussein's egg frying, shot through glass from below; spray from a shower exploding in crystalline droplets into the viewer's face; a burning helicopter falling toward us in a reenactment of Sabrina Harman's nightmare. The only thing missing is 3-D.

A strange thing happened to Errol Morris's film style in *Standard Operating Procedure*. He is best known as an investigative, forensic filmmaker who had an alternate career as a private detective, and who has an obsessive interest in getting deep into the truth of a situation that has been clouded by lies, false beliefs, and prejudgments. His masterpiece, *The Thin Blue Line,* had the salutary effect of springing a man from prison who had been wrongfully convicted of murder in a Texas courtroom. Morris's interviews with the various participants had the effect of raising questions about who could really be believed, and his reenactments, though they violated one of the taboos of "straight" documentary, established with graphic clarity the impossibility of the prosecution's account of the murder. But these were *forensic* reenactments of the sort that can be effective in a courtroom. They restaged in a schematic, deliberately unrealistic style the set of events that corresponded to alternative verbal narratives. But the reenactments of *Standard Operating Procedure* have a different effect altogether. To the extent that they feel "staged" they of course do not fool anyone into believing the illusion that they are eye-witnesses at Abu Ghraib (They might be contrasted, in this regard, with Stephen Spielberg's illusionistic reenactments of the gas chambers at Auschwitz in *Schindler's List*.) At the same time, however, they have little forensic utility as ways of testing the plausibility of competing stories. Their effect is rather to augment the *surreal* character of the events, to immerse the viewer in the nightmarish, horror-film atmosphere of the prison. It is as if Morris's forensic instincts, and his vocation as a detective, had run into the generic cul-de-sac of the movie detective story, namely, film noir. Morris takes us into Abu Ghraib's heart of darkness, but it is not clear that he was able to find a way out.

What, then, is revealed by Morris's film? I would suggest three

things: 1) the radically new character of the digital image, dis-
cussed in the previous chapter, as a double-entry bookkeeping
of the real, combining the analog, iconic representation with dig-
itized metadata as the new automatism of photography; 2) the
extent to which Abu Ghraib prison, while exemplifying a "stan-
dard operating procedure" promulgated by the CIA and the Pen-
tagon, was exceptional only in that it was a prison under siege
(in contrast to Guantanamo), and a place where unauthorized
photographs were taken and put into circulation; 3) a new under-
standing of one of the principal actors, Sabrina Harman, who is
transformed by the film from the leering "thumbs-up" girl, remi-
niscent of the delighted spectators in American lynching photo-
graphs, into a woman of conscience who recognized a crime tak-
ing place and determined to record it for the world.

There is, finally, a fourth lesson to be learned from *Standard
Operating Procedure,* and that is the limitations on how much we
can know about past events by treating photographs as keyholes
through which to spy on the truth of historical events. Morris has
declared that a century from now these images will be what we re-
member of the war in Iraq. The Bush administration made every
effort to produce its own iconic images of triumph and victory,
from the hooding of Saddam Hussein's statue with an American
flag, to the Mission Accomplished photo op, to the video tape-
loop of Saddam's dental examination after his capture. But none
of these images took hold, except as embarrassing revelations of
miscalculated propaganda. The unauthorized, illegal, and unsuc-
cessfully suppressed amateur photos taken by beleaguered GIs in
Abu Ghraib prison are what will remain as the icons of Operation
Iraqi Freedom.

This fact cannot be explained by forensic methods, a short-
fall that is made clear by Morris's own research into the mystery
of the Hooded Man. Misidentified by the *New York Times* as Ali
Shalal Qaissi—called "Clawman" by the GIs—on March 11, 2006,
the elusive figure of the "the *Real* Hooded Man" became the sub-
ject of Morris's *New York Times* blog of August 17, 2007, which at-
tempted to set the record straight. In preparing the background

for *Standard Operating Procedure,* Morris had discovered (along with many other researchers) that the Hooded Man was actually Abdou Hussain Saad Faleh, nicknamed "Gilligan." Morris derives a lesson about photography from this mistake, namely, "the central role that photography itself played in the mistaken identification, and the way that photography lends itself to those errors and may even engender them." It is as if photographs, by virtue of the authority we grant them, and compounded by our own prejudices and preconceptions, "attract false beliefs—as fly-paper attracts flies."

Morris's skeptical deconstruction of photographic truth-claims drew hundreds of responses, mainly sympathetic. Dozens of hypotheses were tried out and debated by the puzzle-loving insomniac readers of the *Times* over the next few weeks. As the discussion proceeded, however, this kind of search for the "deep truth" behind the photographs began to run into a wall of resistance. Respondents began to point out that the obsessive search for the truth behind the photograph was missing a much larger point, namely, that the actual identity of the Hooded Man is irrelevant to the power of the image. In fact, one might put it even more strongly and insist that it is precisely the *anonymity* of the Hooded Man that is the key to the power of the image.

The reference of a photograph, the real object or event "captured" by it, is not the same as the meaning it may acquire as a cultural icon. This meaning can only be understood by looking carefully at the photograph itself as a formal and iconographic entity, and by tracing its reception among viewers. If the only photograph of the Hooded Man was the profile shot taken from the side by Sabrina Harman, it would not be one of the most famous images in the world today. It is the frontal pose and the symmetry of the image that provide the formal conditions for its iconic power. The question then is not "who is the Hooded Man?" but (to quote James Agee on Walker Evans's photographs of sharecroppers) "who are *you* who will study these photographs . . . and what will you do about it?"[6] I believe Morris is correct that this is the image that will be remembered from the Iraq war, but it will not be re-

membered because it was Gilligan rather than Clawman. It will be remembered for the very reason Sabrina Harman was motivated to take pictures in the first place: it reminds us of Jesus. A new kind of Jesus, admittedly, one whose tormented face is concealed from us, and whose poise at this moment of stress is transformed by still photography into an indelible icon of what a Christian nation accomplished in its crusade to liberate the Middle East.

9 State of the Union, or Jesus Comes to Abu Ghraib

This *analogy* is the very site of the theologico-politic, the hyphen
or translation between the theological and the political. It is also
what underwrites political sovereignty, the Christian incarnation of
the body of God (or Christ) in the king's body, the king's two bodies.

JACQUES DERRIDA, "What Is a 'Relevant' Translation"

From the moment the enemy appears—the enemy vanishes.

GIL ANIDJAR, *The Jew, the Arab: A History of the Enemy*

Is there a *Guernica*, a masterpiece of artistic reflection on a his-
torical atrocity, lurking in the artistic responses to Abu Ghraib, the
war in Iraq, or the War on Terror?[1] Probably not. The photograph
of the Hooded Man is not a master*piece* but a master *image*—a
metapicture. In its uncanny echoing of the image of the human
clone (see Paul McCarthy's *The Clone,* chapter 3 above), its viral
reproduction and circulation, and its resemblance to the iconog-
raphy of the Passion of Christ, it has, as I have previously noted,
a status similar to a corporate logo or emblem. As a metapicture,
it becomes an icon of image production as such, symbolizing the
new status of the image in the age of biocybernetics. As an icon
of image power, it vacillates between weakness and omnipotence,
abjection and apotheosis: it is both the image of a victim and of a
bionic weapon of mass destruction (see David Rees's "Bionic Abu
Ghraib Man," chapter 6 above)—a truly dialectical image in Wal-
ter Benjamin's sense, capturing "history at a standstill."

When it comes to works of art, perhaps Inigo Manglano-
Ovalle's *Phantom Truck* (see chapter 6, fig. 20, above) will provide
the best enigmatic memorial of the war on terror as a totality. It
is an installation, appropriately enough, not a painting or photo-
graph, and it is virtually impossible to represent in a picture. It
presents the beholder with an inscrutable, shadowy structure, not
a clear, legible figure or space. It is about invisibility, secrecy, and a
terrorism *without spectacle,* evoking the more terrifying and insid-

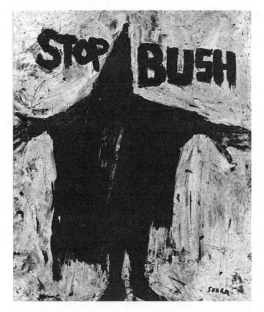

FIGURE 31.
Richard Serra, *Stop Bush* (2004). © 2010 Richard Serra/Artists Rights Society, New York. Photograph courtesy of Gagosian Gallery.

ious strategies of bioterrorism—the unimaginable and unreadable emerging out of obscurity and gloom. It asks us to contemplate what it means to encounter a fabricated monument to an imaginary casus belli in almost total darkness?[2]

As for Abu Ghraib, it seems at first glance that no great work of art has based itself on the photographs, though some significant artists have made the attempt. Richard Serra is perhaps the most famous artist to tackle the subject, and the result is appropriately virtuosic, with dashing, hurried brushstrokes that could be castings off of molten lead well as paint. But, as one can see, it is thus more about painting than it is about Abu Ghraib, which explains the need for the scrawled legend, dating the image firmly in a past moment: "STOP BUSH."

It was more than Bush that needed stopping, and "it"—the nameless, shadowy conflict known as the War on Terror—is still going on. I prefer Hans Haacke's star-gazing, self-hooding American citizen (plate 2), or the silkscreen culture-jamming of Forkscrew Graphics linking iRaq to the iPod (fig. 29), or the ephem-

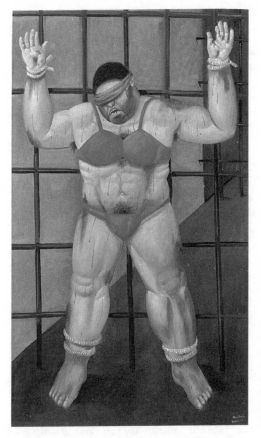

FIGURE 32.
Fernando Botero, *Abu Ghraib* (2005). Oil on canvas, 180 × 114.5 cm. © Fernando Botero. Photograph courtesy of Marlborough Gallery, New York.

eral Iraqi mural that couples the Hooded Man with the Hooded Statue of Liberty (fig. 27), or Guy Colwell's surrealist triplets (fig. 30), or the comics of David Rees (fig. 26).

The other artist who has addressed Abu Ghraib directly is Fernando Botero, the Latin American sculptor and painter who has often been ridiculed for his blimpy, dough-boy figures. Arthur Danto has argued that Botero, despite the scorn heaped on him by the New York art world, has finally discovered his true subject in the tortured bodies of Abu Ghraib.[3] It is precisely because Botero's bodies are so overinflated that the stress and pain inflicted on them becomes hypervisible. It is not that Botero's fig-

ures are *fat,* moreover. They are clunky, blocky, but solid with mus-
culature. What is done to them seems to be done to the painting
as well, as if pain and paint had merged. One feels that Botero
contemplated the photographs carefully and packed their visceral,
embodied essence into his paintings like sausage casings stuffed
with suffering.

Danto's ambivalent endorsement of Botero is structured inside
a contrast between painting as "an art that can show the invis-
ible" and photography as an art that cannot do this. He dismisses
the Abu Ghraib photographs themselves as "snapshots," trivial,
banal productions of incompetent amateur photographers doing
very conventional things, accompanied by an extremely bad atti-
tude (triumphant, cruel, proud). The only thing he gets right, in
my view, is the classification of the photographs as conventional
amateur snapshots. Aside from that, they are reasonably compe-
tent, and they can hardly be dismissed as trivial, given the his-
tory of their reception. As for the bad attitudes, they are difficult
to know with certainty, and we have some evidence of variability
among the persons who made the pictures.

But the most important error in Danto's account is the gener-
alizing claim that photography cannot show the invisible. If there
is one thing the Abu Ghraib photographs can be said to have done,
it is to *make visible* what would otherwise have remained invisible.
More generally, one has to note that the work of making the invis-
ible visible is precisely the task of photography in some of its most
distinguished moments, as Walter Benjamin took pains to empha-
size in his concept of the "optical unconscious" and early photog-
raphy's vocation (e.g., Etienne Jules Marey's images of captured
motion) of creating images of things that cannot be observed with
the naked eye.[4] The existence of these photographs may have been
caused by bad people doing bad things, but their very existence
has been one of the defining historical events—call them "iconic
acts"—of our time.[5] They deserve a little more respect, which is
what Rory Kennedy and Errol Morris provide in their documen-
tary reanimations of the Abu Ghraib archive. And the one that de-
serves the most respect is, without question, the Hooded Man,
the Bagman of Baghdad, the Man on the Box, the Jesus Clone,

to which we might now add the title, the "Invisible Man" of Abu Ghraib. Why has this photograph had a circulation in the global image-repertoire comparable with the most market-saturated corporate logos and icons? And what would count as the right kind of respect for this image?

There is, as previously noted, something uncanny about the emergence of this specific image. In the folklore surrounding the techniques of torture, I have picked up rumors of a "Jesus position" involving hooding plus forced standing on a pedestal as a kind of standard operating procedure in the invisible community of modern torturers.[6] Could this have been staged with this procedure in mind? Certainly, being forced to stand in a fixed position for any substantial length of time is a form of psychological torture, the effects of which are known to be more long-lasting than straightforward physical abuse.[7] There is also Sabrina Harman's testimony (see discussion in chapter 8) about her initial impulse to take photographs: she had noticed that one of the inmates shackled in a stress position "looked like Jesus Christ. So I went and got my camera." And once you started looking for him, Jesus was and is everywhere in Abu Ghraib, not just as the Hooded Man but as Shit Boy (fig. 36) and numerous others. But just the same, there is only one Hooded Man, isn't there?

Well, actually, no. There are lots of hooded men, and in fact there have been several candidates for the role, and there were five different photographs taken from different angles on the famous Hooded Man himself. It seems likely that there were many hooded men at Abu Ghraib who were never photographed and will never be seen. If Sabrina Harman's profile shot (fig. 33) had been the only one, we would never have had the Hooded Man as the icon we know. There is something about the frontal, symmetrical address of the image that contributes to its aura, making it shimmer with references to other images that seem related to it. Most notable is the invisible potential for its facelessness to suddenly turn into facingness: a pair of white dots of paint in the right place on the hood would be enough to give the figure eyes, and make it look back.

So this chapter tries to face the simple question that has

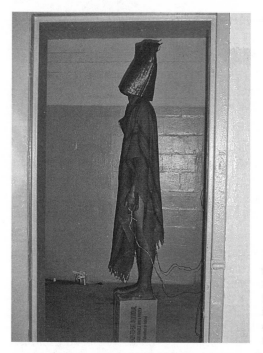

FIGURE 33.
Hooded Man seen
in profile. Photo by
Sabrina Harman taken
at Abu Ghraib prison,
October 2003.

haunted this book from the start: why did this image become the icon for the entire Abu Ghraib scandal, and how has it acquired an iconographic resonance that goes beyond this immediate event to touch on the nature of the contemporary world system during the era of the Clone Wars and the War on Terror? To recapitulate: the Hooded Man is a "world picture" in three senses of that phrase: 1) as a globally circulated and instantly recognizable icon, which requires only minimal cues, visual or verbal, to be called to mind; 2) a symbol of a planetary conflict (the Global War on Terror) that is not confined to the present moment of the early twenty-first century, but resonates deeply within a long history of figures of power and abjection in the repertoire of Christian iconography and beyond;[8] and 3) as a symptom of a new world order of image-production and circulation made possible by biodigital technologies, the era of "cloning." The fact that the image goes beyond the specific echoes of the Passion of Christ to evoke medieval and Re-

naissance images of the human body (and Christ's body in particular) as an *imago mundi* or microcosm of the world helps to reinforce the uncanny sense that this image was already, in some sense, quite familiar as an icon, even at the first moment of its appearance in April of 2003.

Hildegard von Bingen's wonderful illumination captures this last dimension in a single image (plate 4). Von Bingen shows us the figure of Adam at the center of the mundane, earthly sphere in a proto-humanist posture that portrays "man as the measure" of the sensuous, bodily universe. But then she frames that universe inside a greater world, beyond the ring of fire that encircles the terrestrial frame of the four elements. That outer frame turns out to be the body of Christ, the "second Adam" who redeems the fault of the first. As the clone of the Father, Christ is the perfect divine *imago dei,* while the imperfect Adam is the *imago mundi.* The relation between Christ and Adam is, at the same time, analogous to the two bodies, divine and fleshly, immortal and mortal, of the sovereign. In a similar way, as we have seen, the Hooded Man of Abu Ghraib is our contemporary *imago mundi,* manifesting two bodies: the actual Iraqi torture victim, and his virtual image circulated globally, or (as David Rees has shown us—see chapter 6, fig. 26), "regular Abu Ghraib Man" and "Bionic Abu Ghraib Man," the former a weak victim, the latter a dark avenging angel with "special powers."

The great art historian Meyer Schapiro provides an ideal methodological primer for reflection on this image and its many clones and mutations.[9] Writing in the early 1960s in an effort to reflect on the evolution of images within a semiotic framework that would respect both the textual sources and the pictorial repertoires that give images their meaning, Schapiro could hardly have predicted an age like ours, when the world is in the grip of a global religious revival along with the holy wars of images that inevitably follow. Schapiro took up this subject at a time when the main religious issues on the horizon were the fresh memories of fascist paganism and communist atheism, not a global Christian crusade and Muslim *jihad.*[10] But perhaps the calm, detached tone of Scha-

piro's effort to understand the relations of Jewish and Christian icons, and especially the genealogy that links the figure of a victorious Moses to a crucified Christ, may serve us now to gain some perspective on a set of images that are difficult to look on without shame, outrage, and an uncanny sense of recognition.

Schapiro's essay on "Words and Pictures" was built upon a series of relationships that are foundational to the interpretation of images. The first is the relation of an image to a text that it illustrates, and, closely connected with this, the relation of the "literal" and "symbolic" meanings in both image and text. The second is the formal distinction between frontal and profile renderings of the human figure, and their association with the implied "address" of the image as an "I" facing the spectator as a "you," or what the linguist Benveniste called "first person" and "third person" addresses of a picture. The third is his distinction (grounded in the formal difference between profile and frontal views) between "themes of state" and "themes of action"—that is, between images that confront the viewer directly with a static, frontally posed figure, and a self-contained action seen beyond the picture plane, a contrast strangely reminiscent of Michael Fried's distinction between images of theatricality and absorption. We could illustrate this contrast with the frontal figure of the iRaqi inserted into the dancers of the iPod posters (see chapter 6, fig. 29, above).

Schapiro analyzes the way the figure of Moses raising his arms at the battle of the Israelites with the Amalekites is absorbed, retrospectively, into Christian iconography as a "prefiguration" of Christ crucified, which then in turn becomes the prototype for gestures of both sacred and secular sovereignty throughout Christendom, including the gesture of the priest celebrating mass, or the monarch addressing his subjects (plate 5).

Here is Schapiro quoting Pope Honorius II (1124–30), on the multiple valences of the figure with the outstretched arms:

In it are represented the sacrifice of the highest pontiff (sc. Christ) and the battle of the King of Glory. Moses prefigured it when he prayed on the mountain with outstretched hands, while Joshua, who is Je-

sus, fought with Amalek, devastated the kingdom of the defeated en-
emy, and brought back his people joyous in victory. Thus Christ on the
mount of the Cross prayed with outstretched hands for the unbeliev-
ing and denying people and, as a victorious leader . . . Fought under the
standard of the Cross against Amalek, that is the devil, and laid waste
his conquered kingdom; having defeated the evil enemy, the Lord de-
spoiled Hell. (Honorius Augustodunensis, *Gemma Animae* I, quoted in
Schapiro, 60–61)

Schapiro notes the many different kinds of images that are con-
densed into the figure with the outstretched arms, from the por-
trayal of Moses with his arms supported by Aaron and Hur, to
"orants" or "oratorical" praying figures of the catacombs, to Daniel
in the lion's den, to pagan figures of deities with their arms out-
stretched, sometimes supported by their ministers, sometimes
alone and unsupported, all the way down to the depiction of Chris-
tian sovereigns such as Henry II, whose images display

the same analogy of the king to Christ through his posture as a cross
and to Moses through the supporting bishop-saints. . . . The role of Mo-
ses is ascribed at one point to the ruler and at another to the priest.
Both are at the same time religious and secular powers in close alli-
ance with each other. (39, 43)

It should be clear from this analysis that Schapiro regards the
"theme of state" as not merely a formal matter of figural "stasis"
and frontality in the address of the image, but as a key resource for
the iconic representation of religious and political sovereignty. In
addition, Schapiro's way of moving from the literal to the symbolic
meaning of these themes of state is cumulative and historically re-
versible. Later versions of an image "remember" earlier versions,
recuperating and transforming them at the same time, so that the
figures of Aaron and Hur, the "supporting" ministers of Moses,
can disappear from the scene in order to stress the absolutely in-
dependent power of the sovereign, as in the figure of Hobbes's *Le-
viathan*, where the hands of the monarch control the sword of sec-
ular violence and the shepherd's crook of religious "care for the

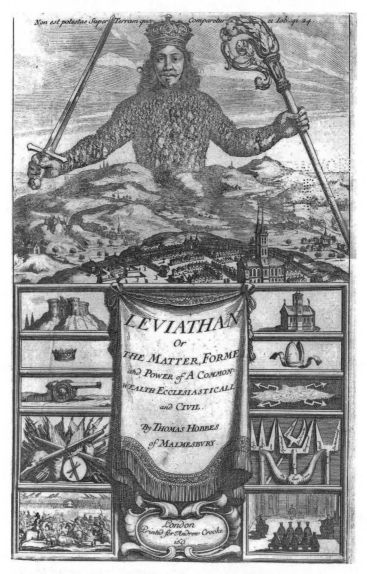

FIGURE 34. Frontispiece to Thomas Hobbes's *Leviathan* (1651).

salvation" of the people.[11] One might think of Hobbes's *Leviathan* as an emblem of the theory of the strong "unitary executive," a favorite doctrine in the Bush administration's attempt to consolidate maximum power in the executive branch of government.[12]

But equally important is the reverse historical reading that looks back to the representation of Moses as a prefiguration of Christ, and attributes the victory over the Amalekites to the divine power of the Christological gesture. It is not only that symbolic meanings accumulate as an image moves forward in history, in other words, but that its new meanings have the effect of reframing the past, and rendering temporality and narrative as a simultaneous tableau. The "theme of state" renders history itself as an eternal, static image that is unchanging in its basic form, even as its full meaning is unfolded in new images "to come" in a promised apocalyptic future when the Messiah will return to Earth in triumph. Moses's victory over the Amalekites not only prefigures the first coming of Christ to offer himself as a sacrifice, but also his second coming as the conquering sovereign of the Last Judgment.

Perhaps it is now becoming clear why the figure of Hooded Man became the universally recognizable icon of the entire Abu Ghraib scandal. At the formal level, this frontally posed figure, like the figures of prayer Schapiro invokes, faces the viewer directly, hailing the viewer as the "you" who is addressed by an "I." The static character of the "theme of state" is reinforced further by its positioning on a pedestal, which makes it clear that "action" or movement is precluded, that absolute stillness was required to maintain this position. The stasis of the image is further reinforced by its symmetry and contrastive color scheme. It makes a simple and singular impression as a black, diamond-shaped form against a light background, a form that can be instantly recognized from a distance, and copied in a schematic silhouette without any need for further details. The hood covering the face renders the figure even more abstract and anonymous. It could be any Iraqi, or, for that matter, any suspected terrorist captured by the U.S. military. The true identity of the Man on the Box was the subject of debate for several years after the first revelation of the Abu Ghraib photo-

graphs. He was first identified as Satar Jabar, a carjacking suspect, by a story in *Newsweek,* July 19, 2004.[13] In the winter of 2006, however, several sources, including the *New York Times* claimed that he was a former Baath Party official named Ali Shalal Qaissi. According to *Vienna Die Presse,* a self-described "independent centrist daily," Qaissi was "a secret service henchman of Saddam Hussein," a political criminal who richly deserved the treatment he received.[14] Errol Morris has claimed a definitive identity for the man as an innocent bystander swept up in one of the nightly raids of the U.S Marines, but we would still have to admit that, if the "Jesus position" was standard operating procedure, there could have been other individuals who played this role at Abu Ghraib and elsewhere.

But perhaps we should listen to Michel Foucault's advice on the way to deal with an image that has become the master-image or metapicture of an epoch. In his reading of Velasquez's *Las Meninas* (both a masterpiece and a master-image), Foucault discusses the temptation to establish the meaning of a picture without ambiguity, "to determine the identities of all the figures presented." "These proper names," notes Foucault, "would form useful landmarks and avoid ambiguous designations." But, as he goes on to insist:

The proper name . . . is merely an artifice: it gives us a finger to point with, in other words, to pass surreptitiously from the space where one speaks to the space where one looks; in other words, to fold one over the other as though they were equivalents. But if one wishes to keep the relation of language to vision open, if one wishes to treat their incompatibility as a starting-point for speech instead of as an obstacle to be avoided, so as to stay as close as possible to both, then one must erase those proper names and preserve the infinity of the task. . . . We must pretend therefore not to know who is to be reflected in the depths of that mirror, and interrogate that reflection in its own terms.[15]

In part this means replacing the proper names of the invisible man with his generic identities: the thief, the terrorist, the innocent man. And it means admitting that it is this ambiguity that con-

stitutes the power of this image to serve as a master-image in the first place. In this sense, the "proper" name—i.e., the correct, definitive key to the meaning—of the Man on the Box is, like the question of the identity of the "real historical Jesus," destined to remain uncertain. Like the image of Jesus "proper," it has a life of its own that acquires new dimensions of meaning in every new context that it encounters. Among the many images that emerged from the Abu Ghraib scandal, it stands out as the only one that conforms to Schapiro's concept of the "theme of state." By contrast most of the other photographs are formally complex, even chaotic, images of action, in which bodies and forms are tangled together, or blurred into the background. The symmetry and facelessness of the Hooded Man, by contrast, operates like a Rorschach inkblot, inviting projection and multiplicity of association.

And then there is the curious fact that, despite its context in scenes of horror and scandal, it has a curious modesty and dignity. The figure of the hooded Iraqi is *not* naked. He is not contorted into a "stress position," humiliated by having his nakedness photographed, or forced to crawl on all fours, leashed like an animal (though images of Jesus on a leash are a recurrent motif in images of the Passion). He is not smeared in excrement or stacked in a chaotic mass of naked indistinguishable bodies, or forced to simulate a sexual act. He is not a decomposing corpse packed in ice, but more (as we shall see presently) like the uncannily beautiful corpse of the Christological motif known as the Lamentation or the Man of Sorrows. Although the hood renders him anonymous, he appears as a singular figure elevated on a pedestal, an image of dignity and poise that becomes even more remarkable when one reflects on what we know about the event being captured by this photograph. The most elementary way of doing this is to project yourself into the situation depicted. Imagine yourself balancing precariously atop a cardboard C ration box, with electrical wires attached to your fingers and genitals, stifled and blinded by a hood.[16] You have been told by your torturers that if you fall off the box, you will be electrocuted. In the context of uncounted days of sleep deprivation, beatings, and cries of pain from your fel-

low prisoners, it would be something of a miracle to remain balanced on top of this box for even a minute. And yet you do this long enough to be photographed, and thus transformed into an image that will maintain this pose, this composure, as long as the image continues to exist.

But what, finally, are we to make of the obvious resemblance of this image to representations of Christ with his arms raised, either at the crucifixion or the resurrection, or in scenes of prayer and blessing. I say that this is obvious, and yet it is important to acknowledge that the resemblance to any particular image of Christ is imperfect, and that there will be considerable resistance, even outrage, at such a suggestion. For one thing, it seems somewhat implausible to suggest that this photograph was *meant* to recall the figure of Christ, even allowing for the torture convention labeled as "the Jesus position." If there is some resemblance, it is surely accidental, and incidental to the real meaning of the image. For those who care about the political meaning of this image, its resemblance to images of Christ may, as noted previously, seem to be a distraction from its real, literal meaning, an aestheticizing of a historical document.[17] For those who care deeply about the image of Christ, it may be deeply repugnant to think that this photograph of an Iraqi prisoner, who was a terrorist suspect in a war zone at the time, and at best a car thief captured in a military sweep, should be associated with the Prince of Peace, the Son of God, the King of Kings. The resemblance to images of the crucifixion, moreover, is rather tenuous. The crucified Christ stretches his arms upward, not downward. Christ is naked except for a loin cloth; he doesn't wear a cloak. His face is visible, and crowned with thorns rather than hooded. He is suspended from a cross, not standing on a pedestal. He has nails in his hands, not wires attached to them.

These contrasts were captured vividly in a photomontage created by the *Chicago Tribune* to illustrate an op-ed piece that I had written shortly after the Abu Ghraib photographs came to light (fig. 35). At the same time this montage reveals the difference, however, it reinforces the resonance between the two fig-

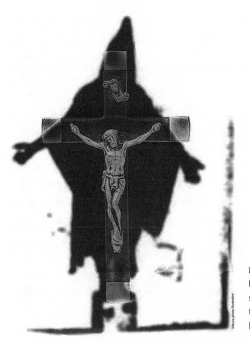

FIGURE 35.
Echoes of a Christian
symbol. Montage from
the *Chicago Tribune*
(July 2004).

ures. The question is, what sort of resonance, and how can we talk about it? How can we get at the precise meaning of this image in a way that respects its pictorial as well as its historical and political specificity, while reckoning with its circulation in a world of images, and its numerous reframings and mutations? To call the Man on the Box a "Christ figure" is perhaps simply to give in to an iconographic cliché, unless we take the trouble to analyze more deeply the other levels of resonance contained in the image. What would it really mean to see this image "as" Christ, as opposed to all the other modes of "seeing as" that could be brought to the image?

The answer lies in a deeper reflection on Schapiro's distinction between themes of "state" and "action." There is a related distinction that focuses, not on the formal character or iconographic content of the image, but the state of mind of the beholder, and that is the contrast between devotional and narrative readings of sacred images.[18] A narrative reading of the Hooded Man provides a date

and a proper name to the figure, and a provenance of the photograph itself, from its production in Abu Ghraib prison at a specific time in the fall of 2003, to its public release in the spring of 2004 and the subsequent scandal. It reads this against its formal grain as if it were an image of action. A devotional reading is contemplative and empathic, slowing down the time of the image to a kind of stasis that mirrors the bodily state of the figure in the mental state of the beholder. It puts the viewer in the position of the figure, a process that is encouraged by the frontality of the theme of state, in its (paradoxically blind) "face to face" encounter with the beholder. Schapiro calls attention to the "inert mask" that often characterizes the face of "the ceremonial fetish of the god frontal" (83), an effect that recurs in Western paintings of the godhead: "the full-face is sometimes blind, a schematic mask that is turned toward one but has no penetrating gaze" (92). This is a "seeing as" that does not assume that the image is exhausted by its narrative reading, much less the pointing finger of the proper name, but asks what it means to live with the image and the world it depicts, to ask what it wants from us.

Perhaps the most obvious thing the picture demands from the devoted viewer—particularly a U.S. citizen—is an acknowledgment of responsibility. To put it in the crudest terms, this photograph and what it reveals was paid for by our tax dollars. We "own" it, and must "own up" to what it tells us about ourselves, as if Haacke's hooded Star Gazer were to remove his blindfold and look in the mirror. Even if we opposed the Bush regime and its war in Iraq, as so many did, we are still responsible for this image. Thomas Mann's clear opposition to Hitler's regime did not, in his view, excuse him from a sense of responsibility and guilt as a citizen of the German nation. This is an image of *state* in the most precise sense: an image of state-sponsored torture, the state to which we belong as citizens. Just as the Romans crucified Jesus as an "enemy of the state," a political dissident who was accused of assuming a false position of sovereignty as "king of the Jews," the Hooded Man was accused of being an enemy of the state. Seen as an accused terrorist, he is not a mere criminal, but a political ad-

versary who represents a rival claim to sovereignty.[19] Terror and torture are, in fact, the twin images of the "state of exception" that grounds political sovereignty in post-Hobbesian political theory: the sovereign, as Carl Schmitt puts it, "is he who decides on the exception," and the exception is both the "state of emergency" and the exception to the rule of law that the sovereign claims in the time of emergency.[20] A primary purpose of the War on Terror was to claim exceptional, indeed unlimited, powers for the sovereign to determine exceptions to the rule of law. Torture is thus a justified exception to both American and international law since, by definition, it is used only against (suspected) terrorists. And the terrorist is not just the enemy of the law, but of the sovereign himself; he is the necessary counterpart to—antitype and double of—the sovereign, claiming for himself an exceptional status that mirrors the role of the sovereign.[21]

That is why the iconic tableau that unfolds in the Passion of Christ takes the form it does, as a mock coronation. Jesus must be humiliated and tortured, not in just any manner, but in a carefully choreographed spectacle that simultaneously "raises him up" as a crowned sovereign, and "brings him down" to the level of a common thief.

Schapiro notes that "pagan opponents of Christianity had mocked the cult of a God crucified like a common criminal" (51). And Foucault points out the symmetry between the bodies of the sovereign and the condemned criminal: "In the darkest region of the political field the condemned man represents the symmetrical, inverted figure of the king".[22] Did the Abu Ghraib torturers mistake a car thief for a terrorist, or vice versa? Does his elevation on his pedestal reflect his probable identity as an innocent man? (But what is innocence in this context?) Or does it make the political meaning of this image a kind of obscene parody of the Passion, an obscenity that does not affect the dignity of the image, however, but reflects the moral status of its producers? Is this is not an image of *our* moral and political "state of the union," of the United States, at this time?

A devotional reading of the Hooded Man also has to take note

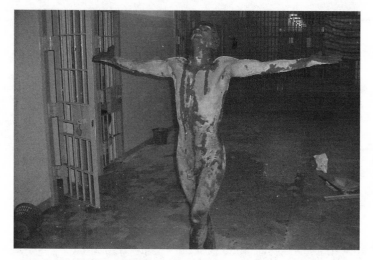

FIGURE 36. "Shit Boy." From CID master disk of Abu Ghraib photographs.

of the way the picture evokes other images from the Passion cycle, not just the crucifixion. The only sense in which the crucifixion bears on the image, in fact, is in its putative narrative location as the figure of a tortured criminal on the verge of execution, in this case by the modern (and almost uniquely American) technology of electrocution, not the archaic ritual of crucifixion. But the specific posture of the Hooded Man and his elevation on a pedestal connect him to other episodes of the Passion, and beyond that, to other images of Christ. The downward slant of the arms links him with images of Christ performing gestures of welcome, beckoning, surrender, and descent, as opposed to the upward gestures associated, for instance, with the crucifixion, the transfiguration, and the ascent into heaven. There is a contrast as well with the Mosaic figure with supported arms exerting military force with his raised arms. Thus, we find exactly this downward arm position in representations of Christ descending into Hell where the downward gesture is pulling up Adam and Eve out of their graves,[23] or the Sermon on the Mount with its welcoming vulnerability, or in the so-called Man of Sorrows or Lamentation, a nonnarrative image that represents Jesus after the crucifixion but before the

entombment, his bathed body, as in Fra Angelico's treatment of this theme, seemingly on the borderline between death and life, crucifixion and resurrection (plate 6).

The pedestal links the figure to images of the transfiguration, or to the mock coronation of the Ecce Homo, when Jesus is displayed to the crowd from an elevated position crowned with thorns. Finally, the hood firmly identifies the figure with scenes of the mocking of Christ, where he is generally portrayed with a blindfold, as in the renderings of Grunewald and Fra Angelico (plate 7). One can of course object that all this religious iconography is simply beside the point for a modern digital photograph that was produced by some misguided American soldiers in the context of a secular war. But to raise this objection is immediately to be reminded that images—in no matter what medium—are open to history and to human perception in ways that escape the intentions involved in their making. Some images are forged by history—which means by accident and luck as well as by design—and they become the icons of the time. The war on terror was declared by a pious Christian American sovereign to be a "crusade" against evil, a holy war that made sense to many Christian (and Jewish) fundamentalists as the millennial struggle that will lead directly into the Apocalypse and the arrival of the Messiah.

Did American citizens in the spring of 2004 notice the resemblance of Lynndie England leading an Iraqi on a leash to Tintoretto's treatment of a similar moment in the Passion? Did they notice the uncanny coincidence in the release of Mel Gibson's film *The Passion of the Christ* at the very time the Abu Ghraib images were made public in the spring of 2004? Did they notice the resemblance between Gibson's portrayal of the pleasure and glee that the Roman soldiers take in torture and the grinning faces of American soldiers mocking their Iraqi victims? Did they ask themselves what has become of Christianity in a time when its major cinematic expression completely eliminates its positive message in favor of an obsessive concentration on the minute details of the tortured human body, from beatings, to a scourging that literally flays the flesh from the victim, to agonizingly slow death by that

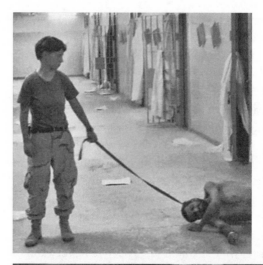

FIGURE 37.
Iraqi prisoner on
leash held by Lynndie
England (2003).

FIGURE 38.
Jacopo Robusti
Tintoretto, *Way to
Calvary* (1566, detail).
Scuola di S. Rocco, Ven-
ice, Italy. Photograph
courtesy of Scala/Art
Resource, New York.

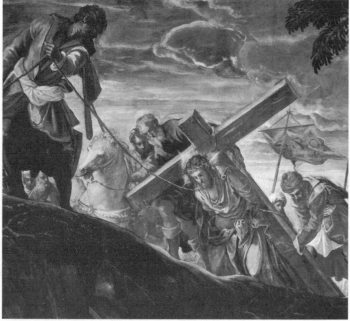

"stress position" known as crucifixion? Did they notice that Arabs and Muslims have now assumed the position of the sacrificial victims in a Christian crusade against evil?

Whatever the intentions of the hands-on (as opposed to systemic) producers of the Abu Ghraib images, their effect is not only to produce an updating of Judeo-Christian iconography, but to reopen the question of what the Christological fusion of images of the torture victim as conquering sovereign meant in the first place. The figure of Moses, his outstretched arms supported by Aaron and Hur, inspiring his armies against the Amalekites, is an image of a ruthless conquering power. Meyer Schapiro's citation from Honorius stresses the devastation wrought upon "the kingdom of the defeated enemy." Amalek is the devil, and the victorious Christian prince "laid waste his conquered kingdom" (61). Small wonder that some Muslims suspect that they might be playing the role of modern Amalekites to the conquering armies of a Judeo-Christian coalition, and that the "laying waste" of Iraq might be something more than mere incompetence.

Certainly the Muslim world is aware that the torture practices carried out in American prisons included deliberate acts of religious desecration and profanation, including the improper treatment of the Koran. The forced nakedness of the male detainees in full view of American women was based on the assumption that, as Raphael Patai puts it in *The Arab Mind,* "One of the most important differences between the Arab and the Western personality is that in the Arab culture, shame is more pronounced than guilt."[24] Guilt, for Patai, is a matter for the more advanced "Western" notion of inward "conscience," whereas shame depends upon being exposed to the gaze of others. This sort of vulgar racial stereotyping explains why, when there were shortages of all basic necessities at Abu Ghraib, there was an ample supply of women's panties to be used as hoods.[25] Mark Danner notes further that torture victims were sometimes ordered to curse Islam and to "thank Jesus" that they were allowed to live.[26] In this light, Rush Limbaugh's notorious remark that the abuses of Abu Ghraib were like an American "fraternity initiation" take on an unsuspected sig-

nificance. Suppose the abuses, at some semi-conscious level, were understood to be a kind of conversion ritual, "flipping" Iraqi detainees to work as informers for the American occupation? Suppose further that the idea was not merely to "break" the detainees psychologically, but to convert them from Islam to Christianity?²⁷ This might help explain the most devastatingly ironic resonance in the imagery of the Hooded Man, namely, its resemblance to the famous motif of the Veiled Mohammad (plate 8).

The covering of the Prophet's face with a veil or the fire of his halo was a common practice, and it is at one with the iconophobic traditions shared by all three "religions of the book," Judaism, Islam, and Christianity—especially Protestant Christianity. The second commandment forbidding the making of images of God (or of any other living thing) seems to have extended to God's prophets and messengers as well, and is enforced with particular stringency in Islam. In this light, the Bagman's hood becomes a protective veil to hide his features from the gaze of the impious, and the ambiguous figure of the Hooded Man becomes a synthesis of the three great world religions that are central to the Global Holy War on Terror. Jesus, Moses, and Mohammad, all descendants of Abraham, reunite in a tableau of peace, sacrifice, and welcoming.

Perhaps now we are in a position to explain the uncanny power of the image of the Hooded Man. As an exemplar of Schapiro's "theme of state," it captures the contemporary convergence of secular and sacred power in the holy war on terror. But it does so, not simply by reinforcing the Manichean scenario in the typological identification of Christ, Moses, and Mohammad, but by bringing into the open what Walter Benjamin would have seen as the dialectical resources of this image, displaying "history at a standstill." The Hooded Man heightens the contradictions embedded in the theme of state by staging it as an icon that does not remain securely on the positive side of the sacred-secular confusion (e.g., Christian democracy and enlightenment vs. Muslim tyranny and idolatry), but forces an *enjambment* of good and evil, god and the devil, Islam and the Judeo-Christian alliance. That is why

the image has "two bodies," shuttling between sovereignty and abjection, terror suspect and torture victim, criminal and martyr. It also positions the American spectator as caught between two incompatible positions: in a state of empathy with the tortured victim or as an accomplice of the leering torturers. The shaming, which was the avowed motive of photographing these scenes in the first place, comes back redoubled to haunt the photographer, the spectator, and the state of the union and the world that he represents. No wonder that George W. Bush, although both shameless and incapable of admitting any guilt, remarked that "nobody wants to see images like this."

This brings us to Schapiro's final horizon in the interpretation of iconographic themes of state, namely, the "norms of representation" that constrain the appearance of an image. The typological condensation of Moses, Jesus, and Mohammad, the Priest, Avatar, and the Sovereign, in Judeo-Christian-Muslim "themes of state" passed through not only changes of style, but different forms of mediation, from paintings hidden in catacombs, to impressive mosaics in public places, to illuminated manuscripts and oil paintings, to the choreographed rituals of religious and political spectacle. Now the latest avatar of this image has metastasized in a new medium, the digital photograph and its global circulation on the Internet. Containment and control of its meaning is no longer conceivable. The new law of images in the age of biocybernetic reproduction is one that fuses mass uniformity and rapid evolutionary variation, the simultaneous appearance of typological "prefigurations" and "postfigurations" as uncanny doubles and evil twins, themes of state that confuse democracy and tyranny, order and anarchy, terrorism and torture. Perhaps the Hooded Man would, as Hans Haacke has suggested, be the appropriate figure to deliver the next State of the Union address, as long as we replace the hood with the American flag. Could it be that the Second Coming has already occurred at Abu Ghraib prison, in a literal fulfillment of St. Paul's warning that "the day of the Lord . . . cometh as a thief in the night"?[28]

CONCLUSION
A Poetics of the Historical Image

The first historical event is that *there be* a history [a story, *une historie*].
And if there is a history, it contains the universal in itself as one of its
abstract structures rather than being able to be universal. . . . Free,
a sinner, historical, man is a being to whom something has happened.

JEAN-PAUL SARTRE, *Notebooks for an Ethics*

Underneath what science itself knows there is something it does not
know. . . . These laws and determinations are what I have tried to bring
to light. I have tried to unearth an autonomous domain that would be
the unconscious of science, the unconscious of knowledge, that would
have its own laws, just as the individual human unconscious has its
own laws and determinations.

MICHEL FOUCAULT, *Foucault Live*

What kind of story have I been telling here?[1] I began by suggest-
ing that every history is really two histories, the story of what hap-
pened and the story of the perception of what happened, its rep-
resentation in verbal and visual narratives, punctuated by iconic
moments such as the destruction of the World Trade Center and
the release of the Abu Ghraib photographs. But I have also been
telling a quite different kind of story, one that moves more slowly,
and at a different level, from the events that constitute the public,
eventful history of our times. This is the history epitomized by
the clone, the icon of a revolution in the sciences of information
and of life. I have called this the era of "biocybernetics" to empha-
size the interweaving of two technical advances that have affected
every level of human life—economic, aesthetic, political—in our
time. The invention of the computer and the decoding of DNA, the
"secret of life," are the names of this double revolution, and it is
their recombination that produces a new regime of digital images,
incarnated by the mythic avatar of biocybernetics we call "the
Clone." More generally, cloning as a figure for the technological
production of life epitomizes the epoch of what Michel Foucault
called "biopolitics," the transformation of modern states into en-
gines of "biopower" and the "governing of life," or "making live"

(*faire vivre*) in contrast to traditional polities in which the sover-
eign's primary power was expressed through the control of death.[2]

The contrast between the two levels of this history—call them
the "War on Terror" on the one hand and the "Clone Wars" on the
other—can be put into dramatic relief by reflecting on the ques-
tion of the dateable historical event. The war on terror is inaugu-
rated and defined by a date: September 11, 2001, "911," the number
of emergency.[3] The date has become a cognitive fetish, a talisman
to conjure up a break in world history as significant as Bastille Day,
the Fourth of July, and May Day. It is so specific, so iconized, that
it is not even dispersed across a momentous year such as 1492,
1789, or 1968. It defines a before and after, erecting a wall in time
between "pre-911" thinking and "post-911" thinking. Post-911 pun-
dits quickly declared an end to postmodern irony and skepticism,
an end to any trace of critical thinking that might oppose the utter
certainties of moral righteousness, coupled with the means of vio-
lence provided by the world's largest, deadliest military organiza-
tion. The ability to transform ideals into reality, to actualize the
imaginary, to convert a metaphoric into a literal war was given
to the post-911 neoconservative intellectuals as a fabulous gift.
Coupled with the ability to mobilize mass fear at will, this was a
prescription for the declaration of a holy war between good and
evil, along with all the warning signs of fascism: the declaration of
an indefinite state of emergency, consolidation of absolute power
in the sovereign, corruption of the judicial system, suspension of
basic human rights, and politicization of every branch of govern-
ment. The United States entered into a period in which the princi-
pal form of official, collective emotion was terror—the paralyzing
fear of an invisible, anonymous enemy that could strike any-
where without warning. But since this fear produced paralysis, the
cure was comforting: keep on shopping; don't do anything. Like
the experience of passing through airport security checkpoints
while an ominous voice announces that the terrorist alert level
has been raised to orange, the real message is to do nothing and
keep moving. Look after yourself and pay no attention to your un-
lucky neighbor. Keep the economy humming with borrowing and

spending, with tax cuts and creative transformations of imaginary wealth into real bucks for the lucky few, ruin and poverty for the vast majority. It was only when the economy crashed at the end of the Bush era that terror was replaced by panic, a form of affect that does not produce paralysis and stasis, but encourages a mandate for immediate, urgent action, prior to any careful reflection.[4] The economic bubble burst, creating the conditions for just such a political atmosphere. Obama's improbable, miraculous election appeared to be a piece of good luck for the American polity, just as George W. Bush's dubious legitimacy and manifest incompetence was a piece of incredibly bad luck. We need to reflect on this matter of "historical luck" more fully, because it leads us directly to the other side of the history, the "iconology of the present," that I have been exploring.

Does anyone remember the date on which the world's newspapers announced that the "secret of life" had been decoded? Not likely.[5] We just know that it was announced at some point in the last decade, that it was predicted a long time before that, and its implications for the future are still highly speculative. We know that, the day after the discovery of the secret of life, everything pretty much went back to normal, in contrast to the day after 9/11, when a state of global emergency was declared that changed everything.

So there are two temporalities and two notions of "the event" at work in the history of images I have been assembling in these pages. The temporality of the War on Terror is marked by very recent datable events that remain iconic in the collective imaginary. The temporality of the Clone Wars is of a much longer *durée*. It is an updating, a reliteralizing of a metapicture that has always haunted the human faculties of imagination and practices of representation. Making a living image of a living thing is the utopian goal of mimesis. It is a godlike act, and the clone signifies biotechnology's temptation to "play God." Biblical narratives of the origin of life reinforce the sacral character of the reproductive process. The creation of man is the story of making an artificial life form, and Eve may be regarded as a clone of Adam (on the

model of cloning as the production of a new creature from a part
of another). Even the doctrines of the Incarnation and the Virgin
Birth flirt with the process we now call cloning, as God "begets" his
Son, a perfect image of the Father, not by having sex with Mary,
but by using her virginal womb as the in vitro host for an already
quickened fetus, a copy of himself.[6] The Greeks would have under-
stood cloning as a botanical process of grafting and hybridization,
in which case the god is a gardener. Small wonder that the Clone
War, like the War on Terror, is a Holy War in which gods and holy
men play key roles. George W. Bush probably discussed stem cell
policies with the same "higher father" who advised him on the in-
vasion of Iraq.

Until now we have always fallen short of the perfect copy.[7] There
has always been a flaw in the simulacrum. It is always a mere copy,
belated, secondary, deficient. But the clone promises a deep copy,
a perfect transcript at both the digital and analog levels, visible
embodiment and molecular structure coordinated. The mythic,
metaphoric picture of the living image has been realized and liter-
alized in the same historical period as the onset of a War on Ter-
ror (also based in the literalizing of a metaphor), producing a con-
vergence of two distinct orders of historical time.

One way to put this is to note that the Clone Wars have been
going on since the concept was first popularized back in the 1970s,
and the figure of artificial life has been with us since time imme-
morial. The war on terror, by contrast, was provoked and declared
on specific dates, and it has been quietly "undeclared" by the
Obama administration.

The question, then, is what mediates these two temporali-
ties, the slow time of technical and structural innovation, and the
quick time of contingent historical events, including accidents of
birth, physical appearance, and temperament? My answer, pre-
dictably, is the image, and especially the iconic figure that comes
to express a collective emotion and reinforce a collective affect. I
think of these two modalities of history as epitomized in the work
of Jean-Paul Sartre and Michel Foucault. Sartre is all on the side
of historical contingency, the luck of the draw, the importance of

coincidence, irony, and the historical uncanny. Foucault, by contrast, is the historian of the long *durée,* of the onset of biopolitics and the biopicture as dominant modes of political consciousness since the eighteenth century.[8] History for Foucault is the story of impersonal systems, epistemes, disciplines, and institutions. Of course there are ruptures and breaks in Foucauldian history, but they only become iconic in retrospect, when the master historian arrives to perform the archaeological dig and reassemble the historical order of things. The birth of the biopicture, of biopolitics, occurs with Adam Smith and the nineteenth-century economists.[9] It bypasses Marx and takes for granted the supremacy of capitalism as the economic rationalization of Darwinism. The reduction of the public to a population to be controlled and regulated, even for its own good, is the key to the biopolitical paradigm. The image of man that emerges from this episteme is the clone, the interchangeable, nonsingular human organism. This might be thought of as the generic icon of the automaton, and it is tailor-made for the stereotype of the terrorist, the absolute enemy who is also depicted as the faceless, anonymous humanoid. Foucault's concept of the biopolitical went far beyond any technical issues of biology to confront the entire framework of neoliberal economics from the eighteenth century to Milton Friedman and the Chicago School. *Homo economicus,* the rational, clear-sighted clone of the market system with its blind forces and invisible hand, is the mirror image of *homo sacer,* the blinded sovereign subject wearing the hood of self-torture and self-deception.

Giorgio Agamben extended Foucault's insight into the biopolitical in its most extreme, emergent form: the phenomenon of the camp for refugees, illegal immigrants, or unlawful combatants, where humanity is reduced to "bare life," the figure of *homo sacer* that reduces the qualified life (*bios*) of which humans are capable to *zoe,* the mere existence of a living thing that may be killed without a second thought.[10] It is just a bit of historical luck, of contingency, that this figure emerged in a viral photograph of a scene staged in Abu Ghraib prison in October of 2003. But it is ironic, uncanny contingency that makes the precise formal and aesthetic

qualities of this image turn it into *Ecce Homo Sacer*, a fusion of the bare life of the torture victim and the all-too-familiar lineaments of Judeo-Christian sovereignty. It is this icon that brings together two forms of historical totalization: the long *durée* of biopolitics à la Foucault, and the concrete totalizing of Sartre in the singular figure. Abu Ghraib's Claw Man meets Sartre's Kaiser with the withered arm.[11] This is a poetics of history that, in my view, transcends the debate between Foucault's history of impersonal systems and Sartre's agents and accidents. This poetics is what throws up, from time to time, an icon that captures the structure of feeling of an epoch. This is the role that the Hooded Man has played in our time.

But what is "our time"? Is it the nightmare of the War on Terror and the Bush regime? Or is it captured in the simultaneity and coincidence of the debate over cloning and stem cells and the spectacular destruction of those architectural clones known as the twin towers?[12] Is the Sartrean existential situation only to be found here in the United States? Or is it something much longer range such as the meltdown of the global economy and ecology, and the gradual unfolding of the evolutionary implications of biopolitics and neoliberal ideology? Obviously it is all these things, and any attempt to provide a totalizing picture of our time must reckon with multiple temporalities, and the diverse ways in which various communities experience them. It must reckon above all with the new communities created by the hegemony of biopolitics, principally the vast increase in the numbers of refugees, displaced persons, undocumented resident aliens, and illegalized immigrants. According to the United Nations High Commissioner for Refugees, the War on Terror in its Iraqi "front" had the effect of producing 4.2 million displaced persons, about half of whom were forced to flee to neighboring countries.[13] The United States has taken little responsibility for the human costs of its War on Terror. Similarly, as of this writing it has declared the "Great Recession" and financial crash of September 2008 to be "technically" over while unemployment continued to rise.

All these declarations of the end of an epoch, coupled with

mandates to "look toward the future" and put the past behind us, must be viewed with suspicion. The election of Obama was indeed a decisive break with the Bush era—at the level of the imaginary. And the imaginary, as we have seen, is capable of becoming realized. But other, enduring realities of the War on Terror and the Clone Wars are far from over. The former may have been renamed as "Overseas Contingency Operations," and the latter may seem to be settled by policy adjustments concerning stem cell research, but they could return with a vengeance at the slightest unpredictable provocation. The basic biopolitical struggle for a decent, humane world order (including health care for the citizens of the world's most powerful democracy) is being waged on many fronts, and the specter of the dark recent past will preside over any conceivable present well into the unpredictable future. The Hooded Man of Abu Ghraib, accused terrorist, torture victim, anonymous clone, faceless Son of Man, will remain the icon of our time for the foreseeable future. And behind the veil of this spectral enemy, the faces of Jesus, Mohammad, and Moses will continue to haunt us.

Acknowledgments

It takes a village, perhaps even a global one, to write a book like this. Early in the Global War on Terror I sent an all points bulletin to my art historical colleagues, asking them to help me create an image archive, and I owe profound debts to Zainab Bahrani, Hans Belting, Hannah Higgins, Caroline Jones, Evonne Levy, John Ricco, and Joel Snyder. The editorial group of *Critical Inquiry*, Bill Brown, Lauren Berlant, Dipesh Chakrabarty, Arnold Davidson, Elizabeth Helsinger, Francoise Meltzer, Richard Neer, and (again) Joel Snyder provided constant stimulation and a salutary check on my enthusiasms. Hank Scotch did the heavy lifting as my research assistant, and the load was lightened at every turn by Jay Williams, managing editor of *Critical Inquiry*. Key institutions and individuals played a crucial role: the Franke Institute for the Humanities at University of Chicago, directed by Jim Chandler, provided a public and interdisciplinary forum to try out the basic idea; the Wissenschaftskolleg zu Berlin was the seed-bed for the first draft, with Horst Bredekamp's *Bildwissenschaftsgruppe* (a.k.a. the "Picture Boys" plus Anca Oroveanu), and Yaron Ezrahi, Ruth haCohen, Stefan Litwin, Lydia Liu, Nancy Fraser, and Eli Zaretsky supplying intellectual electricity throughout a memorable year; the Hamburger Bahnhof, the Thyssen Lectures of Humboldt University, and University of Munich's Lecture Series on "the iconic turn" in 2004–5 provided the public testing grounds for the first drafts, as did the Max Planck Institute's groundbreaking confer-

ence on cloning organized by Giuseppe Testa; the University of Rome's conference on Meyer Schapiro in 2006 organized by Maria Giuseppina di Monte opened up the "theme of state"; the Leverhulme Trust Distinguished Research Professorship at the University of Nottingham's School of Geography in 2007–8, where I was hosted by Stephen Daniels, provided a critical period of intense labor, as did the Clark Institute for Art History led by Michael Ann Holly; the Central European University in Budapest where I was hosted by Yehuda Elkanah provided critical inspiration, as did the Tate Modern conference on Ethics and Aesthetics, organized by Diarmud Costello and Dominic Willsdon; the Cardozo Law School's conference on Jacques Derrida in New York City organized by Peter Goodrich opened up the "autoimmunity" hypothesis; Tsinghua University in Beijing where Wang Ning hosted the editors of *Critical Inquiry* helped me to elaborate the concept in the context of "world pictures"; Birzeit University in Palestine, where I have often been the guest of Ahmad Harb, Karim Barghuti, Tania and Hanne Nasir, Roger Heacock, and Abdul Karim Fatah, linked the project to the white hot core of the Israeli-Palestinian question, as did my invitations to the Bezalel Academy and the Van Leer Institute at Hebrew University in Jerusalem, the COPRO Film Festival in Tel Aviv, the Shenkar Forum and the Tel Aviv Art Museum; the Chicago Humanities Festival and New York Humanities Institute, with Ren Weschler as the presiding spirit in two places at once linked the project to the work of Errol Morris; and the Catédra Arte de Conducta (literally, the "Institute for the Art of Conduct") created by Tania Bruguera in Havana, Cuba, introduced me to her concept of "useful art." I have also been inspired by the work and conversation of a number of visual artists, including Magdalena Abakanowicz, Larry Abramson, Tania Bruguera (again), Gregg Bordowitz, Antony Gormley, Hans Haacke, Errol Morris, and Robert Morris (again and again), as well as the various artists whose work is featured in these pages.

Judith Butler and Marq Smith made crucial interventions with their incisive, detailed reader's reports in the final stages of the project, and the earliest stages would never have been possible

without the support of my wife, Janice Misurell-Mitchell, my children, Carmen and Gabriel Mitchell, and my closest of friends and neighbors, Bill Ayers and Bernardine Dohrn, Ellen Esrock and Ned McLennen, Bonita Plymale and Florence Tager. My steadfast editor, Alan Thomas, who read every page of this book, and many discarded ones, deserves eternal credit for whatever merits it may have.

And for inspiring many of the words and thoughts in these pages I must mention Gil Anidjar, Mark Benjamin, Akeel Bilgrami, Gottfried Boehm, Jonathan Bordo, Neal Curtis, Stephen Eisenman, Peter Galison, Hajo Grundmann, Scheherezade Hassan, Fredric Jameson, Rashid and Mona Khalidi, Norman Macleod, Hillis Miller, Nicholas Mirzoeff, Marie-Jose Mondzain, May Muzafar, Daniel Rabinowitz, Jacques Ranciere, Mark Siegler, Gyorgy Endre Szonyi, Michael Taussig, and Slavoj Zizek.

And finally, the two mentors, whose work, like oil and vinegar, do not quite mix but nevertheless flavor the unruly salad of this book, and to whose memory it is dedicated: Jacques Derrida and Edward Said.

Notes

Preface

1 Political scientist Robert Pape has argued convincingly that suicide terrorism is a tactic that generally arises among populations that live under military occupation by a foreign power. There were no suicide bombers in Iraq before the U.S. invasion and occupation, and suicide bombing in Israel-Palestine only began after decades of military occupation. See his *Dying to Win: The Strategic Logic of Suicide Terrorism* (New York: Random House, 2005).

2 "Full Text: July 2007 National Intelligence Estimate (NIE) on Al Qaeda Threat to U.S. Homeland," http://intelwire.egoplex.com/2007_07_17_exclusives.html. Accessed November 21, 2009.

3 Scott Shane, "6 Years after 9/11, the Same Threat," *New York Times*, July 18, 2007. http://www.nytimes.com/2007/07/18/washington/18assess.html?_r=1. Accessed November 21, 2009.

4 See Eric Brewer's analysis of data on worldwide deaths from terrorist attacks provided by the Rand Corporation and the National Counterterrorism Center (NCTC), which discloses what he calls the "Bush Bubble," a sharply increasing death rate after the onset of the War on Terror. http://rawstory.com/news/2008/White_House_Increase_in_terror_attacks_0110.html. Accessed November 21, 2009.

5 Anatol Rapaport, "Editor's Introduction" to Carl von Clausewitz, *On War* (first pub. 1832; London: Penguin Classics, 1968), 53. Anatol Rapaport is a distinguished game theorist and former professor on the Committee on Mathematical Biology at the University of Chicago.

6 Dan Froomkin, "War: The Metaphor," special to washingtonpost.com, August 4, 2005.

7 Statement by Captain Dan Moore, the head of Naval ROTC at Northwestern University at the first teach-in on the Abu Ghraib photos, June 2004.

8 Ron Suskind, "Faith, Certainty, and the Presidency of George W. Bush," *New York Times Magazine*, October 17, 2004. The key Bush aide turns out to be Karl

Rove. See http://maschmeyer.blogspot.com/2009/03/reality-based-community
.html.

9 Friedrich Nietzsche, *Twilight of the Idols* (1888), from *The Portable Nietzsche,*
ed. and trans. Walter Kaufmann (New York: Viking Penguin, 1954), 466.

Chapter One

1 The second epigraph to this chapter is from Gil Anidjar, *The Jew, the Arab:
A History of the Enemy* (Stanford, CA: Stanford University Press, 2003), xxiii.

2 There are precedents, of course, for a war on a concept or abstraction. The cold
war was widely understood as a war against international communism. But com-
munism had identifiable nation-states (the Soviet Union and China) as its spon-
sors, and it came to a fairly definite end in 1989, with the fall of the Soviet regime.
The other precedent that comes to mind is the Crusades, portrayed as a war to
"liberate" the Holy Land from the Muslims. But there the goal was also definite,
and the conquest of Jerusalem was understood to be the central objective.

3 NBC's *Today* show, August 30, 2004. See Dan Froomkin, "War: The Metaphor,"
special to Washingtonpost.com, August 5, 2005.

4 See my discussion of the "Saddam as Hitler" iconography in the first Gulf
War in my essay "From CNN to JFK," in *Picture Theory: Essays on Verbal and Vi-
sual Representation* (Chicago: University of Chicago Press, 1994). On the ontol-
ogy of the enemy as a kind of vanishing entity, see Anidjar's brilliant discussion
in *The Jew, the Arab,* xxiii.

5 My thanks to Stephen Daniels for this suggestion.

6 Artist Phil Toledeano produced a "bobble-head" version of the Abu Ghraib man
(a doll with a bobbing head) as part of his "American Gift Shop" project in October
of 2009. The doll had to be produced in Shenzhen, China, because no American
toy manufacturer would touch it. Toledeano explained his choice of the image as
follows: "it was one of the most iconic images of the war. . . . It was the Iraq war's
'naked girl running down the road after being napalmed.'" See http://www.amer
icathegiftshop.com/#/5. Accessed December 3, 2009. Toledeano's "shop" also of-
fers such items as neon signs advertizing "Regions Destabilized" and an inflat-
able Guantanamo Bay prison cell. See also http://amysteinphoto.blogspot.com/
2009/10/must-see-shows.html. Accessed November 14, 2009.

7 This image first appeared in the *Scranton Tribune* (the morning edition of the
Scranton Times), May 12, 2004. My thanks to Dennis Draughon for allowing me
to reproduce it here.

8 Sarah Palin's most telling joke in her speech to the 2008 Republican conven-
tion was to compare a community organizer to a small town mayor, with the
difference being that a mayor (which she had been) had actual responsibilities
to a constituency.

9 See Lev Manovich's essay on social media, "The Practice of Everyday (Media)

Life: From Mass Consumption to Cultural Production," *Critical Inquiry* 35, no. 2 (Winter 2009), 319–31.

10 Obama used the traditional medium of television, of course. But his ability to dominate this terrain was based in the massive amount of fund-raising he was able to muster from small donors through the Internet.

11 See Robert Draper, "And He Shall Be Judged," *GQ*, May 2009, for a discussion of the way Secretary of Defense Rumsfeld provided the president daily intelligence briefings headed by biblical quotations emphasizing the "crusader" character of the war.

12 See Rashid Khalidi's *Sowing Crisis: The Cold War and American Dominance in the Middle East* (Boston: Beacon Press, 2010) on the persistence of cold war imagery in contemporary politics and in the war on terror; see also Jacques Derrida's argument, in his interview with Giovanna Borradori in *Philosophy in a Time of Terror* (Chicago: University of Chicago Press, 2003), that the war on terror was a biopolitical mutation of the cold war, a "Cold War in the Head," or "head cold." This argument will be discussed at length in chapter 4.

13 The proximity of Obama's election to a revolution was of course made explicit in the right-wing portrayal of him as a radical, a Muslim, and a communist. But it also became a quite real issue in the debate over the criminality of the Bush administration, and the question of trying them for war crimes. As Philip Gourevitch noted in spring of 2009: "As a rule. The war-crimes prosecutions of the past century were conducted by a group of states, acting collectively, against (usually defeated) leaders of another state. When states hold their own leaders to account, it tends to happen not after an election but after a revolution." *New Yorker,* May 11, 2009, 34.

14 See Griselda Pollock, "Response to W. J. T. Mitchell," in *The Life and Death of Images,* ed. Diarmud Costell and Dominick Willsdon (London: Tate Publications, 2008), 209.

15 Frank Rich, "The Culture Warriors Get Laid Off," *New York Times,* March 15, 2009, 12.

16 See my essay, "The Work of Art in the Age of Biocybernetic Reproduction," in *What Do Pictures Want?* (Chicago: University of Chicago Press, 2005).

Chapter Two

1 The second epigraph to this chapter is from Gil Anidjar, *The Jew, the Arab: A History of the Enemy* (Stanford, CA: Stanford University Press, 2003), 131.

2 See Frank Rich, "The Culture Warriors Get Laid Off," *New York Times,* March 14, 2009.

3 *Human Cloning and Human Dignity: The Report of the President's Council on Bioethics,* with a foreword by Leon R. Kass, chairman. (New York: Public Affairs, 2002).

4 See Oliver Burkeman and Alok Jha, "The Battle for American Science," *Guardian*, April 10, 2003. "Rove's alertness to Bush's Christian-conservative voter base and Kass's moral convictions proved a powerful combination when it came to one of the most radical science policy changes to emerge from the current White House: the clampdown on human cloning."

"The Bush presidency was in its infancy when Rove identified cloning as a topic that needed to be tackled. The administration's contempt for the issue was made transparent when he suggested introducing a bill into Congress that would ban all forms of cloning. Kass readily agreed: 'We are repelled by the prospect of cloning human beings,' he has written, 'not because of the strangeness or novelty of the undertaking, but because we intuit and feel the violation of things that we rightfully hold dear.'"

5 It's important, however, to keep in mind here Walter Laqueur's observation that terrorism is a thoroughly ideological term, and that yesterday's terrorist is frequently today's hero of national liberation. *A History of Terrorism* (New Brunswick, NJ: Transaction, 2001). One can see this sort of transformation at work in the month-by-month mutations of the status of Moqtada al Sadr, the "fiery cleric" who led the Shiite insurrection in Iraq in the early years of the U.S. occupation. Al Sadr has been denounced as a criminal, reviled as a murderer, and hunted as a terrorist, but ultimately he was invited to join the "political process."

6 Robert Pape, *Dying to Win: The Strategic Logic of Suicide Terrorism* (New York: Random House, 2006).

7 Geoffrey Nunberg, "How Much Wallop Can a Simple Word Pack?" *New York Times*, July 11, 2004, Op Ed page.

8 See Ann Mongoven, "The War on Disease and the War on Terror: A Dangerous Metaphorical Nexus," *Cambridge Quarterly of Healthcare Ethics* 15, no. 4 (2006): 403–16.

9 See chap. 2, "Metapictures," in my *Picture Theory* (Chicago: University of Chicago Press, 1994).

10 Peter Arnett reported this as the view of an anonymous American officer during the Tet Offensive of 1968. It turns out to be quite difficult to trace the precise source of the quotation, which has become central to the folklore of asymmetrical wars against insurgencies.

11 Quoted in "The Haze Administration: 'War on terror' Is Out; 'overseas contingency operations' Is In," *Wall Street Journal*, April 5, 2009.

Chapter Three

1 This chapter was originally delivered as the keynote address for "Times of Cloning: Historical and Cultural Aspects of a Biotechnological Research Field,"

a symposium at the Max Planck Institute for the History of Science, Berlin, March 1–4, 2007. I am grateful to the organizers, Hans-Jorg Rheinberger, Giuseppe Testa, and Christina Brandt, for this extraordinarily stimulating event.

2 Richard Lewontin, "The Confusion over Cloning," *New York Review of Books*, 44, no. 16, (October 23, 1997): 18–23.

3 Sarah Franklin, "Making Miracles: Scientific Progress and the Facts of Life," *Reproducing Reproduction,* ed. Sarah Franklin and Helena Ragone (Philadelphia: University of Pennsylvania Press, 1998), 103.

4 The OED's stipulation of a "single sexually produced ancestor" is not consistent with contemporary biological thinking, however, and may be a relic of an earlier view. I'm grateful to Kevin Foster, professor of biology at Rice University, for pointing this out.

5 See my discussion of "metapictures" (pictures of pictures) in the chapter by this title in *Picture Theory* (Chicago: University of Chicago Press, 1994), and the concept of the "hypericon," the "image of image *production*," discussed in *Iconology* (Chicago, : University of Chicago Press 1986), 5.

6 Jean Baudrillard, *The Vital Illusion* (New York: Columbia University Press, 2001), 18.

7 Jean Baudrillard, *The Evil Demon of Images* (St. Louis: Left Bank Books, 1987).

8 Theodor Adorno and Max Horkheimer, *Dialectic of Enlightenment* (1st German edition, 1944; New York: Continuum, 1990), 5, 42, 32.

9 I borrow this phrase from Michael Thompson's classic essay, "The Representation of Life," in *Virtues and Reasons: Essays in Honor of Phillippa Foote,* ed. Rosalind Hursthouse, Gavin Lawrence, and Warren Quinn (Oxford: Clarendon Press, 1995), 248–96.

10 Pamela Sargent, *Cloned Lives* (Greenwich, CT: Fawcett Publications, 1976).

11 Kazuo Ishiguro, *Never Let Me Go* (New York: Vintage, 2006), 166.

12 See, for instance, Jesse Reynolds, "The New Eugenics," in *Z Magazine* 11, no. 15 (November 2002): "anti-abortion rights activists view research cloning as abortion in the name of science." http://zmagsite.zmag.org/Nov2002/Reynolds1102.htm. Accessed February 27, 2007.

13 See *Never Let Me Go,* discussed above.

14 See the memo by Assistant Attorney General Jay S. Bybee (now a federal judge with a lifetime appointment) arguing that torture "must be equivalent in intensity to the pain accompanying serious physical injury, such as organ failure, impairment of bodily function, or even death." Dana Priest and R. Jeffrey Smith, "Memo Offered Justification for Use of Torture," *Washington Post,* June 8, 2004, A01. See also U.S. Department of Justice Memo from Deputy Assistant Attorney General John Yoo to Albert Gonzales, White House Counsel. http://news.findlaw.com/hdocs/docs/doj/bybee801021tr.html. Accessed

December 3, 2009. Even more disturbing than the fact that the designers of the torture system remain unpunished to this day is the continuation, in the Obama administration, of legalistic sleight of hand to justify questionable procedures under the alibi of fighting terrorism. See Charlie Savage, "Obama Team Split on Tactics against Terror," *New York Times,* March 29, 2010, 1, 6.

15 I am grateful to Joshua Carney, associate instructor in communication and culture at Indiana University, for bringing this film to my attention.

16 In return for donating his DNA sequence, Jango Fett received 5 million credits, and "an unaltered clone by the name of Boba," who becomes his "only begotten son" (as it were) and goes on to become a feared enemy in the *Star Wars* saga. See *Wookipedia,* s.v. "Grand Army of the Republic." http://starwars.wikia.com/wiki/Grand_Army_of_the_Republic. Accessed December 3, 2009.

17 Ernesto Laclau, *On Populist Reason* (New York: Verso, 2007).

18 See my essay, "Headless/Heedless: Experiencing Magdalena Abakanowicz," in *Learning Mind: Experience into Art,* ed. Mary Jane Jacob (Berkeley: University of California Press, 2009). As Abakanowicz herself explains: "It happened to me to live in times which were extraordinary by their various forms of collective hate and adulation. Marchers and parades worshipped leaders, great and good, who turned out to be mass murderers. I was obsessed by the image of the crowd, manipulated like a brainless organism and acting like a brainless organism. I began to cast human bodies in burlap to finish in bronze, headless and shell-like. They constitute a sign of lasting anxiety." The notable departure of *Agora* is Abakanowicz's decision to double the "headlessness" of the crowd by arranging it as *leaderless*—which may, all things considered, be a hopeful sign. Source: http://www.princeton.edu/pr/pwb/04/0920/8n.shtml. Accessed December 3, 2009. My thanks to Alan Thomas for help with this point.

19 I'm quoting from conversations with William Fox, poet, scholar, and nature writer. See also Thomas E. Graedel and Paul J. Crutzen, *Atmosphere, Climate, and Change* (New York: Scientific American Library, 1995).

Chapter Four

1 This chapter was originally written for the Cardozo Law School's symposium on Derrida in February of 2005, and appears in a substantially different version in *Cardozo Law Review* 27, no. 2 (November 2005): 913–25. It was reprinted with minor revisions in *Critical Inquiry* 33, no. 2 (Winter 2007), a special issue on Derrida, reissued in book form as *The Late Derrida,* ed. W. J. T. Mitchell and Arnold Davidson (Chicago: University of Chicago Press, 2007). The epigraph to this chapter is from Dexter Filkins, "Profusion of Rebel Groups Helps Them Survive in Iraq," *New York Times,* December 2, 2005, 1.

2 http://www.nlm.nih.gov/medlineplus/ency/article/000816.htm.

3 See Rashid Khalidi, *Sowing Crisis: The Cold War and American Dominance in the Middle East* (Boston: Beacon Press, 2009), on the persistence of cold war imagery in the War on Terror.

4 Jacques Derrida, interview with Giovanna Borradori, in *Philosophy in a Time of Terror* (Chicago: University of Chicago Press, 2003). References to this interview are cited in parentheses in the text and notes.

5 I am indebted here and throughout to conversations about the immune system with Dr. Hajo Grundmann, who was my colleague at the Wissenschaftskolleg in Berlin in 2004–5. Dr. Grundmann is senior lecturer of epidemiology at the National Institute for Public Health and the Environment, Bilthoven, The Netherlands.

6 The model of the foreign invasion continues to be central to the Obama administration, particularly in its Afghanistan policy, which is based on a notion that if the Taliban is not defeated, Afghanistan will become a base for terrorist training camps that will send attackers against the United States. This is the same kind of misguided thinking that turned Iraq into the "front" (*sic*) of the War on Terror.

7 Also on the symbolic "twin towers" (whose uncanny "twin-ness" or "clonal" character will be discussed later). As Jean Baudrillard noted, "The Twin Towers no longer had any facades, any faces. . . . As though architecture, like the system, was now merely a product of cloning, and of a changeless genetic code." *The Spirit of Terrorism*, trans. Chris Turner (London: Verso, 2002), 40. We should also note that the twin towers had been chosen, against all logic, as the nerve center of the FBI's counterterrorism offices in New York City.

8 Donna Haraway, "The Biopolitics of Postmodern Bodies: Constitution of Self in Immune System Discourse," in *Cyborgs, Simians, and Women* (New York: Routledge, 1991), 203–54, quote on p. 205. For a capsule history of the evolution of immunology, see Francisco J. Varela and Mark R. Anspach, "The Body Thinks: The Immune System and the Process of Somatic Individuation," in *Materialities of Communication*, ed. Hans Ulrich Gumbrecht and K. Ludwig Pfeiffer (Palo Alto, CA: Stanford University Press, 1994), 273–85.

9 For an excellent discussion of the metaphor in ancient philosophy, see John Protevi, *Political Physics: Deleuze, Derrida, and the Body Politic* (London: Athlone Press, 2001).

10 Hans Belting reminds me that this "bipolar image" also has a religious foundation in the concept of *corpus Christi,* the "body of Christ," which is both the collective body of believers and the Eucharistic body consumed in the sacrament of the Eucharist. The same indecidable figure of part for whole, whole for part, synecdoche and reverse synecdoche operates in the Christological discourse.

11 Arthur M. Silverstein, *A History of Immunology* (San Diego, CA: Academic Press, 1989), 1.

12 As Derrida puts it, "What is terrible about 'September 11' . . . is that we do not *know* what it is and so do not know how to describe, identify, or even name it" (94).

13 It must be said, however, that Derrida is far less interested in pursuing the metaphor of the immune system in its "proper" realm of immunology than I am. He does not privilege this notion, as he says, "out of some excessive biologistic or geneticist proclivity" (quoted in Rodolphe Gasche, review of Derrida's *Rogues: Two Essays on Reason, Research in Phenomenology* 34 [2004]: 297). My aim here is to explore the "excess" or supplementarity of the metaphor.

14 The "clonal selection theory of acquired immunity" was developed by Frank McFarlane Burnet, who won the Nobel Prize for his efforts. See the article on Burnet in *The Encyclopedia of Life Sciences,* http://www.els.net.

15 The use of high altitude bombing, and even of the more precise drones to conduct "surgical strikes" on the suspected terrorist concentrations generally, has the effect of making things worse by killing many more innocent civilians than certifiable terrorists, thus provoking a reaction against the United States, and a tendency to side with its enemies. See David Kileullen and Andrew McDonald Exum, "Death from Above, Outrage Down Below," *New York Times,* May 17, 2009, The Week in Review, 13.

16 As of June 15, 2006, TheReligionofPeace.com, a right-wing Web site, counts 5,159 terrorist attacks worldwide since 9/11. Their conclusion, however, is that Islam itself is the principal danger.

17 See the discussion of Kennedy's work by John Seabrook in "Don't Shoot: A Radical Approach to the Problem of Gang Violence," *New Yorker,* June 22, 2009, 32–41.

18 Nicholas Kristof, "Johnson, Gorbachev, Obama," *New York Times,* December 3, 2009, A33.

19 See Greg Mortensen, *Stones into Schools: Promoting Peace with Books, Not Bombs, in Afghanistan* (New York: Viking, 2009): "It was all decided on the basis of congressmen and generals speaking up, with nobody consulting Afghan elders." Quoted in Kristof, "Johnson, Gorbachev, Obama."

20 It was conjectured at the time that the short gap between the first and second impact on the twin towers was calculated to maximize media coverage, since it was obvious that every video camera at the center of the global media system would be trained on the World Trade Center immediately after the initial strike.

21 See the "Uncle Osama" recruiting poster (fig. 11, p. 65) that appeared in the *New York Times,* calling on all patriotic Americans to invade Iraq, a bit of irony

that was lost on the Bush administration, which did exactly what al Qaeda wanted. See also Richard A. Clarke's *Against All Enemies: Inside America's War on Terror* (New York: Free Press, 2004). for a discussion by the head of U.S. counterterrorism under four different presidencies of the folly of the war in Iraq as a response to "terror."

Chapter Five

1 This chapter was first written for a festschrift in honor of Ronald Paulson, published by *ELH* 72, no. 2 (Summer 2005): 291–308.

2 Paulson takes his terms from Thomas Whateley's *Observations on Modern Gardening* (London, 1771), which link the emblematic garden with legible, readable features, and allegorical monuments, while urging an "expressive" aesthetic that produces "immediate impressions." See Ronald Paulson, *Emblem and Expression: Meaning in English Art of the Eighteenth Century* (Cambridge, MA: Harvard University Press, 1975), 52.

3 See also Jacques Rancière on the "sentence image," in *The Future of the Image* (New York: Verso, 2007), 48.

4 Paulson, *Emblem and Expression*, 8.

5 For further discussion of Saussure's concept of the signifier/signified relation as a version of the "word and image" problem, see my essay, "Word and Image," in *Critical Terms for Art History*, ed. Robert S. Nelson and Richard Shiff (Chicago: University of Chicago Press, 1996), 47–58.

6 I am referencing here Jacques Derrida's concept of difference (a deferring, dividing moment) and Jean-Francois Lyotard's "differend," the concept of conflict or disagreement. See Lyotard, *The Differend: Phrases in Dispute*, trans. George VanDen Abbeele (Minneapolis: University of Minnesota Press, 1988).

7 I discuss the differentiations at length in *Iconology* (Chicago: University of Chicago Press, 1986). The Lacanian distinction between the scopic and vocative is discussed in *What Do Pictures Want?* (Chicago: University of Chicago Press, 2005), 351–52.

8 In Jacques Derrida, *Languages of the Unsayable*, ed. Sanford Budick and Wolfgang Iser (New York: Columbia University Press, 1989), 3–70.

9 We should, of course, distinguish the unspeakable from the unsayable. In English vernacular, quite different shades of meaning are associated with "I cannot say" and "I cannot speak."

10 Ludwig Wittgenstein, *Tractatus Logico-Philosophicus*, trans. D. F. Pears and B. F. McGuinness (London: Routledge and Kegan Paul, 1961).

11 John Conroy, *Unspeakable Acts, Ordinary People: The Dynamics of Torture* (Berkeley: University of California Press, 2000).

12 Ruth Leys suggests that trauma theory as a whole can best be understood

as "simultaneously attracted to and repelled by the mimetic-suggestive" model of trauma. Trauma is seen, on the one hand, as hyper-representational, richly mediated by words and images that "haunt" the victim and require something like hypnotic restaging and working through to effect a cure. On the other hand, contemporary "brain-centered" trauma theory regards it, by contrast, as a radically unrepresentable "Real" that cannot be told or displayed. See Leys, *Trauma: A Genealogy* (Chicago: University of Chicago Press, 2000), 6–8. See also Cathy Caruth's *Unclaimed Experience: Trauma, Narrative, and History* (Baltimore: Johns Hopkins University Press, 1996) for a culturalist version of the antimimetic model of trauma as standing outside representation.

13 See Jacques Rancière, "Are Some Things Unrepresentable?" in *The Future of the Image,* chap. 5.

14 Giorgio Agamben, *Homo Sacer* (Stanford, CA: Stanford University Press, 1998).

15 Robert Griffin notes that I am fusing (and con-fusing) two different analogies in Saussure: the first is the comparison of "language to a sheet of paper" in which "thought is the front and the sound is the back" (Ferdinand de Saussure, *Course in General Linguistics,* trans. Wade Baskin [New York: McGraw-Hill, 1966], 113]. The second is the coin, as a metaphor for the exchange value of a sign for something different from itself (a loaf of bread) or something similar to itself (another coin). One might reflect at some length on the motivation for Saussure's two metaphors for language as a form of paper versus metal currency, the one an infinitely divisible medium that is "cut" to produce an infinity of relations between thought and sound, signified and signifier, the other as a hard object whose importance resides in its value or fungibility, not its significance. In either case, the limit condition of the sign (either in an excess or depletion of significance and value) is figured at the convergence of trauma and religious experience. As Blake puts it in "The Mental Traveller": "These are the gems of the Human Soul / The rubies & pearls of a lovesick eye / The countless gold of the akeing heart / The martyrs groan & the lovers sigh." The signified that exceeds all signifiers and the priceless commodity are the semiotic and economic figures of the unspeakable and unimaginable.

16 See Moishe Halbertal and Avishai Margalit, *Idolatry* (Cambridge, MA: Harvard University Press, 1992), for a discussion of the difference between verbal and visual representations of the deity.

17 It is tempting to return here to Saussure's other brilliant analogy for language as a relation of "thought and sound" as something like the interface between two chaotic media or "shapeless masses"—"the air in contact with a sheet of water" (*Course,* 112). "The waves resemble the union or coupling of thought with phonic substance." The unspeakable/unimaginable, then, would be the moment when the orderly succession of linguistic "waves" (of thought/

sound) is interrupted by some chaotic disturbance or excess—a vortex or mael-strom (or a catastrophic tsunami) in language.

18 See, for instance, Joel Snyder's investigations of photography as a "picturing of the invisible," in his article, "Visualization and Visibility," in *Picturing Science/Making Art,* ed. Carrie Jones and Peter Galison (London: Reaktion Books, 1997).

19 See Susan Stewart's "The Marquis de Meese" for a canny discussion of the way the Meese Commission Report on pornography, an attempt to justify the prohibition of pornography, was itself consumed as pornography. *Critical Inquiry* 15, no. 1 (Fall 1998).

20 See the discussion of violence as a way of sending messages in my article on "Representation and Violence," in *Violence in America,* ed. Ron Gottesman, 3 vols. (New York: Scribners, 1997).

21 The city of Leuven in Belgium, for instance, was chosen by the Nazis in World War II to "set an example" to the Belgians of what would happen to *all* their cities if they did not surrender. Similarly, the execution or torture of non-combatants, or the collective punishment of a people that is thought to be "har-boring" terrorists, is itself a form of terror, and a war crime. George W. Bush's declaration early in the War on Terror that we would "make no distinction" between terrorists and those who "harbor" them was a clear declaration of criminal intent from the standpoint of international law, and the "quaint" doc-trines of the Geneva Convention.

22 Richard Clarke, *Against All Enemies: Inside America's War on Terror* (New York: Free Press, 2004), 138.

23 See, for instance, Kass's "Testimony presented to the National Bioethics Advisory Commission," March 14, 1997, Washington, DC, for a sample of what passes for reasoning about human cloning:

repugnance is often the emotional bearer of deep wisdom, beyond reason's power fully to articulate it. Can anyone really give an argument fully adequate to the hor-ror which is father-daughter incest (even with consent) or having sex with animals or eating human flesh, or even just raping or murdering another human being? Would anyone's failure to give full rational justification for his revulsion at these practices make that revulsion ethically suspect? Not at all. In my view, our repug-nance at human cloning belongs in this category. (http://www.all.org/abac/clontx04 .htm, accessed May 21, 2003)

24 See "The Surplus Value of Images," in my *What Do Pictures Want?* for a fuller account of the second commandment's relation to the notion of the living image.

25 Leon Kass's preface to *Human Cloning and Human Dignity* (New York: Public Affairs, 2002), the Report of the President's Council on Bioethics, makes an ex-plicit connection between the terrorist attacks of September 11 and the issue of cloning: "Since September 11," notes Kass, "one feels a palpable increase in Amer-

ica's moral seriousness. . . . We more clearly see evil for what is." (xv). Kass recommends "a prudent middle course, avoiding the inhuman Osama bin Ladens on the one side and the post-human Brave New Worlders on the other" (xvi).

26 Strictly speaking, the role of *sacrificial* victim is ruled out for Agamben's *homo sacer*. He is the figure who "may be killed but not sacrificed." But this is a matter of perspective. From the point of view of the terrorist, of course, suicide is normally an altruistic act of sacrifice for the greater good.

Chapter Six

An earlier version of this chapter was published as "Cloning Terror: The War of Images, 9-11 to Abu Ghraib," in *The Life and Death of Images*, ed. Diarmuid Costello and Dominic Willsdon (Tate Publishing, 2008). © Tate 2008. Reproduced by permission of Tate Trustees.

1 The first epigraph to this chapter is from Norman Macleod, "Images, Tokens, Types, and Memes: Perspectives on an Iconological Mimetics," in *The Pictorial Turn*, ed. Neal Curtis (London: Routledge, 2010).

2 For further discussion, see Sandor Hornyk, "On the Pictorial Turn," *Exindex* 25, no. 2 (February 2005). The original essay version of "The Pictorial Turn" appeared in *Artforum*, March 1992, 89ff. The German translation appears as the first chapter in *Privileg Blick: Kritik der visuellen Kulturen*, ed. Christian Kravagna (Berlin: Edition ID-Archiv, 1997), 15–40. See also *The Pictorial Turn*, ed. Neal Curtis, a special issue of the journal *Culture, Theory, and Critique* (Fall 2009), to be reissued as a book by Routledge (2010).

3 For a thorough discussion of the scientific reliance on images as life forms, see the essay by Norman Macleod in "The Pictorial Turn," a special issue of *Culture, Theory, and Critique* (Fall 2009). See also my discussion of the image/species connection in "On the Evolution of Images," in *The Last Dinosaur Book: The Life and Times of a Cultural Icon* (Chicago: University of Chicago Press, 1998), 103–10, and "The Surplus Value of Images," in *What Do Pictures Want?* (Chicago: University of Chicago Press, 2005), 76–109.

4 Ludwig Wittgenstein, *Philosophical Investigations*, trans. G. E. M. Anscombe (New York: Macmillan, 1953), 32. Wittgenstein thinks of family resemblance as a way of deconstructing the notion that all members of a family (e.g., all the things called "games") must have "something in common." He calls the urge to find the essence or common element of all the things sharing the same name a mere "playing with words." My sense is that such word play is incorrigible and is productive of inexact but nevertheless compelling pictures in both scientific and ordinary language.

5 See Michel Foucault's *The Birth of Biopolitics: Lectures at the College de France, 1978–1979*, trans. Graham Burchell (New York: Palgrave-Macmillan, 2008), 227–29.

6 For a more extended reading of this film, and the whole history of the dinosaur as a cultural icon, see my study, *The Last Dinosaur Book.*

7 At the time *Jurassic Park* was released, the reanimation of extinct animals by cloning was widely seen as impossible, or at least highly improbable, since fossils generally do not contain any trace of soft tissues containing DNA. Since the early nineties, however, it has become clear that the cloning of Siberian mammoths (whose flesh has been preserved in glaciers) is a possibility. And there have recently been discoveries of dinosaur fossils containing soft tissue as well. The impossible, in short, is a historical, not an absolute, prohibition.

8 For more on the question of images, animals, and figures of futurity, see my essay, "The Future of the Image," in "The Pictorial Turn," a special issue of *Culture, Theory, and Critique* (Fall 2009).

9 See my essay, "The Work of Art in the Age of Biocybernetic Reproduction," in *What Do Pictures Want?*

10 "Autoimmunity," in Giovanna Borradori, *Philosophy in a Time of Terror: Dialogues with Jurgen Habermas and Jacques Derrida* (Chicago: University of Chicago Press, 2003). See chapter 4 above for further discussion of this concept.

11 Giorgio Agamben, *Homo Sacer: Sovereign Power and Bare Life*, trans. Daniel Heller-Roazen (Stanford, CA: Stanford University Press, 1998).

12 "Clones symbolize modern homosexuality," notes Martin P. Levine, in *Gay Macho: The Life and Death of the Homosexual Clone* (New York: New York University Press, 1998); see also Roger Edmondson, Clone: *The Life and Legacy of Al Parker, Gay Superstar* (Los Angeles: Alyson Publications, 2000).

13 See Tom Abate, "Odd-Couple Pairing in U.S. Cloning Debate: Abortion-Rights Activists Join GOP Conservatives," *San Francisco Chronicle*, August 9, 2001. Abate notes that the opposition to cloning is based in quite different grounds: "feminists . . . object to cloning" because "it will turn women's eggs and wombs into commodities, while abortion opponents" tend to equate cloning with abortion. See http://www.sfgate.com/cgi-bin/article.cgi?file=/chronicle/archive/2001/08/09/MN24275.DTL.

14 See Ernesto Laclau, *On Populist Reason* (New York: Verso, 2007), for an authoritative discussion of populism, the crowd, and the masses.

15 http://web.archive.org/web/20050924035118/www.weeklyworldnews.com/conspiracies/58985. Accessed November 18, 2005. *The Weekly World News* also reports that the terrorists have perfected a bomb that will turn everyone within thirty miles of its detonation point into a homosexual: http://web.archive.org/web/20051026003801/weeklyworldnews.com/conspiracies/61525.

16 Jean Baudrillard, *The Spirit of Terrorism*, trans. Chris Turner (New York: Verso 2002), 38, 40.

17 See Terry Smith, *The Architecture of Aftermath* (Chicago: University of Chicago Press, 2006).

18 The Taliban envoy was Sayed Rahmatullah Hashimi. See "Taliban Explains Buddha Demolition," *New York Times*, March 19, 2001. "The destruction, according to his account, was prompted last month when a visiting delegation of mostly European envoys and a representative of the United Nations Educational, Scientific and Cultural Organization offered money to protect the giant standing Buddhas at Bamian, where the Taliban was engaged in fighting an opposition alliance. Mr. Rahmatullah said that when the visitors offered money to repair and maintain the statues, the Taliban's mullahs were outraged. "The scholars told them that instead of spending money on statues, why didn't they help our children who are dying of malnutrition? They rejected that, saying, 'This money is only for statues.'"

19 See http://www.paktribune.com/images/EditorImages/Bamiyancalendar .jpg. Accessed December 5, 2009.

20 See David Simpson, *9/11 and the Culture of Commemoration* (Chicago: University of Chicago Press 2005), for a critique of the "memory industry" around September 11.

21 Pastor Mavrakos is a Seventh Day Adventist minister.

22 See Robert Draper, "And He Shall Be Judged," GQ, June 2009, on Donald Rumsfeld's daily "Worldwide Intelligence Updates," which were sprinkled with biblical quotations "mixing . . . Crusades-like messaging with war imagery." http://www.gq.com/news-politics/newsmakers/200905/donald-rumsfeld-ad ministration-peers-detractors. Accessed November 22, 2009.

23 See Kevin Clarke's Web site for a discussion of this image: http://www.kevin clarke.com/.

24 See Richard A. Clarke, *Against All Enemies: Inside America's War on Terror* (New York: Free Press, 2004).

25 As Condoleezza Rice put it in urging the invasion of Iraq despite the "uncertainty" surrounding its WMD, "We don't want the smoking gun to be a mushroom cloud." "Top Bush Officials Push Case against Saddam," CNN.com/Inside-politics, September 8, 2002. http://archives.cnn.com/2002/ALLPOLITICS/09/08/iraq.debate/. Accessed November 22, 2009.

26 I am deeply indebted to Scheherezade Hassan, May Muzafar, and Zainab Bahrani for their help in decoding this extraordinary photograph. Bahrani, a professor of art history and Middle Eastern studies at Columbia, notes that the building in the background may not be a mosque (no minarets) but a Mazar (a shrine or mausoleum). The overtones of a divine army engaged in a holy war would still be suggested by this identification, and if it is indeed a mausoleum, it would suggest that this is a kind of "ghost army," rising from the dead to defend Iraq from invasion.

27 The epigraph to this section is from Vincent Ruggiero, "Terrorism: Clon-

ing the Enemy," *International Journal of the Sociology of Law* 31 (2003): 23–34, quote on p. 33.

28 On Saddam's conflation with Hitler, see my essay, "From CNN to *JFK*," in my *Picture Theory* (Chicago: University of Chicago Press, 1994), chap. 13.

29 See the documentary film *Control Room* (dir. Jehane Noujaim, 2004), which includes testimony from eyewitnesses who noticed that the crowd was composed of many non-Iraqis. See also Robert Fisk, "Saddam Statue Scene Staged," *The Independent*, April 11, 2003. http://www.twf.org/News/Y2003/0411-Statue .html.

30 See "The Greatest Jeneration," http://www.greatestjeneration.com/archives/ 001199.php.

31 Saddam's refusal to wear a hood at his execution had the effect of making him an instant martyr throughout much of the Arab world.

32 See http://www.thetruthseeker.co.uk/article.asp?id=3718.

33 The first epigraph for this section is from Ludwig Wittgenstein, *Philosophical Investigations*, trans. G. E. M. Anscombe (Blackwell: Oxford 1953), 178.

34 See the British medical journal *Lancet*, however, and its reports on the very large numbers of Iraqi casualties, based in population statistics.

35 The ban was lifted by Defense Secretary Robert Gates in the first days of the Obama administration, February 27, 2009.

36 Or alternatively, the presence of photographers may have inflamed the crowd's passions, according to David Klatell, dean of Columbia University's Graduate School of Journalism. "Powerful Images Debuted," *Chicago Tribune*, April 2, 2004, 11.

37 See Michael Taussig's discussion of symbolic mutilations in Columbia, "The Language of Flowers," *Critical Inquiry* 30, no. 1 (Autumn 2003).

38 The distinction between modernist "shock" and postmodern "trauma" is discussed by Tanya Fernando in her PhD dissertation, "Shock Treatments" (University of Chicago, 2005).

39 "Powerful Images Debated," *Chicago Tribune*, April 2, 2004, 11.

40 Sheik Farzi Nameq "condemned the mutilations of the four Americans" as "un-Islamic desecrations." He also warned that this would bring destruction to the city. "Cleric in Fallujah Decries Mutilations," *Chicago Tribune*, April 3, 2004, 3. It seems unlikely that this declaration was based on any notion of the human body as an *imago dei*. That is a doctrine more attuned with Christian theology, and especially with the incarnation and the Catholic doctrine of the resurrection of the body. From an Islamic point of view, mutilation of the dead body is primarily a *social* sin, explicitly defined as such by the prophet himself, one to be avoided because of its capacity to mobilize revenge from the enemy. I am grateful to Abdolkarim Soroush for his advice on Islamic prohibitions on mutilation.

41 At least this was the official explanation, repeated ad nauseum by the likes of Dick Cheney. More likely the program was designed to elicit false confessions that could be used to support Bush administration lies about the connection between Iraq, al Qaeda, and 9/11.

42 Capobianco Gallery, San Francisco. The owner, Lori Haigh, was forced to close her gallery after several attacks of vandalism.

43 Mark Danner, "Abu Ghraib: The Hidden Story," *New York Review of Books* 51, no. 15 (October 7, 2004): 44. See also his *Torture and Truth: America, Abu Ghraib, and the War on Terror* (New York: NYRB Collections, 2004).

44 There were notable exceptions, such as the Taguba Report, and the forensic analysis of the photographs by Brent Pack (see the discussion in chapter 8). The official investigations of Abu Ghraib were more typically hamstrung by limits on how high in the military and civilian hierarchy an investigation was allowed to go. Major General Taguba's career was effectively ended by his scrupulous attempt to provide an honest and thorough investigation. See Danner, "Abu Ghraib," on the "subtle bureaucratic strategy" used to contain the investigations.

45 Another image that resonates with Haacke's *Star Gazing* is the cover of the leading German magazine, *Der Spiegel*, immediately after the presidential election of November 2004. The cover shows the Statue of Liberty blindfolded with the American flag, accompanied by the caption, "Augen zu und durch" ("Close your eyes and plunge forward"). A less literal, but more poetic translation, is offered by the title of Stanley Kubrick's last film, *Eyes Wide Shut*.

Chapter Seven

An earlier version of this chapter was published as "The Abu Ghraib Archive," in *What Is Research in the Visual Arts? Obsession, Archive, Encounter* (Clark Studies in the Visual Arts), ed. Michael Ann Holly and Marquard Smith (Clark Art Institute, January 13, 2009).

1 I wish to than Mark Benjamin for giving me access to the master disc of Abu Ghraib images.

2 Harman testified about this observation in her court-martial, and repeated the remark in interviews with Errol Morris. She also made the observation in her letters written during her time at Abu Ghraib prison. This passage from her letters is quoted in JoAnn Wypijewski, "Judgment Days: Lessons from the Abu Ghraib Courts-Martial," *Harper's*, February 2006, 47.

3 Sarah Sentilles, "'He Looked Like Jesus Christ': Crucifixion, Torture, and the Limits of Empathy as a Response to the Photographs from Abu Ghraib," *Harvard Divinity School Bulletin* 36, no. 1 (Winter 2008).

4 See "The Unspeakable and the Unimaginable," chapter 5 above, for a discussion of the mirroring of mask and hood, torturer and victim.

5 Stephen Eisenman, *The Abu Ghraib Effect* (London: Reaktion Books, 2007).

6 Raphael Patai's notorious encyclopedia of Orientalist stereotypes, *The Arab Mind* (New York: W. W. Norton, 1976), served as the textbook for the neocon intellectuals who provided the theoretical framework for the invasion of Iraq, and it seems to have filtered down to the military and intelligence communities as a guide to practice.

7 Jacques Rancière, *The Future of the Image* (*Le destin des images*) (New York: Verso, 2007), 27–28. Subsequent references to Rancière in this chapter are cited in parentheses.

8 Greenberg, "Avant Garde and Kitsch," *Partisan Review* (Fall 1939), reprinted in *Clement Greenberg: The Collected Essays and Criticism*, ed. John O'Brien (Chicago: University of Chicago Press, 1986).

9 The idea that oil was the "real" motive for the invasion of Iraq could not, of course, be publicly avowed with the same kind of moral rhetoric that could be used with arguments from self-defense (WMD), revenge (al Qaeda and 9/11), and liberation from tyranny.

10 Daniels made this remark in response to my seminar on this subject at the University of Nottingham, July 5, 2007.

11 See my book *What Do Pictures Want?* (Chicago: University of Chicago Press, 2005) for detailed elaboration of this approach to images.

12 Meyer Schapiro, "Words and Pictures: On the Literal and the Symbolic in the Illustration of a Text," in *Words, Script, and Pictures: Semiotics of Visual Language* (New York: Braziller, 1996).

13 Allan Sekula, "The Body and the Archive," in *The Contest of Meaning: Critical Histories of Photography*, ed. Richard Bolton (Cambridge, MA: MIT Press, 1989), 343–88, quote on p. 347. There are surely other kinds of photographic archives besides those compiled around Sekula's categories of "police" and "politeness" (e.g., geographical surveys, historical periods, wars, art collections), but Sekula's terms provide a nice fit with the actual practices of the Abu Ghraib photographers.

14 In letters written at the time to her girlfriend back home, Harman made explicit her understanding that something illegal was going on, and indicated her intention to document it photographically to provide evidence of the abuses. See Wypijewski, "Judgment Day."

15 This claim directly contradicts the commonplace notion that digital photographs have somehow lost their former connection to the Real, and are uniquely open to manipulation and alteration. For more on this argument, see my essay, "Realism and the Digital Image," in *Critical Realism and Photography*, ed. Jan Baetens and Hilde van Gelder (Leuven: Leuven University Press, forthcoming).

16 Sekula, "The Body and the Archive," 351.

17 Of course metadata can be manipulated by someone who knows how, just

as the analog image can be manipulated by anyone with an elementary knowledge of Photoshop. But nothing guaranteed the accuracy of notes about time, place, and camera settings kept in a notebook or on the backs of chemical-based photographic prints. The key difference is that this sort of data is now entered *automatically* along with the analog image at the moment a picture is taken.

18 See Pack's interview with Errol Morris in *Standard Operating Procedure.*

19 Among the as yet unreleased photos from Abu Ghraib are images of naked women and children.

20 Charlie Graner made a similar claim for the documentary, as opposed to "trophy," character of his photographs, in his testimony to the CID investigation, but his testimony was not, in contrast to Sabrina Harman's, supported by any correspondence written at the time. Source: Mark Benjamin of *Salon* magazine (personal communication).

21 See Errol Morris's interview with Sabrina Harman in *Standard Operating Procedure.*

22 According to her interview in *Standard Operating Procedure,* the majority of the court wanted to let her off, but one judge argued that she should be given five years in prison. The sentence was a compromise.

23 Megan Ambuhl was one of the three women caught in the margins of the Abu Ghraib photographs. She married Charles Graner after he went to prison. I quote here from her interview with Errol Morris in *Standard Operating Procedure.*

24 Graner received the commendation in November 2003, in the midst of the torture scandal. See Paul von Ziebauer and James Dao, "The Struggle for Iraq: The Jailer," *New York Times,* May 14, 2004. See also Wired.com for Lynndie England's testimony about the official commendation Graner received, as well the praise from CIA officers who reviewed the abuse photos he had taken. http://www.wired.com/threatlevel/2008/03/convicted-abu-g/.

Chapter Eight

1 The second epigraph to this chapter is quoted in "Abuse Photos Part of Agreement on Military Spending," *New York Times,* June 12, 2009.

2 See Peter Galison's wonderful documentary, *Secrecy* (2008).

3 We should recall here White House lawyer John Yoo's famous definition of torture as requiring "extreme physical pain leading to organ failure or death," which would make almost everything except the murders committed at Abu Ghraib completely legal, or Hillary Clinton's clever addition of "as a matter of policy" to her campaign declarations that she would never allow torture—except as an exceptional deviation from "policy."

4 As I wrote these words in late June 2009, Iran seemed on the brink of a *televised* revolution against a military dictatorship, made possible by new social

media—Twitter, Facebook, YouTube, and proxy servers that served as primary sources for the mainstream media.

5 Brigadier General Janis Karpinski was given command of fifteen detention facilities in Iraq, and was relieved of her command and demoted to colonel after the Abu Ghraib scandal broke. Karpinski's interview in *Standard Operating Procedure*, and her book, *One Woman's Army* (Miramax Books, 2005), makes it clear that the abuses at Abu Ghraib were a direct result of orders that came from the highest levels of the U.S. government.

6 James Agee, *Let Us Now Praise Famous Men* (Boston: Houghton Mifflin, 1939 and 1940), 9. Emphasis mine.

Chapter Nine

Portions of this chapter were previously published as "Sacred Gestures: Images from Our Holy War," *Afterimage* 34, no. 3 (November–December 2006).

1 The first epigraph to this chapter is from Jacques Derrida, "What Is a 'Relevant' Translation," *Critical Inquiry* 27, no. 2 (Winter 2001): 169–200. Derrida is echoing here the classic doctrine of "the king's two bodies," the sacred, divine body of the sovereign that lives forever and the fleshly, mortal body of the actual incarnate king. This underlies the logic of the mantra, "The King is dead. Long live the King." See Ernst H. Kantorowicz, *The King's Two Bodies* (Princeton, NJ: Princeton University Press, 1997).

2 I am echoing here the title of Darby English's brilliant recent book on black artists, *How to See a Work of Art in Total Darkness* (Cambridge, MA: MIT Press, 2007).

3 Arthur Danto, "The Body in Pain," *Nation*, November 9, 2006.

4 See Joel Snyder, "Visualization and Visibility," in *Picturing Science/Making Art* (London: Reaktion, 1997).

5 I owe the concept of the "picture act" (on the model of J. L. Austin's "speech act") to German art historian Horst Bredekamp, who heads the Collegium for Advanced Study of Picture Act and Embodiment at the Humboldt University in Berlin.

6 So far I have not been able to confirm the existence of the "Jesus position" as a generic torture technique, beyond the occasional rumor. I would be grateful for any information on this matter from readers of this book. The Israeli documentary *Avenge but One of My Two Eyes* (dir. Avi Mograbi, 2005) shows one of the favored punishments for uncooperative Palestinian men is to force them to stand atop a stone block for hours without stepping off.

7 The experts in psychological torture interviewed by Rory Kennedy in her film *The Ghosts of Abu Ghraib* are very clear about the severity of long-term trauma caused by stress positions and psychological torture.

8 See my essay, "World Pictures: Globalization and Visual Culture," *Neohelicon*

34, no. 2 (December 2007), a special issue, "Toward 'Glocalized' Orientations: Current Literary and Cultural Studies in China," ed. Wang Ning, for further discussion of this concept. Reprinted in *Globalization and Contemporary Art,* ed. Jonathan Harris (London: Blackwells, 2009).

9 Meyer Schapiro, "Words and Pictures: On the Literal and the Symbolic in the Illustration of a Text," in *Words, Script, and Pictures: Semiotics of Visual Language* (New York: Braziller, 1996). Subsequent references to Schapiro in this chapter are cited in parentheses.

10 See Charles Marsh, "Wayward Christian Soldiers," *New York Times,* January 20, 2006, op-ed page, for an account of the Christian evangelical role in the invasion of Iraq, including prowar sermons on the prospects for converting Muslims to Christianity, the analogy between Saddam Hussein and Nebuchadnezzar, and the importance of war in the Middle East as a preparation for the "earth's final days."

11 The upward gesture of the Leviathan's hand on the shepherd's crook suggests that this aspect of his sovereignty is directed at raising the people up toward eternal life, while the downward gesture of the hand with the sword suggests just the opposite.

12 See Cass Sunstein's discussion of the difference between strong and weak notions of the unitary executive. "What the 'Unitary Executive' Debate Is and Is Not About," University of Chicago Law School, "The Faculty Blog," August 6, 2007. http://uchicagolaw.typepad.com/faculty/2007/08/what-the-uni tar.html. Accessed November 28, 2009.

13 He is still mistakenly identified as the Hooded Man by Wikipedia as of November 28, 2009, which continues to cite the *Newsweek* article. http://en .wikipedia.org/wiki/Satar_Jabar. Accessed November 28, 2009.

14 See Salon.com, March 14, 2006: http://www.salon.com/news/feature/2006/ 03/14/torture_photo.

15 Michel Foucault, *The Order of Things* (New York: Random House, 1970), 9–10.

16 See Seymour Hersh, *Chain of Command: The Road from 9/11 to Abu Ghraib* (New York: Harper Perennial, 2005), p. 29, for a description of this scene.

17 See the discussion in chapter 7 above.

18 This distinction is discussed by William Hood, *Fra Angelico at San Marco* (New Haven, CT: Yale University Press, 1993).

19 On the terrorist as rival and double of the sovereign, see sociologist Vincenzo Ruggiero, "Terrorism: Cloning the Enemy," *International Journal of the Sociology of Law* 31 (2003): 23–34.

20 Carl Schmitt, *Political Theology: Four Chapters on the Concept of Sovereignty,* trans. George Schwab, with foreword by Tracy Strong (Chicago: University of Chicago Press, 2005), 5.

21 Michel Foucault in *Discipline and Punish,* trans. Alan Sheridan (New York: Vintage, 1979).

22 Foucault, *Order of Things*, 29.

23 See, for instance, an icon from the Workshop of Dionysius now in St. Petersburg that shows a Christ figure raising Adam and Eve from the dead.

24 Raphael Patai, *The Arab Mind* (New York: Hatherleigh Press, 1976; revised 1983), 113. One unsuspected virtue of Patai's reductive stereotyping is that it would help to explain the absolute shamelessness of the American government throughout the occupation of Iraq.

25 See the testimony to the surplus of women's panties in Errol Morris, *Standard Operating Procedure.*

26 Mark Danner, *Torture and Truth: America, Abu Ghraib, and the War on Terror* (New York: NYRB Collections, 2004), 227.

27 We know of at least one case where the opposite sort of conversion took place, involving an American GI who converted to Islam at Guantanamo Bay. See Dan Ephron, "The Gitmo Guard Who Converted to Islam," *Newsweek,* March 26, 2008. http://www.muslimmilitarymembers.org/article.php?story= 2009032608411720. Accessed November 30, 2009.

28 1 Thessalonians 5:2.

Conclusion

1 Both epigraphs to this chapter are quoted in Thomas R. Flynn, *Sartre, Foucault, and Historical Reason* (Chicago: University of Chicago Press, 1997), 55, 255.

2 See Paul Rabinow and Nikolas Rose, "Biopower Today," *BioSocieties* 1 (2006):195–217. From a biopolitical perspective, the "times of cloning" are actually three different temporalities: 1) the relatively recent decoding of the human genome, and the first experiments in animal cloning; 2) the whole scientific program of genetics and biotechnology that begins (say) with Mendel, and culminates in the discovery of the DNA molecule in the 1950s; 3) Foucault's era of biopolitics, which begins in the late eighteenth century with emergence of liberalism and new forms of governmentality aimed at the regulation of bodies and populations. What one observes in this triple temporality is a gradual evolution of a potent metaphor into literal, technical reality, from governmental and institutional biopower (eugenics, social Darwinism, public health clinics, racial classifications) to Huxley's *Brave New World,* to the "clone wars" of the twenty-first century.

3 David Simpson reflects on the many "anniversaries" that were consolidated in the dating of 9/11 in his book, *9/11: The Culture of Commemoration* (Chicago: University of Chicago Press, 2006).

4 See Slavoj Zizek, "It's the Political Economy, Stupid," *Critical Inquiry* (forth-

coming, Summer 2010), who argues that what the financial panic called for was precisely *not* "immediate action," but a pause for considered reflection on the whole structure of capitalism. Needless to say, that advice has not been taken by the Obama administration, though that is clearly the deeper anxiety that underlies the global economic crisis.

5 The closest thing to a datable event would probably be June 26, 2000, when Bill Clinton and Tony Blair announced the completion of a rough draft of the human genome.

6 Of course the Internet is awash in rumors of plans to clone Jesus from the DNA traces on that dubious artifact known as the Shroud of Turin. The novelistic treatment of this premise is worked out by James BeauSeigneur. See *In His Image* (New York: Warner Books, 2003).

7 And it is important to remember that the clone, although it may be a "deep copy" of both the analog surface and the underlying code, is never a perfect copy since the environment in which the organism gestates and lives is never identical, and can never (in a temporal sense) be identical. That is why clones are not as exact in their resemblance as identical twins.

8 For a masterful comparison of Sartre's and Foucault's philosophies of history as driven by "total narrative" and "system," respectively, see Thomas R. Flynn, *Sartre, Foucault, and Historical Reason: Toward an Existentialist Theory of History,* vol. 1 (Chicago: University of Chicago Press, 1997).

9 Michel Foucault, *The Birth of Biopolitics: Lectures at the College de France, 1978–79,* trans. Graham Burchell (New York: Palgrave Macmillan, 2008).

10 See Rabinow and Rose, "Biopower Today," for a critique of Agamben's appropriation of the Foucauldian concept of biopower for these extreme situations. Foucault's notion is certainly on the side of something more like normalization—governmentality, social discipline, and control—rather than the "state of exception" emphasized by Agamben. I suspect that Foucault would have agreed, however, that certain features of biopolitics (racial classification most notably) could easily have the effect of normalizing a state of exception, as in the notorious Nazi attempts to legalize ethnic cleansing. This is surely what happens in the obsessive search for legal justification of the Bush administration's secret prison and torture regime. Errol Morris's film about Abu Ghraib, *Standard Operating Procedure,* captures this paradox perfectly, as its title suggests. See chapter 8 above for more on this.

11 I am alluding here to Sartre's emphasis on the contingent fact of Kaiser Wilhelm's withered arm as a determining influence on a key figure in the onset of World War I. See Flynn, *Sartre, Foucault, and Historical Reason,* 20. The Claw Man's deformed hand, however, is not nearly as important as the contingent fact of a singular photograph emerging from an archive of hundreds of images to achieve the status of a global icon.

12 Sartre's concept of historical simultaneity might be seen as his way of transcending the opposition between his existentialist approach to history and Foucault's structuralism. Simultaneity, argues Flynn, "refers to a basic unity . . . between a fact as registered in consciousness and all that is happening elsewhere or that has happened thus far" (*Sartre, Foucault, and Historical Reason,* 12).

13 Reuters, June 5, 2007. "Number of Iraqi Displaced Tops 4.2 million; Shanty Towns Mushroom," United Nations High Commissioner for Refugees. http://www.alertnet.org/thenews/newsdesk/UNHCR/3600c843dbc8bc1408ddae-9d73dd8cf2.htm. Accessed October 1, 2009.

Index

stress positions (*continued*)
191n7; photographs of, 113, 114,
136, 141
suicide terrorism, 67, 74, 173n1, 184n26
Sun-Tzu, 1
Suskind, Ron, xviii
swastika, on U.S. soldier, 110, 111, 130,
plate 3

Taguba Report, 188n44
Taliban: destruction of Bamiyan Bud-
dhas by, 11, 79, 82, 186n18; rationale
for Afghanistan War and, 179n6
Taussig, Michael, 129
terror: as destruction and produc-
tion of images, 78; dinosaur and, 73;
panic and, 6, 10, 52, 163; in post-9/11
U.S., 162–63. *See also* cloning terror
terrorism: aim of, 12, 21, 64; autoim-
mune model of, xv, 20, 45–49, 52–53,
67, 74; biocybernetic model of, 20–
21; biopolitical model of, 44–45; as
cancer, xiii, xiv, xv, 20, 45, 49, 52, 57,
67, 74; cloning and, 14, 17–18, 19–
20, 74–77, 183n25; effective response
to, 48–51, 53–54; increased by tor-
ture program, 103; increased by War
on Terror, xii–xiii, 49, 173n4; as in-
fectious disease, xv, 20, 21, 45, 46,
52; international vs. local, 46; invis-
ible, 84–85; long history of, 20; sui-
cide attacks in, 67, 74, 173n1, 184n26;
violent spectacle in, 51–52, 64, 84,
180n20; as viral proliferation, xiv,
20, 45; worldwide attacks since 9/11,
180n16. *See also* War on Terror
terrorist: as clone, 67, 74, 78, 165; as
double of the sovereign, 153; as hero,
51, 63, 176n5; hooded images of, 62,
109
themes of state, Schapiro's concept of,
122, 144–47, 149, 151–52, 158–60
Thin Blue Line, The (Morris), 133
Thucydides, xi

Tintoretto, 156
toddler terrorists, 76, 77
Toledeano, Phil, 174n6
torture, xvi, xvii; Abu Ghraib photo-
graphs and, 5, 37, 103; in Christian
iconography, 9, 157; citizens' respon-
sibility for, 152; desecration of Islam
in, 157–58; euphemisms about, 61; in
Gibson's *Passion of the Christ*, 155; at
Guantanamo, 118; by hooded figure,
62, 109, 115–16; of Jesus, 153; Jesus
position in, 141, 148, 150, 191n6; in
Marathon Man scene, 58–59; *pathos-
formulae* of Western painting and,
116; powers of the sovereign and,
153; the unimaginable and, 62; un-
intended consequences of, 103; un-
speakability of, 59–60, 62; U.S. gov-
ernment definitions of, 129, 190n3;
uselessness of information from,
59–60; White House memos on, 37,
129, 177n14, 194n10. *See also* Abu
Ghraib archive
trauma: religious experience and, 60,
182n15; vs. shock, 97, 187n38; un-
speakability of, 60
trauma industry, 80
trauma theory, 60, 181n12
traumatic spectacle, 51–52, 64
twin, evil, 19, 34, 66, 75, 89, 160
twins, xiv, 34, 99, 103
twin towers. *See* World Trade Center
destruction
Twitter, xi, 2, 130, 190n4

"Uncle Osama," 52, 65–66, 89, 180n21
unspeakable and unimaginable, 57–68;
cloning and, 66–68; compared, 60–
62; in images of War on Terror, 68;
in Iraq War, 65; as rhetorical tropes,
57–58; temporary nature of, 62–63,
182n17; terrorism and, 63–64, 84;
torture as, 59–60; trauma as, 60; un-
sayable and, 58–59, 181n9